A Sociology of Culture, Taste

A Sociology of Culture, Taste and Value

Simon Stewart
*School of Social, Historical and Literary Studies,
University of Portsmouth, UK*

palgrave
macmillan

First published 2014 by
PALGRAVE MACMILLAN

Palgrave Macmillan in the UK is an imprint of Macmillan Publishers Limited,
registered in England, company number 785998, of Houndmills, Basingstoke,
Hampshire RG21 6XS.

Palgrave Macmillan in the US is a division of St Martin's Press LLC,
175 Fifth Avenue, New York, NY 10010.

Palgrave Macmillan is the global academic imprint of the above companies
and has companies and representatives throughout the world.

Palgrave® and Macmillan® are registered trademarks in the United States,
the United Kingdom, Europe and other countries

ISBN 978-1-349-47790-6 ISBN 978-1-137-37708-1 (eBook)
DOI 10.1057/9781137377081

A catalogue record for this book is available from the British Library.

A catalog record for this book is available from the Library of Congress.

Contents

Acknowledgements		vi
Introduction		1
1	Culture in a Rationalizing World	8
2	The Fate of Cultural Values	32
3	Why Do We Like What We Like?	56
4	Expressing Taste	75
5	Evaluating Culture	105
6	Culture in a Globalizing World	130
7	The Local on the Global Stage	159
Conclusion		177
Notes		180
Bibliography		183
Index		192

Acknowledgements

I would like to thank Andrew James and Anna Reeve for commissioning this book. I am grateful to the reviewers for their insightful and helpful comments. Thanks to my excellent colleagues at University of Portsmouth and elsewhere whose suggestions have enabled me to sharpen the text considerably. A very special thanks to John Stewart for helping me to eliminate inelegant words from the book and to Hannah Stewart for putting up with me hiding away in the study. Many thanks also to James Raiher, Penny Stewart, Shirley Tan, Naomi Robinson, Barry Smart, Sally Munt and Keith Tester.

In Chapters 5 and 6 I have drawn on and developed material from two articles: (2012) Reflections on Sociology and Aesthetic Value. *Distinktion: Scandinavian Journal of Social Theory*, 13(2), 153–167; (2013) Evaluating Culture: Sociology, Aesthetics and Policy. *Sociological Research Online*, 18(1).

Introduction

This book is an account of sociological debates in relation to culture, taste and value. It provides an introduction to several perspectives, and addresses a number of key questions. The book echoes Raymond Williams (1981, p. 13) in conceptualizing 'culture' as both 'a whole way of life' and as 'artistic and intellectual activities'.[1] The debates in this book utilize, at various times, each of these senses of the word. The book brings to the fore the tensions between culture and market forces, between individual expression and impersonal societal forms, between ways of acting and thinking that are value-driven and those that impose order on reality through quantifiable and calculable standards. For example, it considers the pursuit of particular value-systems where cultural values are in retreat as a consequence of processes of rationalization (see Chapters 1 and 2); it argues that taste and cultural evaluation are expressive of class and educational background and yet, also, can to some extent be consciously planned and actively performed (see Chapters 3, 4 and 5). It considers alternative ways of evaluating cultural objects during times in which the logic of profit occupies a dominant position as the arbiter of value (see Chapter 5); it examines tensions in the global field of cultural production where sameness and difference coalesce: where the heavy tread of transnational corporations is accompanied by the pitter-patter of more light-footed culture creators, and where even the most standardized cultural objects have aesthetic properties that are assessed variably by audiences familiar with the codes associated with the particular category of cultural production to which these objects belong (see Chapters 6 and 7). A central argument of the book is that it *is* possible for sociology to engage with questions of aesthetic value (Chapter 5).

In Chapters 1 and 2, the fate of cultural values is considered. More specifically, the following question is addressed: *What is the fate of cultural values in a rationalizing world?* According to the classical social theorist Max Weber (1968[1913]), our lives are increasingly dominated by impersonal forces; we serve institutions instead of institutions serving us; we exist for the sake of our business rather than the reverse; our lives are increasingly governed in accordance with the logic of formal rationality – a type of rationality which imposes order on the world by means of calculable, abstract rules such as those that govern bureaucratic procedures and financial transactions. In these chapters, we examine the continuing relevance of Weber's views on the irreconcilable conflict between formal rationality and substantive (value-driven) rationality, with the former perceived to be in the ascendancy in modern culture. With this in mind, we consider the tensions between 'culture' and administration (Adorno, 1991[1960]). As Theodor Adorno (1991, p. 108) points out, 'culture suffers damage when it is planned and administered'. However, when left to itself, without funding, its very existence is threatened. Administration also needs culture, for the purposes of cultivating or stultifying its people; or to utilize in its pursuit of new markets. Culture and administration need each other, but, regrettably, their ways of viewing the world are antithetical.

Administration, which operates in accordance with formally rational procedures, does harm to culture when it takes it under its wing. There is, then, a 'sibling rivalry' between 'culture' and 'management' that can never be resolved (Bauman, 2005b). So, the price the 'culture' pays for being funded (whether by the state or by a record company) is to be measured in accordance with criteria that have nothing whatsoever to do with questions of immanent quality or value. In short, culture is measured in terms that are formally rational: for example, in relation to sales figures or audience ratings.

Thankfully, as Alan Sica (2000) points out, a world *entirely* dominated by formal rationality is the stuff of science fiction. So, it is here that we introduce one of the key arguments, one of the key themes running through the book: there are countless culture creators in the twenty-first century who seek to evade the totalizing logic of profit and whose *modus operandi* can never be entirely contained by formal rationality. To describe this evasion of the formally rational as *resistance* would perhaps be to overstate the case, for rather than manning barricades, many of these people are merely humming to themselves in the still of the night or creating cultural objects in the half-light, intoxicated, in Baudelairean mode, by wine, poetry or virtue. The world is

teeming with value-laden cultural visions, whether conjured by those operating as professional culture creators, those paid for their craft, or those making up the words to songs under their breath while performing the arduous labours of the day job. Some such visions might be wondrous to behold, others less so. It matters little. What concerns us here is that such creativity cannot be entirely contained or exploited, either because there is nobody interested in containing it or exploiting it, and so these creators are ignored, or because these culture creators are intransigent and refuse to submit to the demands of management. The culture they conjure might therefore be disseminated on a very small scale – in the cellars of folk clubs, in the back rooms of bars, in alleyways, in community centres, in living rooms, in the company of people personally known and respected. There are, of course, other such expressions of what Weber (1968) termed *value-rational* action where resistance *is* perhaps the right word – expressions engendered for example, by ethical considerations, perhaps in opposition to financial capitalism or environmental destruction. In Chapters 1 and 2, at the very core of the debate regarding the fate of cultural values, we also examine Weber's conviction that it is possible to gain inner-consistency in formulating the course of action that will best enable us to follow our calling, the 'godhead' we have chosen to serve, whether it is science, environmentalism, poetry or beauty.

So, we choose the 'godheads' we serve. Or do we? This book also examines the extent to which our cultural preferences and, more specifically, our *tastes* are determined by our social origin and class background. To put it simply: *Why do we like what we like? Why do we dislike what we dislike?* There is here a tension between taste as a creative, spontaneous engagement with a cultural object and taste as something the outcome of which is pre-determined. For example, is our appreciation of Mondrian's paintings only possible because of our ability to perceive his work aesthetically, in relation to other works in the history of art? Is the ability to appreciate this artwork dependent on our social origin and the levels of education, both formal and in-formal, we have received? Or is our engagement with this cultural object actually something far more spontaneous and subjective than can be accounted for in the explanations provided by sociologists? The work of French Sociologist Pierre Bourdieu, one of the key players in this book's *dramatis personae*, provides the theoretical framework within which we conduct this debate about taste. Bourdieu's work also brings to the fore the link between culture and power. For example, he refers to *legitimate* culture rather than *high* culture, drawing attention to the

fact that the most prestigious and revered cultural objects are those which have been consecrated by powerful institutions and people (Bourdieu, 1984[1979]). Furthermore, Bourdieu draws attention to the relational aspect of taste. For example, he considers how taste brings people together (people from similar families, with similar levels of cultural capital (cultural competence, levels of education) and economic capital), and conversely, how tastes 'are the practical affirmation of an inevitable difference' and serve to distinguish one social class grouping from another (Bourdieu, 1984, p. 56). Expressions of taste (and distaste) can be brutal, providing dominant social groups with a means of inflicting symbolic violence on dominated social groups. Bourdieu (1984) considers taste in its broadest sense, drawing attention to the social conditions that give pattern to our disparate cultural consumption choices in, for example, clothes and food as much as in literature and music. His work examines *why* it is that certain individuals seem to naturally gravitate towards complex works of art, and appear to have an unmediated connection with these cultural objects. This seemingly unmediated connection, he argues, is only possible because these individuals will have been trained to perceive culture in this way; more specifically, they will have acquired, over the course of time, an *aesthetic disposition* – a way of perceiving the world that is attentive to form rather than function. However, in Chapter 4, the argument is made that it is important not to lose sight of the *cultural object* which, in Bourdieu's work, is often looked upon from afar, or is little more than a token in a symbolic game.

So, in our analysis of taste, we consider the need to examine *what* is consumed and precisely *how* individuals interact with cultural objects. This involves being attentive to various *affectual impulses* that underpin the act of tasting. Cognizant of the determinisms associated with social origin, we consider responses to cultural objects that extend beyond meaningful social action. We see that such responses might be intensely bodily, characterized by immediacy and triggering feelings of pleasure or disgust. Alternatively, they might be characterized by non-cathartic feelings, such as indifference, envy, moderately-felt pleasure or mild distaste. They might be motivated by a sense of revolt or by impulses rooted in a contrariness that seeks to contradict societal or familial or generational expectations. Furthermore, we consider the creative impulses that inform the *consuming* as much as the *producing* of cultural objects. In Chapter 5 where the problematic relationship between sociology and aesthetic value is outlined, the following questions are addressed: *How can we evaluate culture? How might sociology*

contribute to debates about aesthetic value? A number of perspectives are outlined, each of which, in researching aesthetic value, attempts to find a way of keeping the cultural object in sight. The argument is made that sociological perspectives can inform an approach to aesthetic value that *zooms in* on the precise moment of evaluation and considers the various dynamics that affect the interaction between the individual and the cultural object. The *dynamics of the evaluative moment* include, for example, *the presence of other people and the influence they bear; the pressure to stand out and to fit in; the level of our engagement with the cultural object; the methods and practices deployed in order to engage with the cultural object; the impact of location on the moment of evaluation;* and *the material qualities of the cultural object.* In a world in which the value of culture is increasingly measured in formally rational terms, in relation to its economic value, it is important to gain insight into *other* ways of valuing. This means considering evaluation, at the micro-level, as an everyday activity that takes place in the home, in the street, in the community as much as in the concert hall and the art gallery; it means considering the interplay between individuals, groups, communities and the cultural object; it means being attentive to the varying degrees of engagement with the cultural object, from the distracted to the concentrated; it means being attentive to the various registers of evaluation, from the raised shoulder that is demonstrative of indifference or disapproval to the breathlessness and effusiveness of a passionate, affirmative response.

Inevitably, the book turns also to the impact of globalization (Chapters 6 and 7). These chapters return to the conflict between formal and substantive rationality, between impersonal and creative forces. It considers debates regarding cultural sameness and diversity. With the requisite resources at our disposal we have never had before us such a rich array of cultural objects from which to pick and choose. For example, if we want to listen to music, we have fifteen centuries of music from which to sample, ready to be acquired at the click (or two) of a button. On the other hand, there are a number of transnational corporations disseminating *omnibus products* that are designed to appeal to everyone on the planet (Bourdieu, 2003). Whether we are talking about companies selling food and drink such as McDonald's and Starbucks or media corporations such as Sony and Viacom, the procedure is similar: omnibus products (whether Big Macs, blockbuster films or best seller novels) are designed in accordance with the formally rational motive of profit, and these cultural objects have very few distinctive features but have wide appeal. Their success, or otherwise, is

measured in accordance with numerical, quantitative standards of, for example, sales figures, audience ratings and revenue generation. However, in Chapter 6 the argument is made that even the most standardized cultural object produced and disseminated by transnational corporations is *cultural* and is made up of aesthetic properties which are evaluated and interpreted by audiences and consumers in different parts of the world in various ways, depending on context, and in accordance with the extent to which audiences are familiar with genre-specific criteria, codes and conventions. Furthermore, many attempts to promote omnibus products have failed and so cultural objects are carefully tailored so that a global format is adapted in order to reflect local concerns. In these examples, we see that diversity persists alongside sameness even if this diversity serves the interests of transnational corporations seeking to penetrate into new markets around the world. A means of apprehending this complexity can be found in Roland Robertson's (1990, 1992, 1995, 2003) concept of *glocalization* which refers the co-presence of sameness *and* difference in a globalizing world. However, it is important to recall that, as Robertson (1995, 2003) observes, *glocalization* refers also to the co-presence of the 'local' and the 'global'. 'Local' cultural forms are (re)created and (re)invented on a translocal scale; therefore it can be said that the local is globally produced just as the global is locally produced. This means that the identities associated with nation-states, ethnic or diasporic groups are created in response to global conditions, with each nation or group putting a gloss on its uniqueness, differentiating itself from others. This leads to a proliferation of difference even if the various parties are articulating their difference in similar ways. Furthermore, to re-introduce *culture creators* to the debate, we see that working alongside transnational corporations, which are vehicles for formal rationality and profit, culture creators borrow and steal from 'global' forms in order to articulate their own agendas. They also seek to differentiate themselves from other culture creators around the world by strategically drawing attention to their uniqueness – whether this is based on a sense of heritage and tradition or newness. For example, musicians, whether consciously or semi-consciously, project a marketable, one might say 'touristic' image of themselves on the global stage. They convey their uniqueness in their cultural habitus: in their bearing, their manner, in their bodily demeanour, in their gestures, in their ways of speaking, and, of course, in their performances. In short, their style is embodied; it becomes them and is not something a stranger could readily imitate or assimilate. So, musicians who manage to capti-

vate audiences from distant places or from different cultural milieus manage to do so because they are *complex carriers of signs projected for audiences willing to recognize them as embodying the apotheoses of particular styles or genres.*

Culture has served as a call to action, as a tool for the Enlightenment project and for nation building; it has also served as a homeostatic device used to maintain social equilibrium and preserve the status quo (Bauman, 2005b, 2011). So, it has been a stimulator and a tranquilizer, and, more recently, it has facilitated the expansion of consumer markets. However, drawing attention to the inventiveness of humans, whether in creating culture or in interacting with cultural objects, this book argues that 'culture' provides a challenge to the status quo and prevailing ways of thinking. The light-footedness and quick-thinking inventiveness of culture creators contrasts with the heaviness of economic might, the doggedness of prevailing assumptions and ideological certainty. Culture is the art of the possible, though hand-in-hand with the theme of possibility is uncertainty. During times of economic crisis and uncertainty, the need to defend aspects of culture that envisages alternative ways of perceiving and experiencing the world is all the more pressing. To speak of culture, says Zygmunt Bauman, 'is to make another attempt to account for the fact that the human world (the world moulded by the humans and the world which moulds the humans) is perpetually, unavoidably ... not-yet-accomplished' (Bauman and Tester, 2001, p. 32).

1
Culture in a Rationalizing World

Introduction

Whereas Karl Marx decried without hesitation or reticence what he saw as the 'dominance of things over men' in capitalist society, the German social theorist Max Weber (1864–1920), born 46 years after Marx, deployed the more 'neutral' notion of rationalization to describe a process that both opened up the way to purposive rational action *and* led us into an 'iron cage' (Lowith, 1993[1960]).[1] In the following two chapters, the argument is made that Max Weber's work on rationalization has much to tell us about the fate of cultural values in the late modern world that we inhabit. Weber perceived a world in which cultural values were in retreat and impersonal forces had come to dominate (Gronow, 1988). If the rationalization of thought and action had yielded material wealth and, to some extent, a greater scope for freedom and responsibility of action, Weber was also acutely aware that accompanying such developments were, as Alan Sica (2000, p. 42) comments, 'seedbeds of pathology that affected individuals as much as the societies in which they struggled, vainly ... to maintain their individuality and freedom'. Distinctive cultural values and ways of being, whether creative or morally purposeful, whether aesthetic or ethical in orientation, whether serving the 'demons' of an artistic or a moral value sphere, were threatened by the very same purposeful rationality that enabled them to find an emboldened form in the first place. What troubled Weber was that the modern culture he saw was one in which humans had come to serve institutions rather than vice-versa, where the means of making money had become an end in itself and where the money economy with its emphasis on quantitative reckoning and calculation increasingly served to exile qualitative differences.

8

Although many of his key writings were produced more than 100 years ago, Weber's work, which has been described as a 'science of man', has considerable purchase in enabling us to understand the late modern world we inhabit (Hennis, 2000). The concept of rationalization has at its heart something that is all too apparent: the formally rational, impersonal structures that dominate our everyday lives. Formal in this sense refers to the impersonal ways in which we measure the value of things and in the impersonal nature of so many of our daily interactions, whether in our exchanges with other human beings or in our dealings with the labyrinthine bureaucracies, online and offline, of the private and public sectors.

Rationalization

Rationalization, according to Weber, is a historical process unique to the Western world that involves an increasing mastery of reality by means of calculation, technical procedure, and methodical planning. It involves an increasing mastery of the natural world, of society, and of individual action. As reality is made increasingly 'knowable', science, law and medicine are in the ascendancy and the world is stripped of the magical belief systems that had hitherto dominated. According to Derek Sayer (1991, p. 114), rationalization 'connotes systematicity, consistency, method: whether as a cast of mind, or as the principle on which organizations are structured, it implies the exclusion of arbitrariness and above all of what he [Weber] refers to as "magic"'. Many Weber scholars have disputed the extent to which rationalization is the 'key' to Weber's thought (see, for example, Hennis, 2000), but it is another matter altogether to deny its significance as a dominant theme running through his vast and disparate body of work. Kenneth H. Tucker (2002, p. 161) argues that whereas for Marx the master process of modernity is class struggle, for Weber it is rationalization, 'the march of the bureaucrat, not the proletariat'. Karl Lowith (1993, p. 49) argues that Weber's concept of 'rationalization', like Marx's 'alienation', is a characterization 'of the fundamental meaning of capitalism'. For Marx, the driving force of history is the mode of production of a given society. In Weber's analysis of history, there is no singular 'driving force' of history nor is there a sense of inevitability regarding the direction in which historical events are taking us. Rather, Weber seeks to understand the various factors, material and ideal, that have played a part in shaping the course of events, and, for example, in *The Protestant Ethic and the Spirit of Capitalism* he seeks to 'clarify the part

which religious forces have played in forming the developing web of our specifically worldly modern culture, in the complex interaction of innumerable different historical factors' (Weber, 2001[1904], p. 49). Jukka Gronow (1988, p. 320) argues that for Weber, rationalization is a two-fold process. First, 'a rational and methodical conduct of life originally ethically motivated and embedded in a religious and metaphysical world view becomes detached from the ethics of calling' so that this conduct is institutionalized and comes to dominate the individual in the form of impersonal rules and modes of conduct. Second, the various spheres of life, whether concerned with ethics, law, art or science, are detached from each other, become independent, and, as we will see below, 'the values ruling in them ... change their quality and become mutually incompatible' (Gronow, 1988, p. 320). As we will see below, rationalization is also characterized by the increasing dominance of formal rationality, which 'destroys all genuine cultural values in the modern world and ... petrifies culture into a mechanical apparatus resembling that of a machine' (Gronow, 1988, p. 321). So as to get a clearer idea of rationalization, as Weber perceived it, let us now look at some examples.

Rational capitalism

Weber (2001, p. xxxi), in common with Marx, held the belief that capitalism is 'the most fateful force in our modern life'. Let us, then, discuss the rise of this key vehicle for rationalization, namely that which Weber (2001[1904], 2003) identified as rational capitalism, which emerged in Europe (and subsequently, the United States of America) from the sixteenth century onwards. In his *General Economic History*, he drew attention to six key factors associated with rationalization which played a major part in the development of rational capitalism in the West (Weber, 2003[1927]). The first factor is the use of rational accounting as the norm for large scale industrial concerns which 'determine ... income yielding power by calculation according to the methods of modern bookkeeping and the striking of a balance' (Weber, 2003, p. 275). The second factor is the emergence of a free market not limited by class monopolies or restrictions on access to trading or the ownership of property. The third factor is the increasing use of rational technology such as mechanization so as to make calculable, as much as possible, the production and distribution of goods with view to enhancing profits and increasing levels of production. The fourth factor is the emergence of calculable law which can be

readily administered and which offers a reliable means of adjudication, thus contrasting with forms of law, for example, in patrimonial societies of Asia and in the West 'down to the Stuarts', where the prominent and the wealthy all too often had recourse to 'cheap justice' and could readily buy their way out of trouble (Weber, 2003, p. 277). Although rational law, as Weber understood it, is also subject to abuses and tampering by the powerful, it is far more likely to be fair than is a system based entirely on personal favour or hereditary rule. The legal authority that serves to enforce this type of law is claimed by the state, which is administered by salaried, appointed officials and has a monopoly on the use of violence. The fifth factor in the development of rational capitalism is free labour. This means that there is a property-less class that is formally free, but is compelled to sell its labour in order to meet its needs. The sixth factor associated with rationalization is the commercialization of economic life, meaning 'the general use of commercial instruments to represent share rights in enterprise, and also in property ownership' (Weber, 2003, pp. 277–278). Other related factors associated with the development of rational capitalism include the widespread deployment of instruments of financial rationalization such as tax farming and the free transferability of shares (Weber, 2003).

Crucially, Weber argued that in addition to the above factors, a particular type of economic conduct particular to the occident played a key role in the development of rational capitalism. This conduct has cultural roots in Protestantism, and in particular, in Calvin's doctrine of salvation. *The Protestant Ethic and the Spirit of Capitalism* is Weber's most famous work, and in the section that follows, we can only briefly sketch out its main thesis. Weber sought in part to provide explain a phenomenon that was widely discussed in the Catholic press at the time he was writing: why was it that in countries with mixed religious composition, the prominent business leaders and the most technically and commercially adept employees in business enterprises tended to be, overwhelmingly, Protestants rather than Catholics? Why had Protestants 'shown a special tendency to develop economic rationalism which cannot be observed to the same extent among Catholics' (Weber, 2001, p. 7)? Central to Weber's argument is that the doctrine of Protestantism, as espoused by Martin Luther and John Calvin, inspired a mode of conduct in the world that 'favoured the development of a rational bourgeois economic life … It stood at the cradle of the modern economic man' (Weber, 2001, p. 117). Protestantism emerged as a separate branch of Christianity out of attempts to change the Catholic Church during the Reformation (1517–1648). The

relationship with God of Catholic laymen was mediated by the Church; they were caught up in a perpetual cycle of sin, repentance, atonement, release, and return to sin. The Priest, as mediator, was a figure to turn to in the hour of need, 'a magician who performed the miracle of transubstantiation, and who held the key to eternal life in his hand' (Weber, 2001, p. 71). Catholics could thus, by means of the system of the confession and penance, envisage salvation in spite of an imperfect and unsystematic life, so long as the balance of merit was in their favour. There was no such comfort for Protestants. Inspired by Reformation-era theologians such as Martin Luther and John Calvin, religious faith became a private matter between the individual and God. These theologians sought to strip religious practice of all superstitious, magical and sacramental elements. In short, the Protestant doctrine of predestination, which was emphasized by Calvin and his followers, was crucial in the formation of an ethic compatible with rational capitalism. It held that by the decree of God, mankind was divided into two groups: those who were predestined to be saved, to have everlasting life, and those who were damned to everlasting death. This decision had already been made and there was no means of adjusting one's merit or gaining the favour of God by means of one's behaviour on earth. According to Weber (2001, p. 60) this had the consequence of 'a feeling of unprecedented inner loneliness of the single individual'. It led, inevitably, to salvation anxiety: the question that emerged for each Protestant individual was 'Am I one of the elect?' (p. 65). The solution for the Calvinist was *sola fide*, meaning faith alone. The Calvinist sought, by means of a life of good works, an engagement with intensely worldly activities, or, in Luther's terms, the pursuit of one's 'calling', was a means of ridding oneself of the fear of damnation and gaining confidence that one's success in such activity was a sign of election. This ascetic tendency had a revolutionary impact: it meant that after the Reformation, Protestant individuals proved their worth by means of an intensive self-regulation of conduct in mundane, worldly occupations. Whereas Catholic monks sought their path to salvation in monasteries, isolated from worldly endeavours, the ascetic Calvinist slammed the doors of the monasteries and 'strode in to the market-place of life' (Weber, 2001, p. 101).

Weber found the apotheosis of Protestant asceticism in the writings of Richard Baxter, a seventeenth century Puritan theologian. Baxter repeatedly advocated the moral worth of 'hard, continuous bodily or mental labour' (Weber, 2001, p. 105). The ascetic tendency of Calvinism involved 'a life of good works combined into a unified

system', a rationalization of everyday conduct (Weber, 2001, p. 71). Crucially, the asceticism of the Puritan meant an attitude hostile to idleness, to wasting time, to the pursuit of pleasures or luxuries, to idle talk and sociability. Curiously, it was not, however, hostile to the making of money. So as to illustrate this point, Weber (2001, p. 36) drew a comparison between Catholic attitudes in fourteenth and fifteenth century Florence and those in the eighteenth century Pennsylvania, USA. In Florence, which had a highly capitalistic culture, there was a sense of unease and guilt associated with the making of money, and the rich often donated wealth to the Church so as to salve their consciences. In Pennsylvania, where the Puritan influence was strong, capitalistic acquisition became, for the rising strata of the middle-class, a sign of election, a sign of God's blessing. Making money was now, as part of one's calling, an utterly respectable pursuit as long as this money was saved prudently, acquired legally, and not used as a means of pursuing the temptations and pleasures of an idle life. The order of the day for the emergent Protestant middle-classes was now acquisition for its own sake, and such profits came to be seen as a sign of blessing.

Weber's argument, that the rational pursuit of profit was unique to the West, is contentious. He insisted that *auri sacra fames*, the greed for gold, was no less present in earlier periods of history, in the Ancient world, in China, India, in Babylon, than in the modern world, but what differentiated rational capitalism from these forms of capitalistic activity was the particular ethos, namely the spirit of capitalism, informed by Protestant asceticism, characterized by the rational, cool-headed and systematic pursuit of gain, with labour pursued as end in itself. Although, as has been established above, Weber did not seek to argue that the ascetic tendency in Protestantism was *the* causal factor in the development of rational capitalism, he clearly believed that it played a major role in the emergence of the spirit of capitalism, contending that

> the religious valuation of restless, continuous, systematic work in a worldly calling, as the highest means to asceticism, and at the same time the surest and most evident proof of rebirth and genuine faith, must have been the most powerful conceivable lever for the expansion of that attitude toward life which we have called the spirit of capitalism (Weber, 2001, p. 116).

This argument is controversial: although all the popular religions of Asia allowed for capitalistic activity, none of them, according to Weber, developed this 'capitalist spirit' which he associated with

Protestantism. This is because, Weber explained, 'they all accepted this world as eternally given, and so the best of all possible worlds'. In other parts of the world, the development of rational capitalism was hindered by a reliance on superstition and magic. In *Economy and Society*, Weber (1968[1913], p. 630) stated that,

> No path led from the magical religiosity of the non-intellectual strata of Asia to a rational, methodical control of life. Nor did any path lead to that methodical control from the world accommodation of Confucianism, from the world-rejection of Buddhism, from the world-conquest of Islam, or from the messianic expectations and economic pariah law of Judaism.

In contrast, in finding a justification for being among the chosen by means of the rational pursuit of a worldly vocation, Protestantism was, according to Weber (1968, p. 630), the only religion able to rid itself of magic and the supernatural quest for salvation. In making this argument, Weber has been accused by many scholars of taking up the Orientalist position of his contemporaries in underestimating the Eastern economic 'mentalities' (see Said, 2003[1978], p. 259). Furthermore, it has been suggested that Weber uses the term 'rational' very liberally when referring to developments in the West just as he tends to over-use 'magical' when referring to the East (Parkin, 2002, p. 68). He has also been accused of choosing to ignore elements of economic rationalism in non-Western religions (Rodinson, 1974; Singer, 1972; Turner, 1974) and in Catholicism (Giddens, 2001, p. xxii). Furthermore, it has been suggested by some that there is no affinity between Calvinism and the spirit of capitalism (Sombart, 1915, p. 252). There have also been a number of criticisms of Weber's method in his Protestant ethic thesis (see Giddens, 2001), notably regarding his over-reliance on Baxter's sayings as evidence for his claims. What is missing from Weber's analysis, according to Frank Parkin (2002, p. 62) is 'the proto-typical Calvinist capitalist'. These criticisms need to be taken into account in any twenty-first century reading of Weber's work. However, what is significant for the purposes of this chapter is the latter part of Weber's thesis and in particular his observation that the religious roots of rational capitalism, which he carefully traced, had, by the time he was writing, in the early part of the twentieth century, pretty much died away (Weber, 2001, p. 119).

Over time, Weber argued, wealth has a secularizing tendency and with the spirit of asceticism no longer present, what remained after the

religious roots died was 'utilitarian worldliness'. Victorious capitalism, he argued, no longer needed the support of this religious spirit, 'since it rests on mechanical foundations' (Weber, 2001, p. 124). The instrumentally rational pursuit of profit had now become an end in itself. From now on, the attainment of such wealth would still be a sign of blessing, but such blessing would have more to do with prestige in the eyes of others and less to do with a doctrine of predestination. More significantly, values would increasingly be measured in accordance with quantitative criteria. Regarding the element of hubris in this new materialist culture ruled by abstract godheads, Weber (2001, p. 124) cast aside his scholarly caution and wrote, memorably, that regarding 'the last stage of this cultural development, it might well be truly said: "Specialists without spirit, sensualists without heart; this nullity imagines it has attained a level of civilization never before achieved"'. One wonders what he would make of our consumer society in which participation is obligatory if we are not to fall behind and become 'failed consumers', and where consumer patterns 'embrace all life's aspects and activities', penetrating to the very core of our lives (Bauman, 2005a; Bauman, 2005b, p. 88). What would he make of the rapacious demands of capital, with its relentless motion, reaching from continent to continent, in pursuit of new markets, creating advantage out of new products, and innovative ways of producing things at whatever cost to humanity and the environment (Buck, 2007)? What would he make of the excesses of the world of under-regulated financial capitalism with its complex products, its tax-havens, its Ponzi schemes and its crises, a culture in thrall to impersonal godheads such as 'the markets' 'economic growth' and 'GDP'? The consequences that attend the serving of impersonal 'godheads' will be explored below.

Rationalized culture

Let us now look at some examples of cultural phenomena that, according to Weber, have been profoundly altered as a consequence of the rationalization process. Again, contentiously, these examples are considered to be unique to the West. First, let us further consider religion. Weber (1946a[1918], p. 153) argued that '[a]ll theology represents an intellectual *rationalization* of the possession of sacred values'. This rationalization is expressed in the widespread significance of doctrine, whether the Indian doctrine of Kharma, the Catholic doctrine of the sacrament or the Calvinist doctrine of predestination. There is also a strong rational element in religious hierocracies, which were organized

by officials into institutions, paralleling the rise of secular bureaucracy. Within each organized religion, whether the Anglican church or the Confucian cult, the officials that made up the hierocracies stood in contrast to the charismatic possessors of spiritual values, the religious virtuosos (such as shamans, sorcerers, ascetics) against whom they struggled (Weber, 1946b[1915], p. 288). However, as we have seen above, Weber argued that only in the West has there emerged a religious spirit that has been rationalized to the extent that it has eliminated its magical elements and is entirely compatible with rational capitalism.

Music is another cultural phenomenon to which Weber turned his attention (Weber, 1958). Although in other parts of the world, there are forms of music that involve the combination of a number of instruments and vocal parts, Weber (2001, p. xxix) argued that it is only in the West that, since the Renaissance, there has emerged a 'rational harmonious music' supported by a 'system of notation, which has made possible the composition and production of modern musical works, and thus their very survival'. The use of notation enables ever more complex polyvocal music to be created and ensures that we can hear compositions that have been handed down the centuries. With each player in the orchestra trained to perform their specialist part, music has evolved into a professional art, serving aesthetic rather than practical purposes (Weber, 1958[1921], pp. 41–42; Weber, 2001, p. xxix).

Reflecting on historical developments in architecture, Weber argued that the Gothic vault is an architectural form that is particular to a rationalized culture. Although pointed arches have featured as decorative embellishments as part of architectural styles in many civilizations, whether in the Orient or in Antiquity, the Gothic vault, a uniquely Western innovation, provides an example of the rationalization of architecture. The use of the Gothic Vault,

> as a means of distributing pressure and of roofing spaces of all forms, and above all as the constructive principle of great monumental buildings and the foundation of a *style* extending to sculpture and painting, such as that created by our Middle Ages, does not occur elsewhere (Weber, 2001, p. xxx).

Along similar lines, the rationalization of the arts can also be observed when one considers how Renaissance painters pioneered a 'rational utilization of lines and spatial perspective' (p. xxx). The rationalization process also extended to universities where there emerged 'a rational,

systematic, and specialized pursuit of science, with trained and specialized personnel' (p. xxx).

The concept of rationalization illuminates our everyday experiences: if we go into bookstores, peruse the pages of magazines, turn on the television, or surf the internet, we find countless examples of rationalization, whether in self-help books regarding the best ways to improve our bodies (by means of exercise or diet), or in books that encourage us to maximize our chances of financial, sexual, educational or sporting success. The gym is a focal point for the rationalization of the body, and if sports stars of the twenty-first century are to succeed, they will have to avoid the slightest deviation from the carefully calculated rigour of the training schedule. As Loic Wacquant (1995, p. 76) found in his ethnographic study of boxers on the South Side of Chicago, the only way to succeed in that sport is to subject the body to continual and restless labour in the pursuit of pugilistic excellence. This work on the body and the development of bodily capital involves asceticism and sacrifice, and so the worldly pleasures of fatty food, partying and sexual activity are denied to the aspiring boxer. Rationalization does not just affect the professional. The amateur sportsperson participating in a Sunday league football match will adhere to standardized rules and procedures. As Barry Smart (2005, p. 34) observes:

> Rules and standards apply irrespective of the idiosyncrasies of time and place and their universal application makes competition possible between individuals and teams, notwithstanding the existence of continuing national, regional and local cultural differences.

For the amateur and professional musician alike, rationalized techniques are deployed in music studios so as to order give a uniform consistency to the soundscapes created. For instance, the use of auto-tune software corrects vocal inaccuracies when singers stray off pitch; the use of the click track, which serves a similar purpose as the metronome, synchronizes musical performances so that the tempo is strictly maintained and so that different parts of the music can be laid down like different pieces of a jigsaw puzzle. When a drum sound is sampled and used again and again in a piece of music, there will be no variation in its effect whatsoever. The level of homogeneity will be such that it has the effect of a machine playing the music. These are minor examples, and perhaps more significant are the numerous computer programmes that enable the musician to rationally order their compositions, laying one track down on top of another, deleting a part

and replacing it with another, with little or no limit to the range of effects readily available with which to alter the soundscape.

George Ritzer applies Max Weber's rationalization thesis to contemporary society, providing a striking example of the rationalization of culture. He argues that whereas in Weber's time, bureaucracy was the exemplar of rationalization, today's exemplar is the fast-food restaurant. According to Ritzer (2004), we are witnessing the McDonaldization of society, which is 'the process by which the principles of the fast-food restaurant are coming to dominate more and more sectors of American society as well as the rest of the world' (2004, p. 1). Ritzer argues that precedents of McDonaldization include the procedure-driven legal-rational bureaucracies of the kind described by Max Weber; the scientific management techniques created by Frederick W. Taylor (in the late nineteenth and early twentieth century); the car assembly line method of production pioneered by Henry Ford in the early part of the twentieth century; and the mass production approach to suburban house-building deployed by Levitt & Sons in the 1940s and 1950s. Informed by these precedents, the four key principles of the McDonaldization process are efficiency, calculability, predictability and control. The efficiency principle is concerned with finding the optimum means to a given end (Ritzer, 2004, p. 43). If we take the example of McDonald's restaurants, the maximization of efficiency is relentless pursued so as to speed up, as much as is possible, the time it takes to cook and serve the food, for customers to eat their food and then to leave the premises. McDonald's has streamlined the cooking process so that (for example) the ingredients arrive ready to be assembled in simple fashion (the fries are already pre-cut and there is no need to even slice the buns in half); the employees follow predefined cooking procedures from which they are not able to deviate; the menu is simplified so that the customer has only to choose between a limited range of products; the customers are 'put to work' so that they queue for their food (there are no waiters or waitresses) and they dispose of the rubbish when they have finished eating. This striving for efficiency ensures that the money earned by the restaurant is maximized, workers' time is utilized efficiently so that there is no wasted labour or time spent pondering alternative ways of executing a task, and overall, it can be said that there is a speeding up of the movement 'from secretion to excretion' (Ritzer, 2004, p. 46). As Ritzer insists, the efficiency associated with McDonaldization can be observed in nearly all sectors of society even if it does find its model in the fast-food industry. The same principles of efficiency can be seen in the world of media. Ritzer

argues that newspapers such as *USA Today* reduce stories to their bare essentials so that they jump off the page as 'news nuggets', and the journalistic style is unencumbered either by prolixity or the need for detailed analysis. The news-story consumption process, from the purchase of the newspaper to the digestion of the story, is thus streamlined and the reader is not even burdened with the task of turning the pages of the paper to finish a story.

The second principle, calculability, which has been enhanced by the use of computer technologies, ensures that production processes and end results are increasingly judged in numerical terms; this means that the success or otherwise of a cultural product will be measured in quantitative rather than qualitative terms (Ritzer, 2004, p. 66). Therefore it is the case that many fast-food products are celebrated for their size rather than their taste, and therefore their names contain adjectives such as 'big' and 'large' (never 'small') at the expense of adjectives representing aesthetic criteria. This principle is applicable to other societal sectors, and so, for example, the success of films is increasingly measured in relation to box-office receipts or total income generated from the various 'synergies' associated with the product, rather than on the basis of whether the film's director uses the medium to say anything new or interesting. Similarly, in the world of universities, academics are often judged in relation to the *quantity* (rather than quality) of their scholarly publications and therefore time spent formulating a particularly good idea might well be discouraged if it is likely to hinder the extent of their total output. What the emphasis on quantity does enable, however, is that league tables can be created that compare the research output of one university with another. Applied more broadly, in terms of cultural consumption, attention to calculability ensures that there is a large range and volume of products available from which to choose, many of which are relatively easy to acquire so long as we have the means at our disposal.

The third aspect of McDonaldization outlined by Ritzer is predictability, which means that as it is increasingly the case that we know in advance what to expect when we go to a restaurant, a hotel, a theme park, a pub, a university, a hospital, or whichever social or cultural institution we are discussing, as long as it has been McDonaldized. In seeking that which is expected, we are able to eliminate anxieties associated with the unknown and the unpredictable. Hence it is the case that McDonald's prides itself on the predictability of its food and its restaurants. There are no surprises, whether we order a Big Mac in New York or in Paris. The product will look and taste the

same; it will be the same size and shape. Furthermore, the eating experience will be predictable: the layout and look of the McDonald's restaurant will be reassuringly familiar; we will recognize the customer service script (even if it is in a foreign language!); we will find the same impressive hygiene standards. Ritzer turns to the motel business to provide a further illustration of the predictability dimension of McDonaldization, highlighting the ways in which it impacts upon other sectors. He argues that Alfred Hitchcock's famous film *Psycho* (made in 1960) encapsulated the fear of the unknown (albeit in its extreme form) associated with independently owned motels across the United States of America before the large motel chains took hold of the market and made the experience of the industry more predictable. Motels used to be unpredictable and there was considerable variety in the standards of hygiene, the quality of food, the degree of comfort experienced from motel to motel. The Bates Motel in *Psycho* was, in effect, a nightmarish exaggeration of such unpredictability: the owner was a homicidal maniac who utilized a peephole so as to spy on his victims. *Psycho* was, of course, fictional, and for the vast majority of regular travellers in the 1960s, the degree of unpredictability in motels was not life-threatening. Nevertheless, as Ritzer (2004, p. 88) points out, the emerging motel chains sought 'to make their guests' experience predictable. They developed tight hiring practices to keep "unpredictable" people from managing or working in them'. As a consequence, few surprises emerge in our interactions with employees of Holiday Inn, Best Western, Accor or Premier Inn hotels. And when we enter our rooms, we will be reassured by the nullifying predictability of the room layout, the degree of cleanliness, and the non-challenging artwork that adorns the walls. These motels and hotels might not be particularly thrilling places to stay, but they are designed to assuage the uncertainties and fears that come with not knowing exactly what to expect when travelling. The predictability dimension affects not only customers but also employees. The latter are increasingly obliged to follow scripts in their interactions with customers, hence the ubiquitous and insincere 'have a nice day'; work-tasks are made perfunctory, often requiring little skill, creativity or initiative; and employees are disciplined to perform a number of routine tasks which could be carried out by anyone else occupying the same office (Ritzer, 2004, p. 89).

The fourth dimension of McDonaldization is control, which involves the replacement of human with nonhuman technologies. Such technologies include 'not only the obvious, such as robots and computers

... but also ... the assembly line, bureaucratic rules, and manuals pre-scribing accepted procedures and techniques' (Ritzer, 2004, p. 106). In McDonald's restaurants, nonhuman technologies are used in order to gain control over workers *and* over customers. In the case of the workers, their tasks are controlled by machines, and so, for example, the fry machines ring or buzz when the fries are ready, leaving little room for human judgement. In addition to this, tills are computerized so that the McDonald's employee only has to press a button indicating the particular food product without needing to type in the price or make any kind of calculation. The ingredients for a hamburger arrive pre-prepared and the cooking process is characterized by a fixed pro-cedure from which there can be no deviation. The customer too is con-trolled by nonhuman technologies and if they are to receive their food, they have to adhere to the correct procedures and follow the 'script'. First, the menu offers little choice and so choice is constrained. Second, customers receive visual cues so that they know in advance what they are supposed to do (for example, join the queue, dispose of the rubbish) and how they are expected to behave (Ritzer, 2004, p. 116). In McDonaldized restaurants, the chairs are uncomfortable, the lighting is bright and the décor is garish. These factors are not conducive to relax-ation and induce customers to move on as soon as they have finished dining.

It is worth noting that there are benefits to be derived from the use of nonhuman technologies as part of McDonaldized systems. First, these technologies can save us money and time. They make many of our everyday tasks easier, and so, for example, electronic financial transactions can be completed in a matter of moments, with a few clicks of a mouse. Second, they serve to reduce the degree of human error in the labour process, subjecting the most routine tasks to com-puterized control. However, where interactions with nonhuman tech-nologies have largely replaced human-to-human interactions, there is a tendency for these systems to be de-humanizing. For example, when we call our banks or utility providers, or even when we call a theatre box-office, it is often the case that we have to negotiate our way around labyrinthine computerized voice-systems and call centres. With less and less opportunity to speak to a 'real' person, there is a great like-lihood that we will be angered, frustrated and dissatisfied; when we do speak to someone, they will be compelled to adhere to procedure and so we might as well be conversing with a robot.

The four dimensions discussed above each contain an element of 'the irrationality of rationality', which Ritzer (2004, p. 17) terms the

fifth dimension of McDonaldization. Informed by Weber's notion of the 'iron cage', Ritzer argues that McDonaldization has a number of detrimental consequences. First, he argues that processes associated with McDonaldization strip the world of its mystery, its unknown qualities, in pursuit of the predictable. In short, it disenchants the world. In addition to this, McDonaldization is dehumanizing: it reduces human activity to pre-scripted interactions mediated by non-human technologies. To work in a McDonaldized environment is dehumanizing and requires little creativity or use of reason; to consume in a McDonaldized environment means following inflexible rules and procedures so as to obtain a cultural product with few distinctive qualities (Ritzer, 2004, p. 134). In order to be efficient, workers are forced to blindly follow procedures, and only those in charge are freed up to be more creative in their thinking. It is no surprise then, that the turnover of staff in fast-food restaurants is extremely high; the entire workforce in these restaurants is estimated to turn over three times a year in the USA (Ritzer, 2004, p. 148). Processes of rationalization associated with the fast-food industry are also irrational because of the health risks associated with food that is high in calories and low in nutritional value. They are also irrational because they contribute to environmental degradation:

> Whole forests are being devoured by the fast-food industry ... Styrofoam, virtually indestructible, piles up in landfills, creating mountains of waste that simply endure there for years, if not forever ... [it] contributes to global warming, destruction of the ozone layer, depletion of natural resources, and destruction of natural habitats ... Factory farms and aquaculture create additional environmental degradation and health hazards (Ritzer, 2004, p. 146).

Ritzer's McDonaldization thesis has been enormously successful, but like many such books it has been criticized on a number of counts. For example, it has been suggested that *The McDonaldization of Society* is 'Weber-lite' and that Ritzer is himself contributing to the McDonaldization process by producing McTexts (O'Neill, 1999, p. 42). More substantively, it has been argued that Ritzer has underplayed the variability in the ways in which McDonald's and other vehicles of rationalization are adopted in different parts of the world (Giulianotti and Robertson, 2009, p. 44). It has been noted that, in his earlier versions of the book, he underestimated the degree of resistance to McDonaldization (Turner, 2003, p. 138). It has been suggested that

Ritzer's work is as morally empty as the process it describes (Tester, 1999). Others have argued that Ritzer is motivated by nostalgic bourgeois values and that in denigrating popular culture, he is adopting an elitist stance, looking down with pity or condescension at the dupes who eat in McDonald's restaurants and read McDonaldized publications such as *USA Today* (Parker, 1998, p. 8). Ritzer is also accused of downplaying the significance of material interests driving the process of McDonaldization. According to Smart (1999, p. 4), what is lacking in Ritzer's discussion is

> any sustained analysis of the possible articulation between, on the one hand, the spread of formal rationality and, on the other, the relentless pursuit of capital accumulation, exemplified by accelerating technological innovation designed to reduce socially necessary labour time and strategies to increase existing markets and cultivate new global markets for goods and services.

Although some refute his thesis, Turner (2003, p. 139) points out that many of the criticisms have served as 'extensions, corrections, or additions'. In response, Ritzer has, on many occasions re-visited and modified his argument, which continues to provoke and inspire debate, 'forcing us to define our response to crucial aspects of our everyday life' (Kellner, 1999, p. 195). Such debate is important when in our day to day conduct, we are compelled to follow rationalized rules and procedures in most areas of life, whether we are in a work situation or whether we are pursuing leisure activities. And although it is the case that many of our interactions are with family or friends, we spend a significant amount of time dealing with 'officials', with trained experts, whether their expertise is commercial, technical or relating to matters of government. We follow calculable rules and procedures when we take to the roads in our cars; we observe speed limits, drive on the correct side of the road, pay heed to a complex array of road signs. We deal with labyrinthine bureaucracies when we want to set up a telephone line, update our mobile phones or set up a bank account; we deal with trained officials when we want to renew our passports, our insurance policies, or when we want to arrange legal protection for our family. Our private lives are subject to rationalized processes as much as are our abilities to perform in the workplace, and we are told how to be the perfect lovers, husbands, wives, cooks, and so on; anxiety befalls us as we attempt to reach 'the perfect game' (Sica, 2000, p. 46). In fact, with the above examples in

mind, it is hard to imagine a pre-rationalized world. As Sica (2000, p. 45) puts it:

> The way war is waged, business is carried out, learning codified, and personal life experienced, then evaluated – to begin what could easily become an endless list – have endured a transformation so thorough that picturing a pre-rationalized world becomes ever more a feat of imagination granted only to the most gifted historians, novelists, and film makers.

The type of social action which best accords with the procedures associated with an increasingly rationalized world is, according to Weber, instrumentally rational action, which we shall consider in the section below.

Rational social action

Weber argued that modern culture is beset with tensions between different types of rational social action (instrumentally rational and value-rational) and between different types of rationality (formal and substantive). Let us deal with the first of these, the types of rational social action. In order to do so, a brief outline of Weber's conception of sociology is necessary. Weber (1968, p. 4) considered sociology to be a science concerned with 'the interpretive understanding of social action and thereby with a causal explanation of its course and consequences'. In short, as part of a wider project of understanding historical change, Weber sought to understand the motivations behind social action. He set himself the task of understanding the world we inhabit, arguing that, as Lowith (1993, p. 52) puts it, 'historical investigation should render comprehensible how we are today as we have become'. With the individual as the starting point of his analysis, Weber rejected the possibility of discovering objective meaning in or the true essence of society, and instead sought to understand the subjective meanings and intentions that orient social action. According to Weber, social action can be active and overt or passive and inward; it can include intervening or acquiescing in a given situation. For example, both preventing a robbery and standing back to watch it happen are forms of social action. A specific example Weber utilizes is a bicycle crash. A collision of two cyclists is like a natural event. However, an attempt made to avoid the collision would constitute social action, as would any post-crash remonstration, cooperation, fight or quarrel. To understand such

action means to probe the actors' subjective motivations. With the latter in mind, Weber deployed a method of interpretive understanding (*verstehen*) so as to gain insight into the reasons why an individual, in a particular situation, opts for one course of action rather than another.

In order to interpret the subjective meaning behind social action, Weber differentiated between two types of verstehen: *direct observational understanding* and *explanatory understanding*. The first enables us to see at face value what is happening. One example Weber gives is the action of a woodcutter. Another example is an outbreak of anger. Direct observational understanding enables us to see that, in the first example, a man is chopping wood; in the second, the person's facial expressions are tokens of an outbreak of anger. Explanatory understanding provides a means of determining why the woodcutter is cutting wood and why the person is angry. Weber (1968, p. 8) argued that this type of verstehen brings us closer to a rational understanding of motivation, and places 'the act in an intelligible and more inclusive context of meaning'. We might find that the woodcutter 'is working for a wage or is chopping a supply of firewood for his own use or possibly is doing it for recreation. But he might also be working off a fit of rage, an irrational case' (Weber, 1968, pp. 8–9). We might find that motivations such as jealousy or injured pride have triggered the angry outburst. Verstehen thus involves formulating plausible hypotheses regarding the subjective motivations for social action, a means of interpreting 'the subjective understanding of the action of the component individuals' (Weber, 1968, p. 15). This method can be used at a macro and micro level, as a means of explaining historical events, the actions of states, nations, armies or corporations, as well as the actions of individuals.

We can understand the course of action by means of rational understanding, as for example, 'when someone correctly carries out a logical train of reasoning according to our accepted modes of thinking', or, by means of empathetic liaison with the social actor, we can gain insight into less rational courses of action (Weber, 1968, p. 5). There are, of course, problems with his model of which Weber was aware: namely the normative gulf that separates researchers from their research subjects if those subjects are from cultures with value systems and norms of behaviour that differ hugely from their own. This can be and has been the case with Western scholars observing exotic tribal societies or sociologists interpreting the behaviour of mystics whose experiences cannot be readily comprehended. This notwithstanding, Weber (1968, p. 5) argued that 'the ability to perform a similar action is not a

necessary prerequisite to understanding; "one need not have been Caesar in order to understand Caesar"'.

So as to test hypotheses generated through verstehen, Weber argued that it is expedient to compare social action to a conceptually pure type of rational action so as to 'understand the ways in which actual action is influenced by irrational factors of all sorts, such as affects and errors, in that they account for the deviation from the line of conduct which would be expected on the hypothesis that the action were purely rational' (1968, p. 6). He provided two examples with which to clarify this position. First, we can understand the reasons for a panic on the stock exchange if we contrast what would have been a purely rational course of action on the part of the stock brokers with the course of action that was taken. The mistakes made would be indicative of the intrusion of irrational, affectually determined elements in the course of action. Second, we can comprehend the failings of a political or military campaign if we examine the deviations from what would have been the rational course of action bearing in mind the particular circumstances, the knowledge available and the ends sought by the various social actors (Weber, 1968, p. 6). Checking hypotheses against this yardstick is all the more essential because, according to Weber, we cannot rely on individuals for reliable accounts of their behaviour as the 'ideal type of meaningful action where the meaning is fully conscious and explicit is a marginal case' (p. 22). Therefore, he considered that, for most people, most of the time, social action is enacted in a half-conscious state. However, as Parkin (2002, p. 37) points out, defining exactly what is a pure or ideal type of action is problematic because Weber 'offers no illustration of this pure type of action', and so, to return to the example cited above, we have no idea how a stockbroker should ideally proceed in a financial crisis situation. Furthermore, this raises a more fundamental question regarding verstehen: is the meaning that the sociologist attributes to an actor's behaviour the same as the actor's own understanding of her/his behaviour (Freund, 1968, p. 104)? Or to take it further, is Weber convinced that the sociologist has *greater* insight regarding the meanings and motivations of social action than does the actor regarding her/his own actions (Parkin, 2002, p. 27)? It would seem so. But if Weber can perhaps be accused of understating the problems that sociologists might have in accessing the motivations of social actors, he certainly cannot be accused of shying away from the chaotic nature of social reality or paying heed to the complex, often contradictory motivations and values that orientate concrete cases of social action.

Ideal types

Weber's method of verstehen, then, enables us to hypothesize regarding the motivations of individuals' actions on the basis of 'ideal types' of behaviour. In *Economy and Society*, Weber wrote that 'ideal types' are theoretical concepts that are abstracted from reality so as to help us to better understand and find order in the complexity of that reality. Weber argued that by abstracting from reality by means of a one-sided accentuation of the typical elements or the sum total of common traits of a phenomenon or type of social action, we can compare our ideal-typical construction with the concrete empirical case that we are investigating. By comparing empirical cases, for example, of a historical phenomenon such as bureaucracy or capitalism, or a form of social action, to an ideal type, we are able to see the extent to which this phenomenon or social action differs. It is rarely the case that a phenomenon or action will perfectly match the ideal type, which serves as a means of picking out factors specific to the particular empirical case. This does not mean to suggest that the ideal type serves as a normative or ethical ideal of how things should be. Rather, as Weber (2011[1917], p. 43) wrote in *Methodology of the Social Sciences*, the 'ideal type' serves as an instrument for understanding history and social action and its effectiveness lies in the extent to which it enhances empirical investigation. Its function 'is the comparison with empirical reality in order to establish its divergences or similarities, to describe them with the *most unambiguously intelligible concepts*, and to understand and explain them causally'. There are, doubtless, many pitfalls in the application of this methodological innovation, and the divergences between the ideal type and the empirical phenomenon might reveal more about the sociologist's preconceptions than about social reality. That said, the use of ideal types is unavoidable and we all use them. For example, when we refer to 'capitalism' or to 'bureaucracy' or to 'democracy' or to 'free-trade' in making arguments, we are, in effect referring to ideal types. With this in mind, Weber's (1968, p. 20) suggestion is that in the course of research, as much as possible, we refresh and reformulate ideal types so that our formulation of them involves 'the highest possible degree of logical integration by virtue of their complete adequacy on the level of meaning'. If we use them, we can try and deploy them as methodically as possible. Although Weber did not believe that one could uncover laws of history, it is nevertheless possible, he argued, to use ideal types for the purposes of comparative analysis, as part on an interpretative approach that seeks to isolate the various factors leading

to the development of a particular historical phenomenon. The 'ideal type' method also enables us to guard against a number of ills whether derived from conceptual sloppiness or ideologically slanted interpretations of history. It can therefore, as Wilhelm Hennis (2000, p. 111) suggests, provide 'a litmus test for contemporary errors and fabrications'.

The antinomy between instrumentally rational and value-rational action

Let us now turn to one of Weber's ideal type formulations specifically relevant to this chapter: the type of social action defined as *instrumentally rational*. This is a type of social action which, in its purest form, is 'determined by expectations as to the behaviour of objects in the environment and of other human beings; these expectations are used as "conditions" or "means" for the attainment of the actor's own rationally pursued ends' (Weber, 1968, p. 24). The actor rationally considers the chosen end of the action, the means to the end and the possible secondary consequences of pursuing this course of action. If such consequences are a cause for concern, the actor will reconsider the means deployed and/or the ends pursued. In doing so, the actor will consider alternative means to this end and the relative importance of different possible ends. This type of social action in its purest form, is, in Weber's (1968, p. 26) view, only a limiting case, and he considers that most of our everyday actions are in great part automatic reactions to habitual stimuli. However, under the conditions of the rational capitalism in the West that Weber sought to understand, social action that is in large part instrumentally rational has become a dominant tendency. In *General Economic History*, he argued that this tendency is in part driven by the rationalization of the conduct of life and the emergence of a rationalistic economic ethic (Weber, 2003, p. 354).

A quite different ideal type of rationality is expressed in *value-rational* action, which is driven by convictions and belief systems and is 'determined by a conscious belief in the value for its own sake of some ethical, aesthetic, religious, or other form of behaviour, independently of its prospects of success' (Weber, 1968, p. 25). This could be, for example, action motivated by a religious or a political cause; it could be action inspired by devotion to a cause such as socialism, environmentalism or vegetarianism, or to an ideal such as beauty, music or art. Weber's two types of rational social action stand in stark contrast to one another, and as ideal types are irreconcilable. In reality they often commingle, as illustrated in his thesis on Protestantism, though as we

saw in that example, the significance of the value-rational element receded over time as rational capitalism developed.[2]

Let us now examine the irreconcilability of these types of social action, when viewed as ideal types. From the point of view of instrumentally rational social action, the more that action is oriented by an unconditional devotion to an absolute value, the more it will be fixed unswervingly on achieving one particular end and the less it will take into consideration the consequences of such action. The actions of artists, guided by visions of beauty, pursuing those visions at all costs and continuing to paint whether or not there is an audience for such paintings are wholly irrational from an instrumentally rational viewpoint. In contrast, traders would not have such an attachment to the particular artefacts they bring to the marketplace and would readily abandon them if something else were to become a more convenient means of procuring a profit. We can view the antagonism from the other side: from the viewpoint of value-rational action, as an ideal type, instrumental rationality seems completely irrational. It is devoid of any personal colouration or warmth and is thus completely irrational if one considers that the purpose of our action is to serve human ends. Hence it is that resource-rich city traders, readily accustomed to instrumentally rational action, and resource-poor painters, more inclined towards value-rational action, will likely view each other with mutual incomprehension. Such incomprehension will not just be a consequence of the differing material conditions to which they are accustomed, but will be directly related to the contrast in the courses of action each considers to be worthy of following.[3] There is, then, a conflict between these two types of rational action, and Weber believed that instrumentally rational action was in the ascendancy as part of wider process of rationalization in modern society. In *Economy and Society*, he argued that '[o]ne of the most important aspects of the process of "rationalization" of action is the substitution for the unthinking acceptance of ancient custom, of deliberate adaptation to situations in terms of self-interest' (Weber, 1968, p. 30).

The antinomy between formal and substantive rationality

The above-mentioned conflict is mirrored in the antinomy between two dominant types of rationality in modern capitalist society: *formal* and *substantive* rationality. Let us now examine these ideal types, with examples. According to Weber, rationality is formal when it is calculable, measurable and unambiguous, and economic activity is formally

rational 'according to the degree in which the provision for needs ... is capable of being expressed in numerical, calculable terms and is so expressed' (Weber, 1968, p. 85). Accounting and budgeting are expressions of formal rationality in so far as they are rationalized, and money is, according to Weber (1968, p. 86), 'formally the most rational means of orienting economic activity'. The formal rationality expressed in financial accounting involves, for example, considering the market value of a particular commodity as compared to another; valuing the means required to achieve certain ends in a market situation; making projections regarding the anticipated outcome of a particular market activity; comparing costs and expenditures in relation to returns and profits. So, formal rationality is characterized by its unambiguous nature. A world *entirely* governed by formal rationality would be one that is wholly quantifiable, wholly calculable and devoid of specific human qualities. Such a world is the stuff of science fiction (Sica, 2000, p. 43) and would accord with a completely mechanized and abstract mode of existence. In contrast, substantive rationality is characterized by its ambiguity, by the fact that it is value-driven, pursuing ends that differ hugely, whether political, ethical, aesthetic or religious. It is immeasurable. Substantive rationality is expressed in economic action depending on 'the degree to which the provisioning of given groups of persons (no matter how delimited) with goods is shaped by economically orientated social action under some criterion (past, present, or potential) of ultimate values' (Weber, 1968, p. 85). In other words, if formal rationality is guided purely by rational calculation and the pursuit of certain ends via means that are considered to be the most adequate, substantive rationality might be guided by values such as those inherent in political ideologies; it might be governed by aesthetic principles or adhere to religious doctrines or to a belief in a certain mode of behaviour. It might be concerned with hedonism, with a sense of duty or with the furthering of status claims. Substantively rational economic action is thus concerned more with the pursuit of values than with calculation in purely monetary terms. For example, fundraising for a political cause still has as its primary goal the furtherance of the cause; the associated calculation in monetary terms and the pursuit of profit is a secondary consideration.

The conflict between formal and substantive rationality pervades modern culture, and again, the positions are irreconcilable. For example, although the calculation associated with formal rationality might be perfectly suited to the smooth running of a commercial office it would make no sense whatsoever in a context in which substantive

considerations are dominant. The human costs that come as a consequence of the pursuit of profit for its own sake (redundancies, labour issues, environmental degradation and so on) can only be measured in substantive terms, and the course of rational economic action that seems perfectly logical in accordance with formal rationality seems to be wholly irrational if considered in substantive terms. At the level of government policy across the globe, we see that the pursuit of economic growth, something which can be measured in formal terms, will inevitably come into conflict with substantive considerations, whether moral, ethical or environmental. Regarding the implications for the individual, Weber (2001, p. 32) wrote that from the perspective of personal happiness there is something 'so irrational about this sort of life, where a man exists for the sake of his business, instead of the reverse'. However, we can view it from the other way around: from the point of view of formal rationality, it seems to be wholly irrational to pursue an end that cannot be measured unambiguously, and, for example, the idea of creating paintings that have for their only purpose the serving of an aesthetic ideal would seem to be, from this perspective, completely irrational. So, formal and substantive rationality are irreconcilable; they are different 'godheads'. Although it may be the case that we might find empirical examples of social action that contain a commingling of elements of these ideal types of rationality, Weber's concern was that with formal rationality in the ascendancy in modern culture, human life is increasingly dominated by the impersonal. For example, the market economy creates a group that is quite different to the family network, the community of interests or the neighbourhood clan. What binds the group in a market situation is the coming together of the rational, purposeful pursuit of the interests of a series of individuals. The particular exchanges that take place are ephemeral, and the social action is orientated towards the commodities in question rather than towards the partners in the exchange. The impersonality of this social action ensures that 'there are no obligations of brotherliness or reverence, and none of those spontaneous human relations that are sustained by personal unions' (Weber, 1968, p. 636). Formal rationality operates, as we shall see in the next chapter, 'without regards for persons'. As Gronow (1988, p. 328) puts it, 'it is this very formal and abstract nature of modern occidental rationality which explains Weber's serious worry about the petrification of cultural values and the loss of genuine meaning in modern culture'.

2
The Fate of Cultural Values

Introduction

In public and private cultures, distinctive cultural values, whether ethical or aesthetic, are irrelevant when viewed from the perspective of formal rationality. So, what is the fate of such values with formal rationality in the ascendancy? They disappear from sight, they are repressed, they go into exile, they return in an abhorrent form, whether in the distorted forms of religious fundamentalism or in re-enchanted forms of cultural consumption, in types of commodity fetishism which would even surprise Marx. The most sublime values retreat, as Weber (1946a[1918], p. 155) suggested, 'either into the transcendental realm of mystic life or into the brotherliness of direct and personal human relations'. Or, as this chapter argues, such values are served by *professional culture creators* or by other types such as *the intransigent, the ignored* and *the amateur*. These are culture creators whose activities, from the point of view of formal rationality, are not readily comprehensible because they are in the service of different value-systems and so cannot be entirely contained by the impersonal forces which govern our lives. Going to the heart of Weber's ambivalence towards rationalization, this chapter examines the fate of a modern culture dominated by the expedient and yet impersonal rules of formal rationality. However, the chapter also draws attention to a productive strain in Weber's work on the rationalization of culture. In his *Science as a Vocation* lecture, Weber (1946a) argued that if we face up to the demands of modern culture, with its competing value systems, we do not have to be led by the hand of impersonal forces and serve systems that should, in a more rational world, serve us. If we choose to serve particular cultural values, or pursue a 'calling', we can

purposefully gain clarity regarding how best to serve the specific 'demon' or 'godhead' or value-system that we wish to serve. Furthermore, we can gain clarity regarding the consequences that attend the pursuit of the ends we have set in our sights. This pursuit of clarity, which is particularly instructive in our uncertain times, typifies Weber's doggedness, his desire to face up to the demands of the day.

Formal rationality and legal authority

Formal rationality is expressed in the dominant form of authority in modern society, which is legal authority. As we will see below, this type of authority finds its apotheosis in bureaucracies, the ideal type of which operates entirely according to calculable rules and is indispensable to the running of a capitalist economy and a modern state. This type of authority as expressed in law or in bureaucratic rules is formally rational because it operates with a 'cool "matter-of-factness"', with equality before the law (Weber, 1946c[1915], pp. 220–221). Where legal authority is dominant, people obey rationally established norms, rules and laws, and in a working context, adhere to the impersonal duties that go with their office. It is, therefore, a disembodied, intellectualized kind of authority. This contrasts with more substantive forms of authority which, for example, allow for arbitrariness in decision making as a consequence of 'the personally free discretion flowing from the "grace" of the old patrimonial domination' (Weber, 1946c, p. 220). Whereas a patrimonial prince might bestow 'utilitarian and social ethical blessings upon his subjects, in the manner of the master of a large house upon the members of his household', modern, trained jurists apply a generally applicable, abstract rule of law to all citizens belonging to a given state (Weber, 1946c, pp. 298–299).

Before discussing legal authority in detail, let us first consider Weber's ideas regarding domination and the basis of legitimacy. Weber (1968, p. 212) argued that domination is the probability that a given group of persons will obey certain commands, and 'implies a minimum of voluntary compliance'; only in the case of slavery is submission to authority absolutely involuntary. The degree of compliance is based on a certain interest that may be motivated by, for example, rational calculation, emotional or ideal interests. However, for domination to be effective, it requires more than the cultivation of personal interest or affection on the part of its subjects. According to Weber (1968, p. 212), domination normally necessitates an executive staff to enforce the commands and rules of a given authority; it also,

importantly, requires a belief in the legitimacy of those in a position of authority and the commands they issue. Weber (1968) draws attention to three ideal types of authority. The first, *legal authority*, is impersonal in as much as it rests on 'a belief in the legality of enacted rules and the right of those elevated to authority under such rules to issue commands' (Weber, 1968, p. 215). *Traditional authority* is based on a belief in age-old rules and powers which are held to be legitimate because they are long-standing and have been handed down from generation to generation. Whereas an office holder exercising legal authority will have been chosen by appointment, on the basis of having certain necessary qualifications, the holder of a position of traditional authority is more likely to have inherited that position, whether as a consequence of primogeniture or family seniority. *Charismatic authority* is based on a belief in the extraordinary powers of a particular individual, whether those powers are supernatural or superhuman, derived from what are perceived to be magical, prophetic powers, or from the exceptional qualities of a hero on the battlefield. Examples of this kind range from the shaman to the warrior, from the primitive 'berserk' to the revolutionary or the modern dictator; and in our times, we might add to this list religious leaders and gurus, celebrities in popular culture, arts or sports, and media savvy politicians, the archetype of which is the character of Berck in Milan Kundera's (1995) *Slowness*, whose every movement, when the cameras are switched on, is carefully choreographed and considered with view to the augmentation of his public profile. The type of authority that concerns us in this chapter, legal authority, rests on abstract, calculable rules that operate independently of human passions. Traditional authority is also rule-oriented, even if its rules are not rationally calculated but have their basis in that which is established. Charismatic authority is quite different because, according to Weber (1968, p. 244), it is 'foreign to all rules', and its legitimacy is dependent purely on the ability of the charismatic leader to be exceptional, whether as hero, prophet or demagogue. Its basis is thus emotional rather than rational, based on devotion, sometimes fanatical, and often uncritical, towards the qualities that are perceived to reside in the person of the leader.[1]

Weber maintained that legal authority, as an expression of formal rationality, permeates modern culture and is in the ascendancy in line with a general trend towards rationalization. For example, regarding the ubiquity of the legal authority of bureaucratic administration in modern culture, Weber (1968, p. 223) writes that '[t]he whole pattern of everyday life is cut to fit this framework', which is central to the

functioning of the modern state as well as, more generally, to the development of rational capitalism. In its ideal-typical form, legal authority is represented by a system of abstract rules and laws to which all within a given territory or within a particular organization are expected to be obedient, including those in positions of authority (Weber, 1968, p. 217). Within an organization or society governed by legal rational authority, when subordinates obey an order, they are not responding out of a sense of duty to a particular individual but rather to the impersonal order of rules. In its purest form, legal authority is thus stripped of personal content and is governed by abstract principles. However, even if it is, as Weber suggested, the dominant form of authority in modern times, a careful scrutiny of the practices in any given office workplace is likely to reveal that legal authority is rarely be found in an entirely pure form. That said, it would be harder to contest that bureaucracy, as an expression of legal authority and formal rationality, is not ubiquitous in the late modern world we inhabit, even if it is commingled with other elements, depending on context.

Bureaucracy as expression of formal rationality

Let us now look closer into the example of bureaucracy so as to illustrate Weber's concerns regarding a culture permeated by formal rationality. Weber's ambivalence towards rationalization is nowhere as apparent as in his analysis of bureaucracy. On the one hand, Weber lauded the technical superiority of bureaucratic forms of organization *and yet* in describing their significance as part of an emergent rationalized culture, he drew attention to their de-humanizing tendencies. Bureaucracies have a long history and there are examples of bureaucratic organization stretching back to Ancient Egyptian society. However, many of these, whether in Egypt during the period of the New Kingdom or in China, from the time of Shi Hwangti, contained strong patrimonial elements with authority sanctified by tradition rather than by abstract rules, and with subjects dependent on a lord or master, whose power they augmented with their service. Weber (1968, p. 1002) argued that only in modern Western society did there emerge a bureaucratic structure expressive of formal rationality in that it had 'a "rational" character, with rules, means-end calculus, and matter-of-factness predominating'. The transition to this type of organization from earlier models of bureaucracy was fluid (Weber, 1968, p. 967). According to Weber, bureaucracy that is within the sphere of the

state constitutes a bureaucratic *agency* and where it serves capitalist accumulation it constitutes a bureaucratic *enterprise*. In both instances, a money economy provides the most efficient and calculable means of funding this mode of organization, whether through taxation (in the case of the state) or through private profit (in the case of enterprise) (Weber, 1968, p. 956). This bureaucratic structure is 'a late product of historical development' that has revolutionary results, profoundly altering human experience. In earlier, patrimonial forms of bureaucracy, officials received payment in kind, such as, for example, the right to derive economic benefits from the use of a lord's land, and administrative duties were secondary activities. Relationships in patrimonial systems were regulated by favour and privilege. In contrast, the criteria by which the modern official functions are qualitatively different. First, officials are formally free (the office is separate from the worker's household) and they are subject to authority only in relation to their official roles. Second, they become office holders within a clearly defined hierarchy of offices, with the higher offices governing those lower down the scale. Third, each office within this hierarchy has a specific competence. Fourth, their employment is contractual and is thus entered into voluntarily. Fifth, they are appointed (rather than elected) on the basis of their competence (as demonstrated by means of examinations or qualifications). Sixth, they are paid by means of regular salary, set in accordance with the relative importance of their role and function within the hierarchy. Seventh, the office they hold is their primary occupation and '[w]hen the office is fully developed, official activity demands the *full working capacity* of the official, irrespective of the fact that the length of his obligatory working hours may be limited' (Weber, 1968, p. 958). Eighth, the office holder has a 'career' and so may be promoted up the hierarchy if her/his performance is judged by their superiors to succeed in relation to objective criteria. This emphasis on career means that office holding is seen as a 'calling' because it often requires a significant expenditure of time and energy in gaining the technical competence necessary in order to be appointed and because the office holding is the individual's primary occupation. Ninth, the official's role is separate from her/his private existence and s/he 'works entirely separated from ownership of the means of administration and without appropriation of his position' (Weber, 1968, p. 221). Tenth, the official is subject to the rules of the office. The management of the office 'is based upon written documents' and follows general rules which are known by the office holder (Weber, 1968, p. 957).

According to Weber, fully developed bureaucracy 'compares with other organizations exactly as does the machine with the non-mechanical modes of production' (Weber, 1968, p. 973). He argued that the choice 'is only between bureaucracy and dilettantism in the field of administration', and emphasized the benefits of a form of organization based on formal rationality (1968, p. 223). This claim is, of course, contentious, and for many in the twenty-first century, bureaucracy is synonymous with inefficiency. Furthermore, Weber has been accused of overestimating the extent of rationalization and underestimating the capacity of individuals to resist and subvert bureaucratic rationalities (Jenkins, 2000, p. 14). The degree to which Weber was aware of this flip side of rationalization, the kind of creative and playful evasion of surveillance, the resistance of its totalizing logic captured in Michel de Certeau's (1984) account of everyday life, is debatable. Probably he was aware that beyond resistance to rationality there is also incompetence. Although sometimes things go wrong because of circumstances beyond the control of office holders, sometimes they go wrong as a direct result of sloppiness, stupidity, lack of ability or pure intransigence. Regarding the intrusion of more 'irrational' aspects of bureaucracy, Richard Jenkins (2000, p. 14) writes that

> even within the most efficiently rationalized of bureaucracies, "irrational" dimensions of social life – symbolism and myth, notions of fate and luck, sexuality, religious or other ideologies, ethnic sentiment, etc. – necessarily influence organizational behaviour.

The informal and the irrational thus become the flip side of the formal and the rational (see also Douglas, 1987; Herzfeld, 1992). This is emphasized by Sica (2000) in his observation that Western individuals, increasingly forced to practice and exhibit rationality in order to make a living and fulfil the strictly regulated functions that their jobs entail, are increasingly infantile in their spare time. He argues that 'they rush to those few remaining human or animal intimates available to them' and proceed to reward themselves 'with a range of "after-hours" childish amusements which intelligent adults from earlier times would likely consider imbecilic and demeaning' (Sica, 2000, p. 57). These critical points are important especially when one considers empirical examples of bureaucratic organization and the extent to which they differ from the 'ideal type'. However, malfunctions, intransigence, evasions of order and childishness aside, one needs only a dash of what C. Wright Mills (1959) termed the sociological imagination to

appreciate that formal rationality, that matter-of-fact way of viewing the world, permeates our twenty-first century working lives and is ubiquitous in our globalizing world even if our employment conditions are 'flexible' and even if the 'office' we hold is part of a sprawling network that spans borders so as to facilitate the pursuit of capital or the interests of a state agency. After all, 'bottom-line' considerations determine not only how we operate in office but also whether we have office to hold in the first place.

Weber maintained that bureaucracy, in contrast to the forms of organization that it superseded, is efficient and precise, offering calculable results; it is prized for its unambiguousness, operating in accordance with objective considerations (as expressed in general rules) as opposed to the subjective considerations associated with personal grace and favour. For the individual, the clear hierarchical structure of bureaucracy facilitates the possibility of a career and the possibility of a gradual ascent to the top, something that is not so possible in forms of organization that are stifled by precedent and tradition or where upward movement depends on the whims of a charismatic boss. The technical superiority of bureaucracy is an essential requirement of a modern society that has become increasingly complex, and which requires, so as to ensure its smooth functioning, a qualitative expansion of its administration. The reach of administration has penetrated into the minutiae of life and, in recent decades, Michel Foucault has drawn attention to the benefits this expansion of knowledge yielded for the exercise of power. As a consequence of its qualitative expansion, bureaucracies are increasingly peopled by specialists, those who have received expert training and attain virtuosity in a singular area of expertise, an expertise that is much coveted by the holders of power. This means that, on the one hand, we can document the rise of the expert, the proliferation of expert knowledge and the emergence of the official secret, which Weber (1968, p. 992) describes as 'the specific invention of bureaucracy' (this has considerable significance in the extent to which bureaucracy is a means of domination through knowledge) (p. 225). On the other hand, in less glamorous garb, we picture the bureaucrat as an official limited to one role, performing a task repetitively, unaware of the bigger picture. With this in mind, Weber (1968, p. 988) wrote that '[i]n the great majority of cases he [the bureaucrat] is only one small cog in a ceaselessly moving mechanism which prescribes to him an essentially fixed route of march'. In 1926, six years after Weber's death, Franz Kafka's *The Castle* was published, and it echoed the bleaker side of Weber's vision of bureaucracy.

Regarding the officials that populated Kafka's novel, the character Olga observed that they 'are very well educated, but only in a one-sided way; in his own department, an official will see a whole train of ideas behind a single word, but you can spend hours on end explaining matters from another department to him, and while he may nod politely he doesn't understand a bit of it' (Kafka, 2009[1926], p. 189).

The rise of the specialist; the decline of the 'cultivated man'

Weber argued that the rise of the specialist goes hand-in-hand with the decline of the 'cultivated man' and has as its consequence 'a renunciation of the Faustian universality of man' (Weber, 2001, p. 123). With the rise of specialization, that which is gained in terms of efficiency is at the expense of a loss in personal culture. He found that universities were increasingly pressurized to produce a system of specialized examinations so as to generate employees suited to take up posts in the modern bureaucracies of the time, whether state-based or commercial. Such examinations were not entirely new, and had featured in the Islamic Orient, in China, and in the Occidental Middle Ages, facilitating the needs of pre- or semi-bureaucratic epochs. However, Weber (1968, p. 999) argued that '[o]nly the development of full bureaucratization brings the system of rational examinations for expertise irresistibly to the fore'. In modern society, therefore, it is the case that 'patent of education' serves the same purpose as did 'proof of ancestry' in patrimonial, feudal societies. Just as proof of prestigious ancestry enabled status, so educational certificates 'support their holders' claims for connubium with the notables ... claims for a "status-appropriate" salary', and although the move towards specialization meant the creation of a new status group, it was not one rooted in birthright (Weber, 1968, p. 1000). To be 'cultivated' meant to receive a broad, all-round education, without attaining expertise in a singular area. Admission to the ruling strata in administration by notables required this cultural quality, and '[s]uch education may have been aimed at an ascetic type, at a literary type (as in China) or at a gymnastic-humanist type (as in Hellas), or at a conventional "gentleman" type of the Anglo-Saxon variety' (Weber, 1968, p. 1001). It aimed to develop a well-rounded, well-informed amateur, working for the public good. However, this 'type', according to Weber is in decline now that the education systems that serve modern capitalism are geared towards the production of specialists.

Weber also drew attention to the virtues of specialization, and indeed termed himself a specialist. Furthermore, in *Science as a Vocation*, he argued that:

> Only by strict specialization can the scientific worker become fully conscious, for once and perhaps never again in his lifetime, that he has achieved something that will endure. A really definitive and good accomplishment is today always a specialized accomplishment. And whoever lacks the capacity to put on the blinders, so to speak, and to come up to the idea that the fate of his soul depends on whether or not he makes the correct conjecture at this passage of this manuscript may as well stay away from science (Weber, 1946a, p. 135).

It is only by following a 'calling' with enthusiasm, passion and devotion that the scientist will make any contribution to the field. Here again we see Weber's ambivalence: the role of the specialist can be played by the de-humanized official who operates much as does a cog in the machine but it can also be played by the scientist pursuing 'the idea' by means of enthusiasm and hard work. Finding such ideas is only possible if one is 'in the zone', following a 'calling' with zeal, with devotion. This is because the best ideas emerge in a manner akin to artistic inspiration; they 'occur to one's mind in the way in which Ihering describes it: when smoking a cigar on the sofa; or as Helmholtz states of himself with scientific exactitude: when taking a walk on a slowly ascending street' (Weber, 1946a, p. 136). But whereas the ideas that come to artists by means of devotion to the calling might never be superseded because art does not 'progress' even if new techniques are discovered, scientists have to work with the knowledge that their ideas will soon be outdated, and will at best provide new questions that keep the research process rolling onwards.

Without regard for persons

With their emphasis on specialists rather than 'gentlemen', bureaucratic modes of organization have a levelling tendency inasmuch as they recruit office holders on the basis of their technical competence and their performance in examinations; they treat the individuals that enter their systems equally, regardless of status or personal qualities. They are thus, in their ideal typical form at least, more democratic than forms of authority that appoint on a hereditary basis or when

appointments are made on the basis of personal favour or family connections, or forms of organization that treat people differently on account of their status or class or ethnicity. However, these democratizing tendencies come at a cost. Weber (1968, p. 975) noted that the carrying out of administrative procedures in accordance with objective considerations means 'a discharge of business according to calculable rules and "without regard for persons"'. Here we have a mode of social organization that, on the surface, is at least expedient for the purposes of a smoothly functioning society, but which has the absurd side-effect of disregarding all that is human. This brings us right back to the tension between formal and substantive rationality. Bureaucracy, as an expression of legal authority, is technically efficient because it operates in accordance with formally rational, calculable rules. It operates by means of abstract, means-to-end principles and the type of social action that it facilitates is instrumentally rational. This may be all well and good for those at the helm of banks or government ministries, for those seeking to ensure that business is carried out in accordance with calculable rules, but these very same calculable rules can seem rather cold and callous when one is dealing with human life or with values, whether cultural, ethical or aesthetic. We know what it is like to feel as though we are being treated as a 'case' to be dealt with, or as a number rather than as a human being. It is not pleasant to ring up a call centre and to be held interminably in a queue or passed from one automated voice to another. The prickly feelings we experience are not simply those concerned with frustration at being trapped in an automated process; something more unsettling is occurring. We get a sense that we are in a zone stripped of all human qualities, one that pays no heed to what we perceive to be the uniqueness of our existence. The same can be said when we walk into the job centre, when we enter a bank or a government department, or when we enter into a complaints procedure on a company's website. With the dehumanizing tendencies of the bureaucratic organization in mind, Weber (1968, p. 975) tempered his enthusiasm for its technical superiority. Bureaucratic organizations operate more speedily, more efficiently, the more they follow the principle of *sine ira ac studio* (without anger or bias). Therefore, bureaucracy 'develops the more perfectly ... the more completely it succeeds in eliminating from official business love, hatred, and all purely personal, irrational, and emotional elements which escape calculation' (Weber, 1968, p. 975). This 'dehumanization', in accordance with unambiguous, formally rational concepts, fits the needs of a capitalist economy perfectly. However, formal rationality is not equipped to deal with

values that are not quantitatively measurable and cannot measure measure the worth of an idea, unless one is to consider the amount of money that such an idea can generate; it cannot adequately deal with questions of aesthetic or moral value, for these matters are completely at odds with its impersonal, technical processes. In fact, it is very difficult to re-insert value-based criteria of judgement into a system that takes on such a totalizing logic. This notwithstanding, modern society, and in particular modern capitalism, with its complex division of labour, relies on this totalizing logic, on the continuing operation of bureaucratic forms of organization without which it could not function. Bureaucracies are indispensable, even indestructible. Weber was insistent that even in a socialist society, which would be at least in part guided by substantive, egalitarian values, the formal rationality expressed in bureaucratic organizations would, if anything, become even more prevalent (p. 225). The extent to which its totalizing logic is resisted is the subject of much debate. What is clear is that Weber sought to ascertain the extent to which human values or human dignity could be salvaged. In a speech given to the Association for Social Policy, Weber (1909) said that the passion for bureaucracy drove him to despair and that it was horrible to think 'that the world could one day be filled with nothing but those little cogs, little men clinging to little jobs and striving towards bigger ones', and with the irrational consequences of an excess of formal rationality in mind, the crucial question that preoccupied Weber was exploring how 'to keep a portion of mankind free from this parcelling-out of the soul' (1909).

Rationalization and disenchantment

The calculative, technical knowledge associated with rationalization has other consequences, namely what Weber (1946a, p. 155) termed the disenchantment of the world. This is where '[p]recisely the ultimate and most sublime values have retreated from public life either into the transcendental realm of mystic life or into the brotherliness of direct and personal human relations'. The concept of disenchantment, borrowed from the German poet Schiller, refers simultaneously to Weber's pessimism regarding the petrification of values in modern culture and to a worldview freed from illusions and ready to confront the 'demands of the day'. According to Weber, disenchantment is a historical process that has been progressively occurring over millennia and is most apparent in the modern Western world. It involves emptying the world of its magical content. Whereas the 'savage' of pre-

modern times relied on magical means to cajole the spirits and derive benefit from mysterious, incalculable forces, the intellectualized outlook that characterizes a disenchanted world seeks to know and master reality by means of scientific knowledge and increasingly precise and abstract concepts (Weber, 1946b, p. 293). As the world is disenchanted it is secularized, with 'man' at the centre of things in 'a godless and prophetless time' (Weber, 1946a, p. 153). The reason that the most sublime values are driven into the realm of the irrational or into private existence is that our lives are increasingly governed by intellectualized, abstract processes, principles and techniques. According to Jenkins (2000, p. 15), the significance of Weber's notion of disenchantment is twofold. First, it refers to the eradication of a comforting world view, to 'the shattering of the moral, cognitive, and interpretive unity' of the pre-modern enchanted world. Second, it refers to the fact that the world is increasingly losing its mystery as it becomes known in formally rational terms – that is, it becomes calculable, quantifiable. The extent to which the twenty-first century world we inhabit is disenchanted is debatable. It is hard to dispute that the process of 'knowing' the world and the universe beyond has accelerated as expressed in everything from stem cell research to space exploration. However, the disenchantment argument is not without its critics. For example, it has been argued that it is a hubris-laden misapprehension stemming from a 'modern' outlook to presume that there ever was an 'enchanted' primitive world (see Jenkins, 2000). Furthermore, according to Jenkins (2000, p. 17), 'the "objective" knowledges of Western science are becoming increasingly understood as (at best) contingent rather than permanent verities'. 'Progress' and 'advancement' in science are often measured in terms of the extent to which human interests are served (Peggs, 2009, p. 96). With every scientific discovery, the world seems, arguably, more mysterious than ever, and the mutation of various viruses, for example, has undermined the sense that humans are progressively gaining control over the world through science and medicine. Weber understood the sense of powerlessness experienced by the individual in the face of a body of scientific knowledge that is expanding exponentially. However, perhaps he underestimated the extent to which disenchantment has been accompanied by a parallel process of re-enchantment. For example, prominent modern (re)enchantments include alternative medicine, alternative lifestyles, alternative explanatory frameworks (astrology, luck), neo-paganism, spirituality, religious fundamentalism, psychoanalysis; in addition to these, there are the (re)enchantments

associated with the production of fantasy or seduction such as advertising, branding, popular culture, fashion, celebrity culture, gambling, sports, tourism and science fiction (Jenkins, 2000, p. 18). Then there are 'postmodern' re-enchantments that offer up magical simulations of reality, whether in shopping malls, hotel complexes, theme parks, fast-food restaurants or tourist destinations (Ritzer, 2005). Michel Maffesoli (1996) argues that re-enchantment pervades our social lives and is articulated in our affiliation, often temporary, with a number of 'tribes' formed on the basis of symbolic and aesthetic attachments, values, lifestyles, tastes or interests. Consumerism – arguably the most prominent enchantment – has become 'the most persuasive and pervasive globally extensive form of cultural life, one to which more and more people around the world continue to aspire' (Smart, 2010, p. 4). On the political front, with a 24/7 media-driven news culture, politics is more about enchantment than ever, with political parties ever-reliant on the charismatic authority and popular appeal of leaders. There has also been a re-enchantment observable in the (re)turn to religious fundamentalism, as witnessed in strains of Islam that have gained prominence in the Middle East or in forms of Christianity in the United States of America. Furthermore, Mike Davis (2004), in his reflections regarding the proliferation of slums around the world, finds that many of those living in such conditions have turned to Islam and Pentecostal Christianity (as opposed to left wing politics) so as to find solace in the face of traumatic urbanization. With all this in mind, it is worth paying heed to Jenkins's (2000, p. 22) observation that (re)enchantment is as integral to modernity as is disenchantment and other prominent processes such as globalization (see Chapters 6 and 7).

An increasing technical mastery of things, as a cumulative process, enables us to better know and understand the world and, as much as possible, to eliminate all that is incalculable. However, this mastery does not necessarily represent progress. Returning to examples cited above, although the rationalization associated with Renaissance perspective in the visual arts introduced new techniques, this did not result in the creation of paintings that were necessarily better than those produced in previous centuries. Similarly, although the use of the Gothic vault was a brilliant technical innovation, it was not aesthetically superior to the Romanesque style. A similar tale can be told regarding the quality of human existence. Life is not necessarily more pleasant because we have the opportunity to know more. With this in mind, Weber suggested that the rationalization process brings in its train a host of personal dissatisfactions. We are confronted with a

sense of personal limitation as we face up to an onslaught of know-
ledge and culture that we cannot possibly absorb. Weber (1946a,
p. 139) provides a clear example with which to highlight the fact that
'increasing intellectualization and rationalization do *not* ... indicate an
increased and general knowledge of the conditions under which one
lives', and as we will see in the discussion that follows, the rationaliza-
tion process entails radical changes in the external conditions of life,
but the individual's life lags far behind.

The example Weber provided is this: the majority of passengers trav-
elling on a streetcar will be unlikely to know exactly how the streetcar
is set in motion. This knowledge is not mysterious, magical or out of
reach. It is readily demonstrable by, for example, a physicist. However,
to know how a streetcar works is not a requirement for those making a
journey. The passengers have only to pay their fare and they will have
the right to travel; they will, quite reasonably, anticipate that the
streetcar will be set in motion and they orientate their conduct accord-
ing to expectation. The same reasoning can be applied to our everyday
lives: we know little of the 'tools' we utilize, and when we pick up the
phone, when we turn on the television, when we switch on the com-
puter, we might not know precisely how each of these things works.
Despite an increasingly technical orientation towards reality and the
increasing sophistication of the means at our disposal for pursuing our
chosen ends, it might be said, with some justification, that 'the savage
knows incomparably more about his tools' than does the individual in
modern society (Weber, 1946a, p. 139). What the rationalization
process does enable, however, is the *possibility* to know all of the above
things, the possibility to calculate how things work, to find out pre-
cisely how the streetcar is set in motion, to find out how the phone or
the television or the computer works. The knowledge is now there at
our disposal and it would only be a matter of taking the time to
research and to absorb this information. The technical means are
increasingly available with which to understand the minutiae of our
existence. The problem is that when confronted by the vast array of
knowledge that underpins the conditions of our complicated lives, we
realize that there is simply too much information to take on board.
The disenchanted world is increasingly knowable, but the weight of
knowledge is crushing. When, in the course of a given working day,
with limited time at our disposal, we have to choose between pursuing
the urgent tasks at hand associated with making a living or spending
time researching the inner-workings of each piece of technology we
use and deploy, we might be forgiven for taking the former option.

Whichever option we take, we soon realize that even where we do keep pace with developments, there is always something more to know and 'there is always a further step ahead of one who stands in the march of progress' (Weber, 1946a, p. 140). Here again, Weber's conception of rationalization is tinged with pessimism. It becomes a curse of the modern condition to be forever sacrificing the present in order to strive after a Utopian future, one of improved external conditions, one that is forever out of reach. And so, whereas 'Abraham, or some peasant of the past, died "old and satiated with life" because he stood in the organic cycle of life; because his life ... had given to him what life had to offer', 'civilized man' can only catch a fragment of what is on offer; 'what he seizes is always something provisional and not definitive, and therefore death for him is a meaningless occurrence' (Weber, 1946a, p. 140).

Facing the demands of the day

Weber's response to the existential problem of the meaninglessness raised by disenchantment is to 'face the demands of the day'; to refuse to fall back on illusions or to return to religion. Even though he understands the position of somebody for whom a 'religious return' is necessary, Weber (1946a, p. 155) suggested that to go into the 'arms of the old churches' involves an intellectual sacrifice that he is not willing to make. The world is disenchanted, and any attempt to attribute to human existence some kind of mystical or moral unity in the light of what we now know is to fall back on self-deception. Facing disenchantment steadfastly also means realizing that there is no such thing as 'progress', not including, that is, progress of a technical kind, which rationalization yields in great quantities. It means also recognizing that there is a polytheism of competing values, many of which are irreconcilable and none of which have inter-subjective validity. According to Weber (1946a, p. 148), the Ancient Greeks faced this antagonism of values, but in their enchanted world, they sought to gain the favour of various gods – the representatives of these competing values – by means of sacrifice. So, they sacrificed to Aphrodite if in need of help in matters of love, to Poseidon if they were setting out on a difficult adventure across the sea, to Ares if they needed assistance in war. The Ancient Greeks thus found a way of comprehending and dealing with the multi-headed nature of human existence. Weber contended that in a disenchanted world with no such recourse to gods or to demons, the individual has to realize that there is no easy way out and has to face up to the fact that there are competing values to choose between,

values that are contradictory, such as those that emerge from science or from religion, such as those concerned with peace, with beauty, with truth, with honour, with justice. Just as with the Greek gods, if individuals are to serve one of these 'godheads', they might well undermine the interests of another. For example, to 'turn the other cheek' might accord with one kind of religious ethic but it will run contrary to another: that of resisting evil. The various competing attitudes to life cannot be reconciled and they are forever at war with each other. And so it is that in *Science as a Vocation*, Weber (1946a, p. 154) argued that 'the tension between the value-spheres of "science" and the sphere of "the holy" is unbridgeable'. Each value sphere stands in isolation and speaks 'truth' only in relation to its own logic, by means of inner consistency. What does this modern 'polytheism' entail? To take the example of science, it means that is futile to search in this value sphere for the meaning of life or for the proof of God's existence just as it is impossible to find the justification for scientific principles in theology. There is no external authority by which science can be justified and science cannot lend authority to sacred values. Weber (1946a, p. 143) echoed Tolstoy, arguing that '[s]cience is meaningless because it gives no answer to our question, the only question important for us: "What shall we do and how shall we live?"'.[2] Science can provide us with technical and practical innovations that benefit (or hinder) human existence, but it can tell us nothing regarding the choice we face between competing values; there is no way of comparing one value sphere with another, deciding scientifically which is the best. Science cannot provide us with normative guidance regarding conduct, nor can it provide us with value-oriented principles with which to guide our actions. As Weber (2011[1917], p. 52) wrote in *Methodology of the Social Sciences*, 'it can never be the task of an empirical science to provide binding norms and ideals from which directives for immediate practical activity can be derived'. With nothing to link one value sphere to another, modern culture is stripped of inner consistency. This is articulated boldly in Charles Baudelaire's collection of poetry – the *Fleurs du Mal*, which is expressive of Nietzsche's view 'that something can be beautiful, not only in spite of the aspect in which it is not good, but rather in that very aspect' (Weber, 1946a, p. 148). Along similar lines, contradictory consequences can stem from pursuing 'good' or 'ethical' courses of action, consequences which are quite at odds with the original intentions of the action. There are countless examples throughout history of where people have wreaked havoc and destroyed human lives on the basis of what they would consider to be noble intentions.

Culture and administration

A clear example of the clash of value spheres in relation to the field of cultural production was provided several decades ago by Theodor Adorno (1991[1960]). He drew attention to the struggles that exist between culture creators and state or publically funded 'administrators'. According to Adorno, when taken under the wing of administration, culture creators are more readily able to find an audience and make a living than if they are left to struggle in 'free-market' conditions. However, in 'signing up' with administration, their creativity is likely to be stifled by the demands of management; culture creators are forced to answer to those who may know very little about their particular 'culture'. Administrators specialize in the kinds of technical matters that enable an organization to flourish, and yet they end up supervising modes of cultural creation that they are not qualified to understand. The clash between the formal rationality of the administrators and the substantive rationality of the culture creators is writ large. Administration adheres to a logic that is inimical to creativity. Furthermore, as Adorno (1991, p. 113) points out, administrators must 'for the most part refuse to become involved in questions of immanent quality which regard the truth of the thing itself or its objective bases in general'. Adorno thus shares Weber's (1968, p. 975) concerns that bureaucratic organizations operate more efficiently the more they follow the principle of *sine ira ac studio*, the more they are 'dehumanized'. They might be the only 'management' available for culture creators, but operating within a completely alien value sphere, they are certainly not the ideal stewards of matters artistic. More recently, Zygmunt Bauman (2005b) argued that there is a new 'management' overseeing and enabling cultural creation in our contemporary culture, a culture which he terms 'liquid' modern. According to Bauman (2011), 'culture', as in the modern culture described by Adorno, was of use to 'management' because it worked as a homeostatic device serving to maintain societal equilibrium. In liquid modern times, Bauman argues, culture serves the interests of the consumer market thus necessitating the creation of cultural forms that are bought, sold and disposed of with great speed (2010, p. 73). In contrast to state-led cultural enterprises of earlier periods of modernity, liquid culture 'has no "people" to "cultivate". It has instead *clients* to seduce'. In this liquid culture, transience is valued over duration and creativity is subordinated to the logic of the consumer market. Therefore, conflict between the interests of the culture creator and 'management', each

representing different value spheres, is inevitable unless the former chooses to conform to the criteria set by the latter.

The intransigent, the ignored and the amateur

The twenty-first century culture creators postulated by Bauman are confronted with a similarly melancholy choice to the one contemplated by their predecessors: whereas in the earlier period of modernity, culture was 'managed' and sustained by state-led administrators, in today's society, the administrators are those at helm of the consumer market. There is not much to choose between the patrons of old and new, and both seek to utilize culture for their own purposes. Furthermore, both sets of management have in common a desire to make culture measurable. For management in the relatively recent past, the success of culture creators was measured in terms of their contribution to the maintenance of social order. For 'liquid' modern management, culture is evaluated in terms of the extent to which it enhances the profit margins of consumer markets. The principle criteria by which consumer products are measured is formally rational: success is measured in terms of sales figures in an economic system which is geared towards relentless capital accumulation. What can be the response of *professional culture creators* to this? They might, so as to attend to the material conditions of their existence, comply with the demands of management and thus serve a value-system that is entirely different from their own. They are at least able to embark upon cultural projects and as they do so, they might nevertheless find a way of serving their 'godhead' as well as the interests of management. There are many who manage to thrive under these conditions, and patronage – whether derived from monarchs or media conglomerates – has long fuelled creativity. This is because cultural innovation can and does occasionally emerge out of the combustible mixture of the logic of profit and artistic will. Even if, as Bauman (2011, p. 109) observes, a consumer market that seeks to satisfy long-term needs 'is a contradiction in terms', it does nevertheless leave behind cultural objects which do not find their way to landfill sites as swiftly as their designers and promoters anticipated. So it is, for example, that we hear enthusiasts, aficionados and fans speak of 'classics' in fields of popular culture that have only been in existence for a few decades. So it is that the Beatles' music is taken by many to represent the apotheosis of the cultural spirit of an era even though it was initially formulated as disposable pop music, and fans of rap music eagerly revisit 'old school' hip-hop.

Prestige is attributed to many production line created cultural objects, whether cars, vans, phones, computers or items of clothing that acquire 'cult' or 'classic' status among collectors for many decades after their introduction to consumer markets. Of course, those who operate in the most autonomous region of the cultural field, the part that is most independent of commercial interest, will be best positioned to serve their own specific calling, but even those benefitting from commercial patronage will be able to pursue a value-rational course of action and will be able to serve, to a greater or a lesser extent and depending on their degree of autonomy, their chosen aesthetic ideals. The cultural object that they produce will at least in part represent cultural values that cannot be comprehended from the point of view of formal rationality. The extent to which it opposes, in a political or ideological sense, the impersonal rules of capitalism and legal authority is another matter entirely. What is significant is that simply by creating this type of work, *professional culture creators* provide an outlet for value systems that cannot be entirely contained by formal rationality. There are, of course, many professional culture creators seeking to make their work readily quantifiable and to 'brand' it, just as there are many willing to make sacrifices so as to serve their ideals. In order to ascertain more precisely the various types of cultural creativity that are in play in the autonomous and less autonomous regions of the cultural field, research seeking to gain an interpretive understanding of the motivating force behind differing types of such social action is necessary.

Beyond the conflict across value systems that exists between the professional culture creator and management, it is important to point out that other culture creators might choose to ignore the demands and enticements of management; or, equally the culture creator might be entirely overlooked by management. Those who ignore the demands of management are *the intransigent;* the latter are *the ignored. The intransigent* include, for example, those who carefully craft sculptures, which become carefully guarded secrets, but destroy such efforts before they have been viewed by others. It might include those who write books of poetry with view to the very modest circulation of their oeuvre; those who compose and perform music in order to be heard only by a close circle of associates; those who create paintings to realize a personally defined vision. This is not to romanticize such people or to assume that their work is aesthetically loftier or morally superior to the work that emerges in the consumer market out of the struggle between management and culture creator. It is not even to say that they are 'under-

ground' or avant-garde. It is, however, to draw attention to the fact that there are innumerable people creating cultural objects who are simply not interested in marketing their wares on a large scale or having their work stamped with the logic of formal rationality. Poets, for instance, enter a world in which it is very difficult to be taken under the wings of management or to serve a different value sphere. Holcombe (2007) draws attention to the fact that the supply of poets exceeds the demand of the public, and most poetry publications are read by the friends and family of the poet and sometimes by other would-be poets and educationalists. Poetry magazines in Britain do well if their circulation figures exceed 1,000 and many publications cease to exist within a year of their launch. Even if hundreds of thousands of poems are sent annually to these magazines and to Britain's small poetry presses, poetry is not an art-form that is on the radar of those seeking to find new areas of growth in the consumer market. It might be the case that many of the poets swelling the ranks of *the intransigent* already have occupations that enable them to attend to the material conditions of their existence, and so the act of cultural creation is simply a form of sublimation, a source of amusement, an edifying or challenging outlet, or even a calling. It is something that evades, whether intentionally or unintentionally, the demands of the consumer market. A second type, not dissimilar to the intransigent is *the amateur*. According to Antoine Hennion (2007, p. 97), amateurs feel 'a natural affinity towards the objects of their passion' (see Chapter 4). The concept of the amateur, for Hennion, does not have the pejorative connotations that the English usage of the word usually carries and which implies the non-professional, the autodidact or the hobbyist. Instead, Hennion uses the term to refer to those who pursue their cultural activity systematically and develop their sensibilities in relation to their cultural pursuit. The amateur might therefore include the double-bassist who operates as an IT consultant during office hours but is utterly devoted to his calling as a jazz player; it might include the wine lover, the cartoonist or the painter for whom the finest moments of life are those which are set aside to serve their art. This grouping has neither the time nor the inclination to serve 'management', especially as the day job the amateur holds might already be performed in accordance with the demands of the capitalist economy. The amateur's acts of cultural creation take place out of hours, out of the reach of the impersonal forms that tyrannize existence, and their cultural creations, forged with care and devotion, are unlikely to be of interest to those oiling the wheels of commodity capitalism.

There are also many culture creators who aren't invited to be 'managed', whether because their work is excessively complex, insufficiently marketable or whether it is simply not up to the standards required. These are *the ignored*. This grouping might include scriptwriters whose creation is far too complicated and edgy for even HBO to take on board, perhaps because the dialogue lends itself more to the Fringe Theatre or the Parisian Left Bank than to the scenarios of *The Sopranos* and *The Wire*. It might include those who are out of kilter with prevailing fashions such as sculptors whose work is figurative in an era of conceptual art, or novelists who write like Gogol in the era of the Booker Prize, or it might simply be those who fail to be in the right place at the right time, or to know the right people. Many of those choosing to self-publish their books can also be counted among *the ignored* even if a small percentage of them go on to sell large quantities of their books. In 2012, it was reported that between 2006 and 2011, there was a 287 per cent increase in the number of self-published books (235,625) in the United States of America (Flood, 2012). The self-published author Polly Courtney was quoted as saying that the great volume of self-published books 'has the potential to devalue the quality, to remove all the filters that were in place' (cited in Flood, 2012). However, when considering *the ignored*, the matter of quality is less important than the fact that there will be a lot of authors whose books are not read by many people at all; significantly, these books will rarely fall into the hands of 'management'. Also among the ranks of the ignored are the 'freak-show' types who can barely sing or dance or play an instrument but who nevertheless throw their bodies in the direction of reality television auditions, only to be, in the main, rebuffed. As Richard Giulianotti and Roland Robertson (2009, p. 28) write regarding what they term the millennial phase of globalization (see Chapters 6 and 7), just as individuals are subject to ever-intensified rationalizing processes such as surveillance, there has been a strong assertion of the intensely personal. They write that 'there has been a curious revelling in this culture of surveillance' that amounts to a tendency to enjoy being watched, whether via social networking sites on the Internet or on 'reality television' shows where the participants 'reveal all'. Individuals within the grouping that makes up *the ignored* might be desperate to strike a pact however Faustian with 'management', but not even Mephistopheles is interested in their souls. They are ignored because of their ineptitude or simply because they are among the many thousands trying to capture the attention of the reality television producer. But even if they remain undiscovered, the

ignored can nevertheless be found roaming the streets, populating cultural venues, playing at open mike nights and posting music on online sites. Without having been captured in any way, their cultural visions are at large, unhindered by the requirements of administration or the profit motive even if the culture creators in question do all that they can to conform to what is currently in vogue in consumer culture. Such visions might be abominable to behold, or distasteful or wholly unappealing, or they might represent wonders that the world somehow misses out on seeing. The inherent quality of each such vision matters little. Failure, for *the ignored* in a consumer society, is linked to sales figures, exposure, and access to the right places or lack thereof. The world is teeming with innumerable visions motivated by value-systems which are as disparate as they are incommensurable. It is not the purpose of this chapter to romanticize or to judge the above-mentioned types of culture creators but to draw attention to what they have in common, which is that the cultural values they serve can never be entirely contained.

Conclusion: Facing up to modern culture

So, we confront the multi-headed reality that Weber perceived, with disparate value spheres. There is no unifying, magical force to bind them or provide links between them. Therefore, the most one can do, according to Weber, is to confront this reality by being accountable to oneself for one's actions, by pursuing one's 'calling', even if there is no external authority that can validate one's particular choice of 'godhead'; by finding self-clarification and conducting a life that has subjective consistency; by pursuing a responsible course of action, aware as much as possible of its consequences (Weber, 1946a[1918], p. 120). These are bold conclusions and have much resonance in our time, where so many previously sustaining value systems have been demolished. Weber's appraisal of rationalization and modern culture is sobering: in his work there is a denial of 'progress' and he refuses to assign to history any kind of transcendental meaning. He is unwilling to turn prophet or demagogue, and will not be drawn to prognosticate on the likelihood of a future utopia. As Gronow (1988, p. 320) puts it:

> Weber's alternatives are neither the new "Ubermensch" nor the dilettante who only makes himself look ridiculous, but rather the man of modern culture who soberly and without illusions is willing to face the challenge of our times following his own personal values

or demons, fully aware that these values are without any transcendental grounds or intersubjective validity.

Weber's awareness of the incompatibility of values spheres informs his broader conception of sociology which holds that we cannot discover the objective essence of society. We can only study fragments of reality and, more positively, as Lowith (1993, p. 78) puts it, we can ask, as did Weber, 'how man as such, with his inevitably "fragmented" human existence, could nevertheless preserve the freedom for the self-responsibility of the individual'. Science cannot provide us with direction regarding our most deeply rooted beliefs and values; it cannot provide us with ultimate beliefs or value-judgments or the right ends we pursue, nor can it provide a means of adjudicating between the 'truth' of our values systems as compared with those held by others. Science can, however, enable individuals to take responsibility for their course of action by making it apparent that all action, inaction or acquiescence in given situations, has consequences that are expressive of certain values and imply the exclusion of others. Furthermore, the individual can, by means of self-clarification, consider the appropriateness (or inappropriateness) of different means and by so doing can determine the most logical course of action towards achieving a particular end. Weber (2011, p. 53) argued that '[i]n this way we can indirectly criticise the setting of the end itself as practically meaningful (on the basis of the existing historical situation) or as meaningless with reference to existing conditions'. It may thus transpire that the ends are not practical to pursue, or that the consequences of the application of the means will be too costly in relation to the desired outcome. It may be that by applying certain means, the values that we set out to pursue, or indeed other values that we cherish – are lost. In sum, Weber argued that the element of freedom in the process of rationalization is the opportunity to be responsible for our actions and freer in considering and understanding their course and their consequences. He thus proposes a means of facing up to a disenchanted world and having at least some sense of self-purpose in a world which constrains us to follow rules and abstractions. Modern culture is, for Weber, one that is dominated by formal rationality, by calculation and quantitative reckoning. However, he argued that with rational responsibility, the individual does not have to be a mere 'cog in the machine' or a colourless player in the game of heartless human calculation in the financial markets. With life bereft of transcendental meaning, we can still choose our passions, our values, as expressed in our 'calling', even if these passions

and values have no intersubjective validity. We can decide on the best course of action, the best means available to us to achieve these ends, and we can provide a way of weighing the benefits derived from the attainment of the goal against the costs associated with its pursuit. Considering such costs, we can assess the feasibility and desirability of pursuing these ends as opposed to others and can thus attain a degree of inner consistency by ensuring that our actions (and the consequences of our actions) are aligned, as much as is possible, with the standards of the value sphere we have chosen.

The pursuers of cultural values which are viewed as alien from the point of view of capital, of formal rationality, of the logic of profit, can only justify their pursuit in terms of its inner-consistency and their success can only be defined in relation to the parameters of the field in which they operate. However, the extent to which (for example) specific cultural objects produced by autonomous or *intransigent* culture creators are morally or aesthetically superior (or inferior) to those created by commercially funded *professional culture creators* is not possible to ascertain following Weber's argument. Nevertheless, in Chapter 5 of this book, the argument is made, with reference to sociology and aesthetic value, that even if value-judgements do not have universal inter-subjective validity, we can nevertheless research the ways in which value-judgments are formulated inter-subjectively, affected by the dynamics of the evaluative moment and forged through dialogue, debate, discord or playful conversation, in the context of communities. In the next chapter, in contrast, let us now turn to matters of taste and consider the extent to which we are able, if at all, to freely and consciously pursue particular cultural values or express preferences for particular cultural objects.

3
Why Do We Like What We Like?

Introduction

Why do we like what we like? Why do we dislike what we dislike? From a commonsense perspective, taste is a purely subjective, private matter. This perspective is challenged by French sociologist Pierre Bourdieu (1930–2002), one of the most influential thinkers of recent times, whose work on the sociology of taste informs this chapter and the next. In his most famous work, *Distinction: A Social Critique of the Judgement of Taste*, which is based on the analysis of a survey of 1,217 respondents, Bourdieu (1984[1979]) argues that our expressions of taste are in great part determined by our social origin, accounted for by our class background. He disputes the widespread belief in the ideology of 'natural taste' which holds that some people, namely those who are 'cultured', are in a better position to engage with art and other 'high-brow' cultural activities simply because they 'get it' (in contrast to others who don't 'get it') as a result of an innate ability (or lack of) to connect with the cultural object in question. Bourdieu's view would mean that the disinterested contemplation of art espoused by Kant (2005[1790]) is only open to those who have acquired the requisite cultural competences in the course of their lives. Furthermore, Bourdieu argues that expressions of taste are expressions of social power or powerlessness and that social inequalities are reinforced and perpetuated on the basis of cultural distinction. The following chapters draw attention to Bourdieu's profound contribution to an understanding of taste and in particular *why* it is that we have certain tastes and the *ways* in which we express our tastes. However, in doing so, the argument is made that a more detailed, close-up analysis of the act of tasting is required with which to augment Bourdieu's work so that the quotidian

practice of cultural evaluation can be better understood; first, so that we don't lose sight of the cultural object itself, and that we are more attentive to *what* is consumed; second, so that we can gain insight into precisely *how* people taste and the social forms that the tasting takes.

Bourdieu considers taste in its broadest sense, removing the 'magical barrier' that separates aesthetic taste from the taste associated with ordinary consumption. In doing so, he is able to draw attention to the underlying social conditions that underpin seemingly disparate lifestyle choices whether regarding literature, music and other 'arts' or everyday consumption choices in food, interior decoration and clothing. Taste, according to Bourdieu (1984, p. 241), 'is what brings together things and people that go together'. He argues that those sharing similar conditions of existence, with similar resources and competences at their disposal, are likely to have similar tastes or at least will classify and consume cultural objects in similar ways. Those brought together by taste are 'objective classes'; they do not necessarily share a class consciousness, but they are, nevertheless,

> set of agents who are placed in homogeneous conditions of existence imposing homogeneous conditionings and producing homogeneous systems of dispositions capable of generating similar practices; and who possess a set of common properties, objectified properties, sometimes legally guaranteed (as possession of goods and power) or properties embodied as class habitus (and, in particular, systems of classificatory schemes) (Bourdieu, 1984, p. 101).

So, these groupings, and the various factions within these groupings, are made up of individuals who are moving along similar trajectories, whether upwards or downwards in social space, and who share similar social origins and have similar resources at their disposal. Similar origins and similar resources make likely similar taste patterns and similar cultural practices. So, taste brings people together. However, it also expresses the lines of demarcation that separate one social group from another. Tastes, according to Bourdieu (1984, p. 56), are 'the practical affirmation of an inevitable difference'. Taste separates as much as it unifies, and cultural distinction derives from those displaying a preference for the rare as opposed to the common, the prestigious instead of the vulgar, the new rather than the dated. But such difference is derived not only from polar opposites. Expressions of taste also mark out the boundaries that separate a social grouping from those fractionally below them in social space. So it is that established

members of the dominant class, for example, are able to distinguish themselves from rival factions such as the newly wealthy. The threat posed by the latter is at least temporarily lessened when they are put in their place for being *arrivistes*, for being *nouveau riche*, for not possessing the *cultural* competences that are required if one it to gain access to high society.

Habitus

Let us now examine the systems of dispositions which, according to Bourdieu, generate expressions of taste. These dispositions are acquired in the past but are expressed in the present. Bourdieu (1993a, p. 46) sets himself the task of discovering history 'where it is best hidden', in our bodies: in our every move and gesture, in the judgements we make, in the categories of thought and perception that we apply, in the ways in which we speak (p. 46). This embodied history is encapsulated in the concept of *habitus* (Bourdieu, 1984, 1990a[1980], 1993a). *Habitus*, in Latin, means a habitual or typical condition, and the concept has a long history in philosophy and, more recently, in sociology. For example, it features in the writings of Aristotle (the Scholastics translated his 'hexis' into habitus); it crops up in the writings of thinkers as diverse as Hegel and Husserl (Bourdieu, 1990b[1987], p. 12). It can be found in Durkheim's discussion of Christian education, in Marcel Mauss's discussion of the techniques of the body, and in Norbert Elias's (2000[1939], pp. 366–367) work on the civilizing process. 'Habitus' appears in Max Weber's writings on religion (1968, p. 536) and it is apparent in his delineation of the type of traditional social action (see Chapter 1) characterized by ingrained habitation, the kind of automatic reaction that accounts for the majority of our day-to-day actions (Weber, 1968, p. 25). However, *habitus* is not central to the work of any of the above-mentioned scholars and Bourdieu develops its usage, arguing that '[a]ction ... has at its principle a system of dispositions, what I call the *habitus*, which is the product of all biographical experience' (1993a, p. 46). *Habitus* has been described by Richard Jenkins (2002, p. 74) as the bridge that Bourdieu erects between the supra-individual structures of objectivism and the unconstrained subjectivism of individual decision making. The deployment of the concept is Bourdieu's (1990a, p. 55) attempt to transcend the antinomies 'of determinism and freedom, conditioning and creativity, consciousness and the unconscious ... the individual and society'. It explains why it is that we are *likely* to behave in a certain way and yet the concept

allows for a degree of agency. It enables us to see that our ways of think-ing and acting are rooted in past experience but that our responses to the present are not entirely determined by this past. Rather than prioritizing structure or agency, the objective or the subjective, Bourdieu makes the argument that social reality, the external world, exists both inside and outside of individuals. The supra-individual, external social reality is internalized by the individual and as a consequence, the objective and subjective worlds are inextricably linked.

In *The Logic of Practice*, Bourdieu (1990a, p. 53) defines habitus as

> systems of durable, transposable dispositions, structured structures predisposed to function as structuring structures, that is, as prin-ciples which generate and organize practices and representations that can be objectively adapted to their outcomes without pre-supposing a conscious aiming at ends or an express mastery of the operations necessary in order to attain them.

So, the material and cultural conditions of existence are incorporated in the body and mind in the form of durable or even permanent dispo-sitions. They are *structured structures* because they are indelibly marked by social origin, through socialization in the family unit and other early social experiences which are passed on from generation to gener-ation. The system of dispositions associated with habitus are learned implicitly, for example, in the day-to-day routines of childhood in the family home, and explicitly, for example, through schooling. According to Bourdieu (1990a), an individual's early experiences in life are particularly important in the structuring of these systems of dispo-sitions. They develop out of early socialization and play a dispropor-tionate role in defining the ways in which we respond to and anticipate new situations (Bourdieu, 1990a, p. 54). Dispositions change and adjust over time, in response to new experiences, but such change tends to be very slow and gradual, especially given that habitus tends to select practices and actions which are consistent with its disposi-tions. So it is that those accustomed to material deprivation will have developed an orientation towards the world which accords with their social conditions of existence. Some might for example, on the basis of past experience, consider that high culture or *haute cuisine*, is 'not for the likes of us' just as others might consider certain cultural forms to be beneath them.

The dispositions associated with habitus function as *structuring struc-tures* because they inform how we act in and perceive the world on the

basis of past experience. As a product of history, habitus produces individual and collective practices informed by history (Bourdieu, 1990a, p. 54). Because people tend to adjust their practices in accordance with their past experience, a certain level of social reproduction occurs whereby they adjust to what is realistically available and do not seek to go beyond those bounds. As a consequence, the most improbable practices are excluded (Bourdieu, 1990a, p. 54). This explains why social groupings with few cultural and economic resources at their disposal, with no history of participation in higher education, might consider that going to university is 'not for the likes of us', and this attitude can persist over a long period of time, passed from generation to generation. In contrast, those with high levels of economic and cultural capital at their disposal from a young age might consider that it is *inevitable* that they will go to university, even if it turns out that they are not particularly academic. According to Bourdieu (1990a, p. 54), this 'active presence of past experiences' creates a distribution of practices across generations that has more consistency than those which are generated in response to formal rules.

As a *structuring structure*, habitus is not merely reproductive (as is habitual action), it is generative. It reproduces the objective logic of its own conditioning but in doing so, in responding to new situations and circumstances, it transforms these conditionings. It is a practical adaptation to the external world on the basis of previous experience. Our practices can thus be seen as regulated improvisations, as spontaneous responses to the present generated by dispositions that are rooted in the past. The concept of habitus explains that an infinite number of practices are possible which are nevertheless limited in their diversity (Bourdieu, 1990a, p. 55). A useful analogy can be found in the improvisations characteristic of jazz music: accomplished jazz musicians are free to improvise but are constrained by the extent of their ability and technique, the structure of the specific piece of music and, more broadly, the parameters of the genre.

Perhaps the most controversial aspect of Bourdieu's concept of habitus is that it does not represent a *conscious* adjustment and adaptation to the external world. It is in great part *unconscious*, operating 'below the level of consciousness and language, beyond the reach of introspective scrutiny or control by the will' (Bourdieu, 1984, p. 466). Furthermore, it is *practical*, hence Bourdieu's preoccupation with a theory of *practice*. Bourdieu (1993a, p. 76) argues habitus 'functions as a system of generative schemes, generative strategies which can be objectively consistent with the objective interests of their authors without

having been expressly designed to that end' (Bourdieu, 1993a, p. 76). Actors' social conditions of existence are incorporated pre-reflectively into dispositions which in turn shape their orientation towards social reality. Therefore, for example, those who have experienced material deprivation will automatically adapt their practices in the present in the light of their experiences of the past. The dispositions associated with habitus are therefore characterized by a *practical* rather than conscious orientation towards reality and 'predispose actors to select forms of conduct that are most likely to succeed in light of their resources and past experience' (Swartz, 1997, p. 106). Actors' practices and ways of perceiving the world are unconsciously adjusted in accordance with the dispositions they have acquired through social origin and the resources they have at their disposal. Actors thus pre-reflectively adjust their sense of reality so that it accords with what is feasible; to what, in all likelihood, is available to them in life (Bourdieu, 1990a, p. 60). This means that, according to Bourdieu (1990a, p. 61), habitus tends avoid crises

> by providing itself with a milieu to which it is as pre-adapted as possible, that is, a relatively constant universe of situations tending to reinforce its dispositions by offering the market most favourable to its products.

In avoiding such crises by means of pre-adaptation to social reality, a tendency is expressed towards social reproduction and actors staying in the milieus to which they have become accustomed. This means that people 'cut their coats according to their cloth' and 'become accomplices' in making real what was only a probability (Bourdieu, 1990a, p. 65). Actors from poor backgrounds with few resources at their disposal therefore come to see certain positions and goods as being out of their reach and so they adjust their practices towards what is more readily realizable.

Habitus and taste

Let us now consider the significance of habitus in relation to taste. According to Bourdieu (1989, p. 19), habitus is

> both a system of schemes of production of practices and a system of perception and appreciation of practices. And, in both of these dimensions, its operation expresses the social position in which it was elaborated.

Habitus is defined by the relationship between these two capacities: producing and appreciating classifiable practices, products and works (Bourdieu, 1984, p. 170). It is the generative principle of all our practices and our appreciation of such practices; it unites seemingly disparate lifestyle choices. It explains why someone who has experienced a privileged life is more likely to develop a preference for the rare and the refined just as it explains why those accustomed to 'making do' will express a taste for the functional. The opposition which arises between various lifestyle choices, between the rare and the common, the refined and the vulgar, reflects the very different social conditions of existence experienced by those with the most and least resources, economic or cultural, at their disposal (Bourdieu, 1984, p. 176). Bourdieu (1984, p. 177) emphasizes this in the contrast he draws between two types of taste: *the taste of luxury* and *the taste of necessity*. The taste of luxury is expressed by those who have enjoyed a distance from necessity in the material conditions of their existence. It is associated with the opportunities and freedoms that come with possession of high volumes of capital. In contrast, the taste of necessity is expressed by those whose material conditions of existence have been such that they are accustomed to adjusting their lifestyle so that it accords with the functional and the economical. Let us consider the example of food. Whereas *the taste of luxury* enables those in the higher regions of social space to adopt an aesthetic disposition towards dining, appreciating the formal, artistic qualities of the meal, *the taste of necessity* has engendered a preference for foods that are filling, functional and economical. From a commonsense perspective, it is easy to view these food preferences in terms of 'class racism' and to believe that, for example, the preferences for fatty meals is expressive of a *natural* lack of taste, a deficiency in the character of the poor that leads them towards all that is thick and heavy in their food choices (Bourdieu, 1984, p. 178). However, Bourdieu's sociology of taste enables us to see that this preference is rooted in material conditions of existence which are characterized by scarcity. In opposition to this taste for the heavy, those with higher levels of economic and cultural capital tend towards food that is light and refined; those long familiar with 'legitimate' culture are more likely to indulge in food that is delicate, fresh and well-presented, such as *nouvelle cuisine* (Bourdieu, 1984, p. 184). The bourgeois meal is expressive of its distance from necessity; it is characterized by attention to form, with the dishes served in strict sequence. According to Bourdieu (1984, p. 196), '[f]orm is first of all a matter of rhythm, which implies expectations, pauses, restraints; waiting until

the last person served has started to eat, taking modest helpings, not appearing over-eager'. Whereas in the working-class meal, the functionality of the food – its strength-giving properties – is brought into sharp relief, the act of eating, like so many other bourgeois practices, is something that those familiar with *haute cuisine* 'do as if they were not doing it' (Bourdieu, 1984, p. 200). Regarding middle-class food preferences, Bourdieu (1984) finds that those with higher cultural than economic resources and competences at their disposal tend towards relatively inexpensive, experimental and exotic food or dishes derived from peasant cuisine (Bourdieu, 1984, p. 185). Perhaps the concept of habitus is most useful when tracing taste patterns that persist when social groupings move up the hierarchy but nevertheless retain the memory of scarcity in their consumption habits. For example, when special occasions arise or during times of prosperity, those of working-class origin tend towards *la grande bouffe* – the blow-out meal, which consists of an abundance of dishes and a sense of 'plenty'. In its exaggerated form, this meal becomes the *gross bouffe*, an exaggerated version of the blow-out meal. This taste for the *gross bouffe*, expressed by those who have recently acquired high levels of economic capital, nevertheless bears the traces of less prosperous times with its preference for highly calorific food (Bourdieu, 1984, p. 185). So, Bourdieu's habitus concept can help us to explain how the material conditions of existence, both past and present, have a significant effect on our consumption choices.

Field

Bourdieu's concept of *field* refers to the social arena in which *habitus* operates. Examples of fields include the educational system, the State, the Church, the field of cultural production, the field of contemporary fashion, the field of science, the intellectual field, the field of politics (Bourdieu, 1993a, p. 88). There are specific stakes and interests, specific properties that are peculiar to each field. What is valued in one might not be valued in another. Similarly the specific forms of capital (see below) that enable success in one field might not be suited to the laws of another: each field determines which forms of capital are valued or otherwise. According to Bourdieu (1993a, p. 88)

> agents and institutions are engaged in struggle, with unequal strengths, and in accordance with the rules constituting that field of play, to appropriate the specific profits at stake in that game. Those

who dominate the field have the means to make it function to their advantage; but they have to reckon with the resistance of the dom-inated agents (Bourdieu, 1993a, p. 88).

Bourdieu (1993a, p. 72) uses the metaphor of the game – often extend-ing this metaphor so that it borrows from the language of casino gam-bling or poker – in order to explain the competition in each field. In any given field, as in a game, an actor needs to have a strong know-ledge of its logic in order to succeed, and needs to be familiar with its stakes. An actor's habitus attuned to the logic of a field is one that is practically endowed with knowledge of the game rules of that field, and a prerequisite of success in a social field is possession of the requi-site resources (forms of capital). Each field requires a number of people willing to *play the game*, and as in the world of gambling, fields are characterized by struggle: there are a number of actors competing to win, and some are better positioned than others to achieve the top prizes. Those in the most dominant positions will be best able to main-tain their pre-eminence in the face of newcomers to the field who will seek to find ways to get through the barriers that impede their progress. Take the example of the field of law. A newcomer entering the field – someone who has recently finished a law degree and is taking on their first job – will have some familiarity with and know-ledge of the field in order to have gained the position in the law firm. However, the newcomer's habitus will be far less attuned to the logic of the field than those already holding dominant positions such as Senior Associate lawyers and Partners. Accordingly, the chances of the newcomer getting hold of the spoils of the field will be limited. In order to further their strategic interests, they may, for a time at least, have to take up a subordinate position in relation to other lawyers. A prerequisite of success in the field of law or indeed in any other social field is to submit to what Bourdieu (1993a) terms the *illusio* of the game: actors need to believe in its all-consuming import-ance and to adjust their practices to the specific logic of the field if they are to succeed. For example, with reference to culture, Bourdieu writes that:

> Culture is a stake which, like all social stakes, simultaneously pre-supposes and demands that one take part in the game and be taken in by it; and interest in culture, without which there is no race, no competition, is produced by the very same race and competition which it produces (Bourdieu, 1984, p. 251).

To believe in the value of the game is a prerequisite of participation. To question its value is out of the question for those engaged in the struggle; to do so might entail revealing the arbitrary foundations of the game.

Forms of capital

According to Bourdieu, the structure of a field is the state of power relations at a particular moment in time. More specifically, it is the 'state of the distribution of the specific capital which has been accumulated in the course of previous struggles and which orients future struggles' (Bourdieu, 1993a, p. 73). To return to the 'game' metaphor, the structure of a given field at a particular moment in time can be likened to a snapshot of the state of a game in mid-play. Sociological research into the state of play in any given field can provide a snapshot of the power-relationship between the various players in the field, which will depend on who has possession of the essential goods, the forms of capital that are relevant to each field. Some *agents* – as Bourdieu calls them – find themselves in a dominant position, others are subordinate. At any given moment, there will be agents ascending and agents descending. Dominant agents in a given field are well placed to define the stakes of the struggle and to determine what is legitimate. Let us now consider the specific powers and resources that determine the degree of success in a given field. These powers are referred to by Bourdieu (1986[1983]) as *forms of capital*. The forms that are active in each field to a greater or lesser extent – and which individuals need to possess if they are to succeed – include *economic capital, social capital, cultural capital* and *symbolic capital*. The extent to which agents are endowed with these forms will determine the extent of their power. Of course, in any field, some are better positioned than others and have a greater chance of dominance. The distribution of the different types of capital at any given moment 'represents the immanent structure of the social world' (Bourdieu, 1986, p. 46). Furthermore, as we will see in the latter part of the chapter, the composition and volume of capital possessed by agents correlates with the tastes and lifestyles that they are likely to adopt.

Bourdieu (1984, p. 114) argues that social space has three fundamental dimensions: 'volume of capital, composition of capital, and change in these two properties over time (manifested by past and potential trajectory in social space)'. The forms of capital are like cards in a card game and the extent to which agents possess high value cards

determines their position in society; it determines the likelihood of success of the various strategies they deploy. Social class position, in these terms, can be understood in terms of a continuum ranging from those with the most economic and/or cultural capital to those who possess the least. There are a number of permutations of this distribution. For example, those belonging to the dominant fraction of the dominant class have particularly high levels of economic capital; in contrast, the dominated fraction of the dominant class is stronger in terms of cultural capital. At the other end of the scale, those who objectively belong to the dominated social classes will be those with very low levels of economic and cultural capital.

Let us look more closely at the types of capital that are active in various social fields. *Economic capital* is immediately transferable into money. It is, quite simply, the money, property or financial assets that we have at our disposal. According to Bourdieu (1986), economic capital is at the root of all other types of capital, and can be converted into other capitals, even if this conversion takes time. A plentiful supply of economic capital will equate with a degree of power, for capital and power amount to the same thing. However, it is not *directly* operative in cultural games such as those that have as their reward literary prizes (Bourdieu, 1993a, p. 33). Nevertheless, even the ability to win a literary prize involves the indirect use of economic capital. First, possession of money frees up the time required to develop the ability to write something worthy of an award. Economic capital might therefore have bought the time required to study, to read and to practice writing. Second, economic capital can be used indirectly to gain admittance to prominent circles and can enable the attendance at the kinds of social literary events and gatherings that lead to writers becoming *known* in prominent circles and thus potentially eligible for prestigious awards. However, there are limits to this use of economic capital. In the cultural field, for example, membership of the more autonomous, ascetically inclined literary societies cannot necessarily be purchased.

A further significant form of capital is *social capital*. This, in an everyday sense, can be considered to be the connections and networks, formal and informal, that we have at our disposal. It enables us to look at the family as a network which perpetuates and enables social relationships from which individuals accrue benefits over time, whether that means getting a job offer from a relative or utilizing the prestige of a family name. At a more formal level, it can involve access to networks from which benefits can be derived. Social capital is a form of capital that is convertible into economic capital and one that can in

turn be purchased by means of economic capital. The volume of social capital we possess is based on the aggregate networks – both informal and formal – that we have at our disposal, networks that we can mobilize in order to gain prestige in the form of symbolic capital or money (Bourdieu, 1986). Bourdieu (1986, p. 52) argues that this network of relationships 'is the product of investment strategies, individual or collective, consciously or unconsciously aimed at establishing or reproducing social relationships that are directly useable in the short or long term'. At an informal level, the group might be a family or a tribe; at a more formal level, the group might be an organization, a business network, a club or a society. Social capital can be used to make connections in the labour market, and social networking sites on the Internet trade in social capital. This form of capital is also utilized in the formation of personal relationships. For example, in some religious groupings, individuals are steered towards arranged marriages within wider family networks. In secular family groupings, even if marriages are not arranged, dominant family members can be instrumental in contriving to produce occasions on which their young people can meet. An 'appropriate match' can be helped along the way through social functions which bring together individuals 'as homogeneous as possible in all the pertinent respects in terms of the existence of the group' (Bourdieu, 1986, p. 52). The occasions organized in order to achieve this might include parties, hunts, rallies; the bringing together of potential couples might be further enabled by the fact that the young people attend the same select schools or clubs or live in similarly salubrious neighbourhoods. Of course, it is not just marriages, but also friendships and work contacts that are brought about by means of access to social capital. These networks also serve to guard against external threats such as misalliances and relationships that transgress the limits of what is acceptable. However, the situation of each group modifies with the entrance of each newcomer, and so its boundaries and rules are subject to redefinition.

Cultural capital is, broadly speaking, the cultural assets at an agent's disposal. Such assets include educational qualifications and various cultural competences derived from education or social origin such as an ability to appreciate *haute cuisine* or to engage with prestigious cultural forms such as opera and avant-garde art (Bourdieu, 1986). To have high levels of cultural capital is to be familiar with that which is considered to be *legitimate*, that which has been given the stamp of approval by dominant societal institutions such as universities or cultural organizations. A related form of capital, *academic capital*, serves a

similar purpose, but more specifically refers to the propensity towards accumulating experience and knowledge of legitimate culture acquired through the combination of social origin and educational inculcation, whether such culture is 'academic' or expressed in the detached, scholarly appreciation of music, for example, which is, according to Bourdieu (1984, p. 19), 'the pure art par excellence' because '[i]t says nothing and has *nothing to say'*. Cultural capital is most readily available to those who are distanced from economic necessity. This freedom enables a prolonged period of time during which to develop and to apply an aesthetic disposition (see below).

Bourdieu (1986; Bourdieu and Passeron, 1990) argues that the concept of cultural capital is useful in understanding the ways in which cultural and educational competences are transmitted across generations. In his research into the sociology of education, Bourdieu challenges two positions on educational success. First, the commonsense belief in 'natural ability' which holds that the most able will succeed as a result of their innate ability and those who fail do so because of their lack of ability. Second, the alternative belief that educational success is primarily dependent on economic investment (Bourdieu, 1984, 1986; Bourdieu and Passeron, 1990). The concept of cultural capital enables a debunking of both these beliefs. It explains that the competences that are valued in the education system and in wider society are passed down by the dominant classes from generation to generation as though they are heirlooms. The education system is not meritocratic because the children entering the system come equipped with very different levels of cultural capital. Those with high levels of this form of capital will have acquired it from the first moments of their existence by means of inculcation and assimilation. They will have imbibed the *legitimate* way of doing things in their home environment. Economic investment alone is not enough to prepare children to succeed in an education system where cultural capital is a key currency. Therefore, those who enter schooling equipped with high levels of cultural capital start off with an advantage and their whole demeanour accords with the ethos of the education system, which is mainly staffed by people with similarly high levels of cultural capital. Those without the requisite competences not only start at a disadvantage, but their cultural capital has a negative value and therefore they have to spend time unlearning their domestic education (Bourdieu, 1986, p. 48; Bourdieu and Passeron, 1990).

Bourdieu (1986) argues that cultural capital can exist in three forms: in its *embodied, institutional* and *objectified* state. When cultural capital

is in its *embodied* state it is expressed in ways of thinking and speaking (accent, degree of eloquence), eating (manners, degree of familiarity with the formal aspect of dining), and in bodily deportment (self-confidence, casualness, poise, boldness). It is, therefore, manifest in habitus. The accumulation of this form of cultural capital in its embodied state 'derives from slow familiarization' and is learnt over a long period of time (Bourdieu, 1984, p. 66); like the acquisition of a toned body or a sun-tan, it 'cannot be done at second hand' (Bourdieu, 1986, p. 48). This embodied form of cultural capital is transmitted to the child in the home environment. Children exposed to prestigious cultural practices from an early age acquire cultural capital, often unconsciously, when, for example, they hear the sound of piano music or become familiar with the visual art that adorns the walls of the family home. Children taken to the theatre or to museums learn the ascetic pleasures of legitimate culture from an early age; children taken to ballet learn the art of movement; those taken to drama classes learn the art of public speaking. These embodied cultural competences are socially useful and confer scarcity value when the children are assessed alongside others whose early education has not been so intensive. The possession of high levels of cultural capital in its embodied state can secure symbolic and material profits. For example, it might enable one candidate to get a job over a similarly qualified candidate because embodied cultural capital enhances bodily deportment and produces the type of confidence that 'is marked by its earliest conditions of acquisition' (Bourdieu, 1986, p. 49). According to this logic of distinction, high levels of embodied cultural capital enable one person to *appear* to be innately more capable than another. This is because embodied cultural capital seems to be *natural* and not something that has been learnt and acquired over time. This form of capital can thus become *symbolic capital* – which is characterized by recognition and prestige – and is misrecognized as an innate attribute. So, for example, an agent 'groomed' in the ways of legitimate culture appears to be *naturally* adept at understanding musical compositions and *innately* gifted in understanding the motifs in a dramatic work (Bourdieu, 1986, p. 49). The field of education, like any other field, is characterized by a struggle over scarce resources. Those best positioned to acquire these resources and dominate the field will be those equipped with the highest levels of capital. This in turn leads to the reproduction of inequalities in the field, and despite attempts by various governments to 'level the playing field' in the education system, cultural capital is, according to Bourdieu (1986, p. 49), 'the best hidden form of

hereditary transmission of capital'. More visible forms of transmission – such as the passing down of property to an heir – are more readily regulated against by means of inheritance taxes or other forms of redistribution. It is not surprising, therefore, that those in the higher echelons of society invest heavily in consolidating their position in social space and ensuring social reproduction by investing in their children's education.

High levels of cultural capital in its embodied state are costly to acquire, both in terms of time and money, and cannot be passed on or exchanged as readily as can economic capital. Whereas a financial transaction can be completed instantaneously, the exchange of cultural capital in its embodied state occurs over a long period of time, and this is why children from elite backgrounds – already holders of significant amounts of this capital – are sent to 'prestigious' schools so that the accumulation can continue. When *parvenus* and the nouveau riche send their children to elite schools, they are hoping that these schools will endow their children with the kinds of cultural capital that they have not had the opportunity to possess. Of course, the extent to which these decisions – on the part of parents – are consciously formulated is debatable, but Bourdieu uses the term *strategies* to describe how the semi-conscious plans formulated by agents seeking to accrue capital are formulated (1986, p. 48; 1990a).

Cultural capital in its *institutional* state exists, for example, in the institutionally bestowed qualifications and titles which come to be seen as guarantees of intelligence or competence (Bourdieu, 1993a, p. 177). Bourdieu (1986, p. 51) writes that 'one sees clearly the performative magic of the power of instituting, the power to show forth and secure belief or, in a word, to impose recognition'. This recognition is highly prized in the struggle between those 'playing the game' in any given social field as the various players seek to distinguish themselves from each other. For example, in the academic world, titles and qualifications – as forms of *institutional cultural capital* – serve to distinguish the 'academic' from the self-taught (the autodidact) (Bourdieu, 1986, p. 51). The academic gains a degree (!) of power as a result of this possession of capital, and can use it in a number of ways: for example, to apply for an academic position elsewhere, to speak in the media as an 'expert' or in order to get a publishing contract to write a book. In contrast, the autodidact is entitled to 'opinions' but such opinions, even if they are brilliantly formulated, do not acquire the market value of the academic's pronouncements which are backed up by cultural capital in its institutional state. The autodidact may have read as many

books as the academic and in the course of such reading will certainly have acquired cultural capital. Nevertheless, the autodidact's status remains uncertain and is not institutionally sanctioned.

Bourdieu (1984, 1986; Bourdieu and Passeron, 1990) writes in a manner reminiscent of Weber's (1968[1913]) writings on status groups, arguing that the cultural 'nobility', the holders of titles, are the modern equivalents of titular members of the aristocracy or patrimonial lords. The holders of cultural 'titles' 'only have to be what they are', whereas those without educational titles are valued only in terms of *what they do* (Bourdieu, 1984, p. 23). Cultural capital in its institutional state leads directly to *symbolic capital*, to prestige in the eyes of others. It also paves the way to *economic capital*. According to Bourdieu (1986, p. 51) 'the academic qualification ... makes it possible to compare qualification holders and even to exchange them ... it makes it possible to establish conversion rates between cultural capital and economic capital by guaranteeing the monetary value of a given academic capital'. Another example of conversion to economic capital can be in the institutional awarding of prizes. For example, the winners of a literary prize such as the International Man Booker Prize (a prime form of cultural capital in its institutional state) will gain £60,000, but more significantly, this marker of success stamps winning authors with a seal of approval that tells the global audience that the winning book is worthy of purchase. These are all examples of the significance of institutional cultural capital in the loftier regions of society. However, this form of cultural capital is also utilized, to a greater or lesser extent, in all of our lives. When we fill in a job application form, we know that our *qualifications* are more likely than our hobbies to be expedient in our bids to gain paid employment.

Examples of *cultural capital in its objectified state* include cultural goods such as books and paintings (Bourdieu, 1986, p. 50). Such goods bestow legitimacy on their owners and in their material form can be transmitted readily. If I were to acquire an original painting by Vermeer, I would have *materially* acquired cultural capital in its objectified state. In fact, if I were to obtain several paintings by the Dutch Masters, I could adorn my walls with these cultural riches and gain *symbolic capital* in doing so. Cultural capital in its objectified state can also be appropriated *symbolically*. To demonstrate an *understanding* of the Vermeer painting in relation to the historical and cultural context from which it emerged and to discuss its significance in regard to the history of the field of artistic production is to gain cultural capital by means of symbolic appropriation. To do so successfully

requires the possession of an aesthetic disposition (see below) and the requisite modes of perception and appreciation. Most of us, as amateurs, rely on the knowledge of the 'expert' in order to effect this symbolic acquisition (Bourdieu, 1986, p. 50). Cultural capital in its objectified state can be misrecognized as transcending the social context in which it is produced. What we consider to be a brilliant painting can as a result seem to have an innate brilliance that exists outside of time and space. However, this eternalization of cultural capital in its objectified state is based on misrecognition: its value only exists in relation to the state of play in the cultural field, and so 'it should not be forgotten that it exists as symbolically and materially active, effective capital only insofar as it is appropriated by agents and implemented and invested as a weapon and a stake in the struggles that go on in the fields of cultural production' (Bourdieu, 1986, p. 50). Along similar lines, as we will see in the next chapter, the competences associated with possession of high levels of cultural capital can be misrecognized as innate attributes of individuals.

Homologous positions

According to Bourdieu (1984) the two main types of capital (economic and cultural) can create homologous positions in social space: on one side are various fractions whose social reproduction depends primarily on economic capital (and to a far lesser extent on cultural capital); opposed to these fractions are those whose success is dependent on cultural capital – and their social reproduction is ensured in great part through the education system. The fractions on the same side of social space, even though they differ in terms of the volume of capital at their disposal, have in common the composition of the capital in their possession. So, for example, industrial and commercial employers (at a higher level), and craftsmen and shopkeepers (at an intermediate level) have higher levels of economic capital and lower levels of cultural capital relative to their position. On the other side, higher-education teachers (at a higher level) and primary teachers (at an intermediate level), have higher levels of cultural capital and lower levels of economic capital relative to their position (Bourdieu, 1984, p. 115). According to Bourdieu, the tastes and lifestyles adopted by individuals, depend on the volume and composition of the various types of capital at their disposal. Whereas those with a higher preponderance of economic capital tend to be drawn towards bourgeois culture, and have a predilection for established forms and conspicuous consumption,

those with a higher preponderance of cultural capital tend towards cultural experiences that involved the flouting of convention, with an emphasis on the experimental nature of the cultural experience rather than the 'event' of going for a night out with its associated activities of dining and drinking. These differences can be seen clearly in Bourdieu's discussion of theatre-going. Bourdieu (1984, p. 270) found that theatre-goers with high levels of economic capital had a preference for bourgeois theatre, which has much in common with other forms of conspicuous consumption: 'Choosing a theatre is like choosing the right shop, marked with all the signs of "quality" and guaranteeing no "unpleasant surprises" or "lapses of taste"'. In France, this preference for theatre-going finds its outlet in boulevard theatres on the Parisian Right-Bank. These shows tend to be those which have met with critical approval and which are tried and tested 'classics' appealing to a predominantly wealthy, middle-aged audience (see also Stewart, 2010). The shows most characteristic of bourgeois theatre, in common with items of consumption such as the luxury watch or the sports car, tend to be reassuringly expensive to consume and bear all the signs of quality. The repertoire of bourgeois theatre is in great part made up of established plays and revivals; the casts consist of the finest players and the dramatic writing tends to be carefully, expertly crafted, omitting that which is shocking or surprising, and even more so that which is considered vulgar. The boulevard theatre-going experience involves a night-out of conspicuous consumption which includes getting dressed up in fine clothes and dining out in restaurants before or after the show. At the top-end of the scale, those participating in bourgeois theatre-going signal their membership of high society and accrue symbolic capital by virtue of being *seen* in prestigious environs. In contrast, Bourdieu (1984, p. 234) found that theatre-goers with higher levels of cultural capital tended towards Parisian Left Bank theatre which attracts a younger audience and predominantly features plays that are experimental in nature and flout convention, whether ethical or aesthetic. Tickets for these shows tend to be relatively cheap, and the theatre-going experience is more austere than is bourgeois theatre-going. Instead of eating fine food in expensive restaurants, the period after the show is spent digesting the aesthetic or political content of the play. Those attending Left Bank theatre are more likely to display ascetic tendencies, deriving symbolic profit from the richness of the cultural experience rather than consuming conspicuously.

The distinction between the bourgeois theatre-goer and the avant-garde theatre-goer is expressive of a wider struggle between two

fractions of the dominant class: those richest in economic capital and those richest in cultural capital. The pleasures and profits enjoyed by the former are derived from conspicuous consumption and participation in social ceremonies of high society. For the latter, the rewards derive from the ascetic nature of the theatre-going experience. There are similar divisions between these fractions in relation to other lifestyle choices, with the ascetic, cultural capital-rich fractions preferring the austere pleasures of museums, walking holidays, poetry magazines, camping and mountaineering holidays, and the economic capital-rich bourgeois fractions opting for luxury cars, hunting pursuits, business trips, boats, frequenting auction rooms and boutiques, and spa holidays (Bourdieu, 1984, p. 283). The symbolic profits derived from the kinds of luxury consumption habits mentioned above have perhaps become more pronounced among those Bourdieu (1984, p. 305) terms the new bourgeoisie, which 'rejects the ascetic ethic of production and accumulation, based on abstinence, sobriety, saving and calculation, in favour of a hedonistic morality of consumption, based on credit, spending and enjoyment' (p. 310). Bourdieu here draws attention to a more informal, emergent fraction of the dominant class, one whose members are tanned (fresh from skiing and yachting holidays), casual in dress and manner and accustomed to importing business techniques and popular cultural styles from the USA. These observations, of course, have a particularly French resonance and we will see below how other sociologists have argued that many of Bourdieu's observations are too specifically rooted in French society, in a particular era. As we will see in the next chapter, the various lifestyles and taste preferences expressed by these different societal groupings and the various competing factions within these groupings correspond, broadly speaking, with the three types of taste Bourdieu (1984) identifies.

4
Expressing Taste

Introduction

As we have discussed in the previous chapter, there is a commonly held view that some people seem to have been born with good taste. They are able to walk confidently into an art gallery and provide a convincing and elegant exposition of the meaning of the esoteric pieces of art that adorn the walls. If we stand alongside such competent aesthetes in the gallery, we might stew silently, crushed by a sense of inferiority. 'This', we might tell ourselves, 'is a truly cultured person, one who is able to connect with the artwork'. We might feel unable to experience the seemingly unmediated relationship with the art that the aesthete enjoys. However, as we have seen, for Bourdieu (1984), the seemingly 'mystical' union between aesthetes and a work of art can be explained by reference to the *social* conditions that make it possible. According to Bourdieu (1984, p. 2):

> A work of art has meaning and interest only for someone who possesses the cultural competence, that is, the code, into which it is encoded. The conscious or unconscious implementation of explicit or implicit schemes of perception and appreciation which constitutes pictorial or musical culture is the hidden condition for recognizing the styles characteristic of a period, a school or an author, and, more generally, for the familiarity with the internal logic of works that aesthetic enjoyment presupposes.

So, the ability to discern the stylistic characteristics of a work of art, to understand what makes it 'great' or otherwise in relation to the history of art, and to situate its qualities alongside other works of art is the

product of formal and informal learning, whether derived from school, college and university or in the family home; it is, therefore, linked to class background. Nevertheless, the argument is made that in his account of taste, Bourdieu neglects to consider *what* is consumed and *how* it is consumed by individuals. So, the *cultural object*, whether a painting, a book, a television programme, a piece of music, a comic book, a plate of food or a poem, is looked upon from afar in Bourdieu's analysis. In fact, at times it drops out of the picture altogether only to be replaced by symbols in a wider game of cultural distinction. In examining taste, there are other social factors besides class or family background which need to be explored in order to better understand precisely *how* individuals engage in acts of tasting with cultural objects. This means paying attention to various *affective impulses* that underpin the act of tasting.

Legitimate taste and the aesthetic disposition

Bourdieu (1984) differentiates between three types of taste, each of which, broadly speaking, corresponds to a class position. These are *legitimate taste, middle-brow taste* and *popular taste*. The first of these, *legitimate taste*, corresponds to the lifestyles of the professional middle and upper middle-classes and is expressive of the dispositions of those who have in the course of life acquired a high volume of cultural capital. It is important to point out that *legitimate* is a value-neutral concept, and contrasts with normative assumptions regarding what is *good* taste or *high* culture. According to Bourdieu (1984, 1990a; Bourdieu and Passeron, 1990), agents distinguish themselves from one another by means of a range of distinctions within a symbolic system and this symbolic system is *arbitrary* inasmuch as definitions of what is legitimate are imposed by the powerful and have nothing to do with matters of intrinsic quality or value. So, legitimate taste refers to that which has been bestowed with the stamp of legitimacy at an institutional level. It is the taste that carries with it social prestige and reflects the interests of powerful groups. Furthermore, legitimate taste does not refer simply to an appreciation of prestigious works of art; rather, it refers to an *aesthetic disposition* that enables the actor to perceive even the most everyday cultural objects in terms of their form rather than their function. In his analysis of taste, Bourdieu therefore breaks down the barrier between culture as 'the arts' and culture in its wider, anthropological sense. To be 'cultured' means to make the right choices in everyday life as much as in the rarefied world of the arts. To acquire an

aesthetic disposition, a distanced, playful way of perceiving the world, actors will need to have had a certain degree of freedom from economic necessity, that is, a period of time during which to make investments in cultural matters which are gratuitous and disinterested. Such investments do not, at least on the surface, serve any tangible function or yield any immediate or obvious rewards. Rather, engaging in cultural practices or with cultural objects becomes, as it were, a game. Cultural games take the form of *playful seriousness* (Bourdieu, 1984). They are *playful* because they are characterized by disinterestedness, relieved of the need to serve a purpose or a conviction. They are *serious* because the stakes of the game are not questioned and it is taken for granted that the game has value. The aesthetic disposition thus indulges a purposelessness which 'tends to bracket off the nature and function of the object represented and to exclude any "naïve" reaction – horror at the horrible, desire for the desirable, pious reverence for the sacred – along with all purely ethical responses' (Bourdieu, 1984, p. 54). It is interested in representation rather than in what is represented; it prioritizes form over function; it considers the significance of an artistic work in relation to the artistic field from which it has emerged rather than in its relation to reality. For example, the aesthetic disposition enables an actor to identify the key stylistic features that distinguish one artistic period or school from another, and with reference to the history of the artistic field it can identify the major and minor works of a particular culture creator's artistic oeuvre (Bourdieu, 1984, p. 52). The aesthetic disposition revels in the generation of gratuitous knowledge which extends to the home as much as to the art gallery and can be applied as readily to the daily rituals of dining as to the appreciation of art.

The ability to perceive cultural objects aesthetically derives from an explicit or implicit awareness of the state of play in the cultural field. It means to be cognizant of the artistic styles that are in the ascendancy and that have, over time, overlapped with or usurped previously dominant styles. The aesthetic disposition thus corresponds to the existence of an artistic field which has, over time, gained autonomy in the sense of adhering to its own laws (Bourdieu, 1987, p.203; 1993b[1983], 2003, p. 67; see Chapter 5). For those of us who have not had the opportunity to become familiar with the language and history of art, such meaning will not be readily available. The codes, which make perfect sense to the aesthete, will appear to us to be a jumble of inchoate colours and lines. The aesthetic disposition, understood sociologically, enables us to see that, as Bourdieu (1984, p. 3) argues, 'the eye is a

product of history reproduced by education'. To believe in the exist-
ence of the 'pure gaze', the idea that great taste is bestowed at birth in
the minds of talented individuals and that some have an unmediated
connection with a work of art, is to *misrecognize* reality, to adhere to an
ideology of 'natural taste'. Misrecognition in this sense means to
attribute taste to *nature* rather than to *culture* and it correlates with the
erroneous assumption that those who don't understand abstract art are
naturally less able to do so (Bourdieu, 1990a). This is an example of
what Bourdieu (1990a, p. 68) terms a *doxic* attitude: it is a common-
sense, 'pre-verbal taking-for-granted of the world that flows from prac-
tical sense' and mistakes arbitrary conditions for eternal truths. There
might well be differences in levels of intelligence between individuals
but when viewed sociologically, it is apparent that the ability to adopt
an aesthetic disposition in relation to legitimate culture (painting,
music, literature, theatre) or in relation to everyday cultural practices
(the way we eat, the way we dress, the ways in which we decorate our
houses) is determined in great part by our levels of education and by
our social origins. Furthermore, personal attributes such as the ability
to talk eloquently and confidently in a room full of people, to discern a
fine wine or to know what to wear at the theatre, are the products of
upbringing, inheritances handed down like heirlooms, expressive of
our class habitus. Crucially, such knowledge implies knowing what not
to wear, what not to eat and what not to say; it means to know which
'knick-knacks' to avoid having around the house; it means to know
which restaurants to avoid. It is not difficult to see why it is that the
ideology of natural taste is so convincing: those best expressing the
aesthetic disposition do so effortlessly and with confidence. There is
nothing affected or bookish about such displays, which seem all the
more remarkable because we cannot see the conditions of their genesis.

As we have seen, the cultivation of an aesthetic disposition is
enabled by extended periods of freedom from economic necessity.
Such favourable material conditions enable a 'social power over time',
an opportunity to 'possess things from the past, i.e., accumulated, crys-
tallized history, aristocratic names and titles, chateaux or "stately
homes", paintings and collections, vintage wines and antique furni-
ture' (Bourdieu, 1984, p. 71). The significant advantage that possessors
of the aesthetic disposition hold over newcomers to the game of
culture is that their relation to culture is developed pre-verbally and
proceeds to develop at a steady pace, surrounded as they are by cultural
objects, family property, cultivated people and practices (Bourdieu,
1984, p. 75). For example, one of the surest signs of having time at

one's disposal, one of the surest signs of distinction is the ownership of artworks. It takes time to learn what artworks are worth appropriating, and the quality of the appropriation demonstrates the quality of the owner. So it is that

> [t]o appropriate a work of art is to assert oneself as the exclusive pos-
> sessor of the object and of the authentic taste for that object, which
> is thereby converted into a reified negation of all those who are
> unworthy of possessing it, for lack of the material or symbolic
> means of doing so, or simply for lack of a desire to possess it strong
> enough to 'sacrifice everything for it' (Bourdieu, 1984, p. 280).

To be in a position to possess works of art is not possible for all those able to express the aesthetic disposition and so this appropriation distinguishes the dominant from the dominated members of the dominant class. Agents from the *dominated fraction of the dominant class*, those who have high levels of cultural capital but do not have the economic means at their disposal to procure legitimate art objects, have to be more creative in their strategies of cultural distinction. Higher education teachers, for example, are more likely to appropriate art objects at the symbolic level; they will invest energy in utilizing the power that is unique to them (as holders of high levels of cultural capital) to confer status on objects that were once considered to be insignificant or unworthy of the status of 'art' (Bourdieu, 1984, p. 283). So it is that enthusiasts and scholars from this section of the dominant class have transformed the status of previously disparaged cultural forms such as jazz music, comic strips and graffiti, and in doing so this fraction has gained distinction. Interestingly, this dominated fraction of the dominant class, which is richer in cultural than economic capital, lambasts the dominant for their vulgar tastes. However, the dominant fraction expresses its cultural distinction in relation to the dominated classes, whether petty-bourgeois or working class, in precisely the same terms in which it is castigated by the dominated fraction of its own class (Bourdieu, 1984, p. 316). This tension and opposition between these two dominant fractions, each of whom expresses legitimate taste, is examined in Bourdieu's (1984) discussion of the *mondain* and the *pedant*. The *mondain* is somebody for whom the acquisition of cultural capital has occurred *primarily* through social origin, by means of a slow and steady process of familiarization with the legitimate, and *secondarily* through education. In contrast, the *pedant* is someone for whom the acquisition of the aesthetic disposition has occurred at a later stage in

life, predominantly through the education system. The *mondain* adopts the aesthetic disposition in relation to art works, but also in relation to everyday cultural consumption choices. These distinctive choices reveal that a great part of the *mondain's* cultural capital is inherited. The *pedant*, in contrast, has, in the main, acquired cultural capital through education, as exemplified by academic qualifications. The scope of this capital is therefore limited, extending only to specific areas of life or pertaining to a particular specialism. The mondain's competences are similar to those Max Weber (1968, p. 1001) associated with 'the cultivated man'; they are the competences that accompany a well-rounded humanistic education derived from the household as well as through education. In contrast, the pedant is trained to be a specialist, to provide the expert knowledge demanded by modern, bureaucratic and capitalistic institutions (Weber, 1968). The mondain's skills are ingrained in the body as much as in the brain; any embarrassment regarding a lack of knowledge is circumvented by a knowing look, an imperious gesture, a successful bluff. Accordingly, the mondain 'turns questions of knowledge into questions of preference, ignorance into a disdainful refusal' (Bourdieu, 1984, p. 89). With high levels of inherited and acquired cultural capital, the mondain is in stronger position to command authority and thus gain distinction in matters of taste and culture:

> It is, ultimately, the self-assurance, confidence, arrogance, which, normally being the monopoly of the individuals most assured of profit from their investments, has every likelihood – in a world in which everything is a matter of belief – of imposing the absolute legitimacy, and therefore, the maximum profitability, of their investments (Bourdieu, 1984, p. 92).

More than 100 years ago, Weber drew attention to the decline of the 'cultivated man' and the rise of the specialist. Curiously, and controversially, Bourdieu maintains that the cultivated man, as represented by the *mondain*, still has precedence in matters of taste and culture.

Popular taste and the popular 'aesthetic'

Popular taste corresponds to the lifestyles of the working classes and is defined as being in opposition to legitimate taste. Whereas the aesthetic disposition is characterized by a detached, formal appraisal of the cultural object, the popular aesthetic reduces 'the things of art to

the things of life' and perceives art-works in terms of their human content (Bourdieu, 1984, p. 44). This aesthetic is hostile to the kinds of formal experimentation and playfulness that characterizes, for example, avant-garde art or Left-Bank theatre (Bourdieu, 1984, p. 32). At most, it countenances formal experimentation so long as it doesn't break the sense of illusion created by the cultural object in question (Bourdieu, 1984, p. 33). Popular taste is, therefore, suspicious of legitimate culture and experiences 'confusion, sometimes almost a sort of panic mingled with revolt' when faced with exhibits of art that make sense only in relation to the history of art and otherwise appear as nonsensical (Bourdieu, 1984, p. 33). The following quote from one of Bourdieu's respondents is representative of this suspicion of formal experimentation: 'when you see half a dozen squiggles and people spending a fortune on it, well, personally, I'd throw that sort of thing in the dustbin if I found it' (Mr L., cited in Bourdieu, 1984, p. 393). In his research for *Distinction*, Bourdieu (1984, p. 35) found that whereas those expressing the aesthetic disposition were able to perceive 'common' or 'ordinary' objects such as cabbages or butcher's stalls as fitting subjects for 'beautiful' or 'interesting' photographs, those expressing the popular aesthetic, namely those with low levels of cultural capital, were more inclined to find such objects 'ugly' or 'meaningless'. Popular taste prioritizes human content over form and the popular aesthetic is guided by the naïve gaze (in opposition to the 'pure gaze') because it seeks to relate the art-form or the cultural object directly to reality. In contrast to the aesthetic disposition, which is playful and refuses to take the art-form seriously, the popular aesthetic involves getting up close to the cultural form and becoming immersed in the plot, as it were. It involves belief in the scenario and identification with the characters. In the art-gallery or at the photography exhibition, those expressing the popular aesthetic are attentive to the immediate properties of a painting, appreciative of is brightness or its prettiness, applauding the craftsmanship of the artists to the extent that they have represented reality. For example, a painted apple will be appreciated to the extent that it looks like a real apple. So, popular taste is characterized by *seriousness* rather than playfulness, but it also has a Rabelaisian element, expressing a preference for revelry, for celebration, for laughter and for the comedic overturning of propriety; it is associated with festivity and collective effervescence, whether in the music-hall, the theatre, the sporting arena or on the television. Popular taste involves an emotional or moral investment that the aesthetic disposition, with its playfulness and detachment, refuses to make. So, for

example, it enjoys drama that proceeds logically according with some kind of higher purpose, punishing the bad, rewarding the good, and in doing so providing instruction to the viewer. It expects a set of characters that are clearly defined and understandable in terms of their actions and motivations. It is appreciative of a story insofar as it is well-developed and believable, insofar as such a plot could well occur in real life.

Popular taste is negatively appraised by those with high levels of cultural capital as a consequence of its naivety and its moral tenor. Those expressing this dominated aesthetic are, in turn, hostile towards works that require formalistic appraisal. However, this two-way struggle is by no means grounded in equality. The bearers of the aesthetic disposition are condescending towards those expressing popular taste and such condescension has its roots in power: the former have more resources at their disposal and are more prominently situated in the cultural field. They are condescending because popular taste does not seriously threaten their worldview, and those expressing this aesthetic are too low in the social scale to worry about. Similarly, the hostility which those expressing popular taste feel towards legitimate culture cannot ever be expressed with utter conviction because this judgement is haunted by the fact that popular taste is a dominated aesthetic and the proponents of legitimate culture are those 'more likely to know'. In fact, Bourdieu (1984) found that the dominated tend to admit that avant-garde art might actually be rather good but 'is not for me'. This is not to suggest that those familiar with legitimate culture always understand the 'meaning' of complex works of art, but when they encounter cultural forms that they do not grasp, they are more readily equipped with the knowing silence with which to mask any discomfort. This silence is also indicative of a refusal to naively grasp at the meaning of a cultural object.

Popular taste is associated with the working classes; it is the expression of a class habitus accustomed to assuming a dominated position in the relations of production (Bourdieu, 1984, p. 372). The tastes of the dominated classes of society are very much informed by the conditions they have long had to endure, conditions in which they have had to 'make do' with limited resources. They are, therefore, tastes that can be explained by reference to *social* rather than *natural* causes; tastes rooted in necessity, informed by memories of scarcity that persist long after its conditions have passed. So it is that the consumption habits and tastes of a young man might reflect his origins long after he has moved onwards and upwards in social space. His tastes, for example,

might be expressive of the deprivation endured by his grandparents. This is a consequence of the hysteresis, the lag in time that it takes for an agent's habitus to adjust to new circumstances. It is expected that the tastes expressed by actors whose social origin is in the most dominated region of society will take time to adjust to the new conditions in which they are operating. This can be seen clearly in the example of *parvenus* who have not had time to adjust to 'legitimate' ways of spending their money. As Bourdieu (1984, p. 374) points out:

> Having a million does not in itself make one able to live like a millionaire; and parvenus generally take a long time to learn that what they see as culpable prodigality is, in their new condition, expenditure of basic necessity.

Parvenus still harbour the tendency to 'do it themselves', to scrimp and to save, to purchase the cheaper options in the marketplace. Even if they choose to spend extravagantly, Bourdieu (1984, p. 374) argues that they are not familiar with the formal rituals and manners associated with *being served* in arenas of the legitimate such as in prestigious restaurants or hotels. In such contexts, the customer of working-class origin is more likely to feel discomfort regarding the elements of master/slave relationships that are played out. In contrast, those groomed in the ways of legitimate culture are accustomed to *being served* and consider it to be their right. Knowing how to give orders, how to taste the wine, how to tip, how to insist, politely and firmly, that things are done properly, and how to be friendly but not over-familiar with staff – these are social skills that have been acquired by those who have long been familiar with and accustomed to luxury. In order to derive most from the symbolic services that distinguish the splendid from the ordinary establishment,

> one has to feel oneself the legitimate recipient of this bureaucratically personalized care and attention to display vis-à-vis those who are paid to offer it the mixture of distance (including 'generous' gratuities) and freedom which the bourgeois have towards their servants.

As well as being unfamiliar with the various modes of conduct associated with being served, those expressing popular taste, having been long accustomed to the necessary and the functional, are more likely to be bemused by the expenditure that wealthier members of society

seemingly squander on social events such as engagement parties. For the dominated, such expenditure seems to be absurdly wasteful and extravagant, especially when the ensuing wedding is likely to be very expensive. For the dominant, in contrast, the outlay of thousands of pounds on an engagement party is not an extravagance but a necessity. In the world they inhabit, throwing such a party is quite normal, an expectation. For these societal groupings, the engagement party is not just a way of keeping up with peers, it represents an expedient means of consolidating formal and informal networks and is therefore 'an excellent investment in social capital' (Bourdieu, 1984, p. 375).

In their consumption habits, working class women, accustomed to the taste of necessity, tend towards the practical and the functional, rejecting '"frills" and "fancy nonsense"' (Bourdieu, 1984, p. 379). These expressions of popular taste are derived from material conditions of scarcity. Even the deployment of ornaments and knick-knacks in the working class household is motivated by a lack of economic and cultural capital and such objects are used to get maximum effect at minimum cost. This array of disparate trinkets, perhaps acquired at a bargain price, placed alongside each other, creates a sense of revulsion amongst the middle-classes and those accustomed to an aesthetic approach to home decoration that tends towards the minimalistic and the carefully considered. In contrast, Bourdieu (1984, p. 378) found that bourgeois women have a tendency to shop in boutiques and prestigious department stores, and are more likely to appreciate household objects on the basis of their formal qualities and the extent to which, in their relation to other items, they serve to create an overall sense of harmony or beauty. Popular taste is also expressed in the working man's preference for food and drink that is 'strong' and expressive of virility and masculine strength. This is the taste of necessity, associated with salty, substantial, meaty food, served in large portions (Bourdieu, 1984, p. 384). Again, it is worth emphasizing the social causes of this taste. It is food for those social groupings that have historically depended 'on a labour power which the laws of cultural reproduction and of the labour market reduce, more than for any other class, to sheer muscle power' (Bourdieu, 1984, p. 384). Although the proportion of working-class men employed in manual labour occupations has declined in affluent Western societies in recent years, the taste for necessity, as an expression of popular taste, persists, haunted by the memory of scarcity. For twenty-first century readers, some of these examples may seem too specifically redolent of the France of the 1960s

and 1970s. But the argument for the importance of form over function in expressing cultural distinction is made.

Middle-brow taste

According to Bourdieu (1984), middle-brow taste is expressed by those situated in the middling, indeterminate region of social space, caught between what they are inclined to like and what they aspire to like. These middling groups are keen to participate in legitimate culture but they approach it over-zealously, with none of the detachment that characterizes the aesthetic disposition. Instead, they consume cultural forms with a reverence that borders on clumsiness. Whereas the aesthetic disposition is characterized by its cool and disinterested engagement with culture, middle-brow taste is typically overly-scholastic, and its forced eclecticism is shown up by the elective eclecticism of legitimate taste (Bourdieu, 1984, p. 329). When those expressing middle-brow taste are not over-zealous, they are timid; they stammer and stutter because their knowledge does not match their aspiration. When confronted with a challenging cultural matter they are flustered, unable to pluck from their repertoire the bluffs and impressive silences which the aesthetic disposition so readily musters. After all, those long familiar with the legitimate might, with confidence, *flaunt* their lack of knowledge on a given topic (Bourdieu, 1984, p. 330). The audacity and playfulness of the aesthetic disposition can thus be contrasted with the reverential seriousness that characterizes the middle-brow relation to culture. This seriousness is expressed in a taste for culture that is educational, edifying and instructive and in a preference for that which has been imbued with institutional prestige. Middle-brow taste slavishly pursues books that win prizes and art that has been given legitimacy. In deference to authority, middle-brow culture is concerned with the correct way of doing things and finds sure markers of prestige in the logos of familiar brands and in the names of the famous authors. However, despite this devoted attitude towards cultural matters, those expressing middle-brow taste tend to be snubbed in the cultural world because it is a world from which they are, ultimately, excluded. Bourdieu (1984, p. 16) finds that middle-brow taste 'brings together the minor works of the major arts ... and the major works of the minor arts'. This taste is typified by a preference for accessible or déclassé forms of legitimate culture such as classical music compositions that have been popularized through their use in adverts, in film soundtracks, or as a consequence of their repeated play on popular

classical music radio shows. Middle-brow taste has a preference for anything which gestures towards the legitimate or contains an element of the legitimate without its associated complexities or difficulties (Bourdieu, 1984, p. 327). Middle-brow cultural forms include, for example, radio, film and television adaptations of classic literature; light opera and musicals which are played out in arenas of legitimate culture, but which feature catchy and popular songs; best-seller novels which have been given the stamp of institutional approval in the form of awards or which have been reviewed favourably in broadsheet newspapers. Perhaps the apotheosis of the middle-brow cultural form is the historical costume drama.

In his research for *Distinction*, Bourdieu (1984) found that there are variations in the middle-brow taste expressed by different social groupings in the middling region of social space. For example, those in declining professions, such as small shopkeepers or craftsmen, whose composition and volume of capital is not sufficient to enable the pursuit of a different trajectory according with changing trends in the labour market, tend to have rather conservative middle-brow taste (Bourdieu, 1984, p. 345). For example, in home decoration, they prefer the practical and the easy to maintain; in music, they opt for déclassé works of legitimate culture and the repertoires of old-fashioned singers (Bourdieu, 1984, p. 350). Those who have in recent years 'fallen' from the bourgeois class display a preference for popular cultural forms such as cinema, comic books, and jazz which are on the cusp of legitimate culture. With the cultural capital inherited from their social origin, they bring an element of scholarly appraisal to these cultural forms, motivated by a rebellion against that which is established and by an aspiration to rise, by means of such acts of consecration, to the ranks of the dominant class (Bourdieu, 1984, pp. 360–361). In this bid to re-join the bourgeois class, this new petite-bourgeois fraction also has a tendency towards pretension, gesturing somewhat naively towards the aristocratic in taste with their bluffs bolstered by inherited cultural capital. Those expressing this new middle-brow taste also substitute an ethic of pleasure, which accords with a consumerist mentality, for the ethic of duty which had long dominated the lower middle-classes. According to Bourdieu (1984, p. 367), this outlook 'makes it a failure, a threat to self-esteem, not to "have fun", or, as Parisians like to say with a little shudder of audacity, jouir'. The indeterminate cultural position of those expressing middle-brow tastes is expressive of the uncertainties they face in the labour market. For example, many of the new petite-bourgeoisie are

carving out careers in non-established and newly emerging creative professions such as public relations, or providing social assistance through lifestyle advice, fitness coaching, sex therapy, dietetics, astrology or marriage counselling (Bourdieu, 1984, p. 359). Location is also important in the articulation of middle-brow taste, with those living in metropolitan areas, the centres of cultural values, far more likely than provincials to have a stronger relation to legitimate culture (Bourdieu, 1984, p. 363).

Those expressing middle-brow taste have long been the target of ridicule and vitriol. For example, the novelist Virginia Wolff (2012[1941]), a self-proclaimed 'highbrow', reserves her virulence for 'middlebrows' rather than 'lowbrows'. Though Woolf is condescendingly sweet towards those furthest from her in terms of cultural competence, she is merciless towards those just below her. According to Woolf (2012[1941]), the highbrow, a grouping with which she identifies, 'rides his mind at a gallop across country in pursuit of an idea'. The low brow, in contrast, 'rides his body in pursuit of a living at a gallop across life'. These contrasting roles are wondrously complementary. Lowbrows solve practical problems and look after the running of the world and because they are so busy immersed in the world of the practical, they are unable to raise their heads above the action. So, they rely on the highbrows to 'show them' life through the medium of culture. Highbrows, in contrast, are so busy conjuring ideas that they are pretty hapless regarding everyday practicalities. They need lowbrows to mend their cars, build their houses and drive their buses. Woolf (2012) enjoys sitting next to bus conductors so as to ascertain 'what it is like – being a conductor', and thus she further cements this mutually beneficial relationship of opposites. In contrast, she would go to great lengths to avoid sitting next to a middlebrow, someone situated below her in social space. The middlebrow might share Woolf's interest in culture, but does not have sufficient authority regarding such matters and so she states her preference for the 'naivety' of the lowbrow over what she perceives to be the meddling pretentiousness of the middlebrow (2012). This is because, according to Woolf,

> [t]he middlebrow is the man, or woman, of middlebred intelligence who ambles and saunters now on this side of the hedge, now on that, in pursuit of no single object, neither art itself nor life itself, but both mixed indistinguishably, and rather nastily, with money, fame, power, or prestige (Woolf, 2012).

The middlebrow is depicted as naturally of middle-bred intelligence, and is criticized for being betwixt and between art and life; the middle-brow needs to earn a living *and* seeks to gain entry to the world of legitimate culture. In Bourdieu's depiction of middle-brow taste, one can detect a hint of Virginia Woolf's mocking attitude. However, whereas Woolf's depiction of the middlebrow is essentialist, Bourdieu (1984, p. 327) seeks to draw attention to the social conditions from which middle-brow taste emerges:

> What makes the petit-bourgeois relation to culture and its capacity to make "middle-brow" whatever it touches, just as the legitimate gaze "saves" whatever it lights upon, is not its "nature" but the very position of the petit bourgeois in social space, the social nature of the petit bourgeois, which is constantly impressed on the petit bour-geois himself, determining his relation to legitimate culture and his avid but anxious, naïve but serious way of clutching at it.

Without the benefits of cultural acquisition that come from a pro-longed stay in the education system, those expressing middle-brow taste are typically those who are reverential towards legitimate culture but unable to understand its rules (Bourdieu, 1984, p. 319). The auto-didact is perhaps the archetypal middle-brow figure. Excluded from the privileges of a childhood steeped in legitimate culture with its scholas-tic exercises and its freedom from necessity, left to gaze longingly at a world which is desirable but distant and unfamiliar, the autodidact assumes a pious and reverential attitude towards legitimate culture. From the perspective of the privileged, whose familiarity with the legit-imate has stripped it of its mysteries, the middle-brow attitude repre-sents 'a grotesque homage' (Bourdieu, 1984, p. 84).

Critical appraisal

As we have seen in these chapters, Bourdieu makes the significant observation that taste is relational. As he famously wrote, 'taste classifies, and it classifies the classifier' (1984, p. 6). In the act of class-ifying, in expressing our taste judgements, we classify ourselves and such classifications are indicative of our social position. We situate our-selves in relation to others; we align ourselves with certain social groupings; we differentiate ourselves from others. Taste brings people together and it differentiates groups of them from others. As we have seen in this chapter, the various types of taste outlined by Bourdieu are

defined in relation to one another. This is because tastes 'are the practical affirmation of an inevitable difference' (1984, p. 56). They are often asserted negatively, in opposition to other tastes. This negative assertion can be violent, as individuals seek to define themselves in relation to what they are not. This is because cultural distinction is derived from the opposition between, for example, the rare and the common, the distinguished and the vulgar, the prestigious and the denigrated, the new and the dated, the legitimate and the popular. The valorization of a particular orientation towards culture implicitly denigrates its opposite and so, for example, the understated taste of legitimate culture is in great part distinguished by reference to those characteristics to which it stands in opposition: the showiness of nouveau-riche or petty-bourgeois taste. So, while the tastes of the dominant have as a negative reference point the tastes of the dominated, these social groupings also seek to sharply distinguish themselves from those just below them in the social hierarchy. The struggle for cultural distinction takes place just not just between classes but between different fractions of the same class and, as Bourdieu puts it, '[a]esthetic intolerance can be terribly violent' (1993a, p. 104).

Bourdieu's thesis on taste has been widely adopted and applied, but like any prominent thesis has also received a great deal of criticism. Let us consider some of these critical points. The first is that Bourdieu's work is dated (Bauman, 2011; Probyn, 2000, p. 26). In *Culture in a Liquid Modern World*, Bauman (2011, p. 11) argues that Bourdieu's research, which was carried out in the 1960s, provides a snapshot of a cultural order that was already in decline. In the world Bourdieu described, each artistic offering was aligned with a particular social class and taste patterns served to provide clear lines of demarcation between the classes. Classes didn't mix their tastes, and as we have seen above in Bourdieu's depiction of legitimate taste, high status groups were in a position to define the beautiful and the good and used this act of legitimization to distinguish themselves from those below them in social space. Culture, in this model, was very much a socially conservative force, but it has since acquired a new role. Bauman (2011) traces the peregrinations of the concept of culture, from its eighteenth century missionary role in cultivating minds (and in the process, serving as a tool in the building of nations and empires), to its role in Bourdieu's model, serving to maintain and reproduce social order. According to Bauman (2011, p. 11), Bourdieu's work 'captured culture at its homeostatic stage: culture at the service of the status quo, of the monotonous reproduction of society and

maintenance of social equilibrium'. What has changed since then is that culture has ceased to play this role as modernity has moved from its solid to its liquid phase:

> What makes modernity 'liquid' ... is its self-propelling, self-intensifying, compulsive and obsessive 'modernization', as a result of which, like liquid, none of the consecutive forms of social life is able to maintain its shape for long. 'Dissolving everything that is solid' has been the innate and defining characteristic of the modern form of life from the outset; but today ... the dissolved forms are not to be replaced ... by other solid forms (Bauman, 2011, p. 11).

Impermanent forms are successively replaced by other equally impermanent forms rather than by 'solid' forms, and in this liquid modern world culture no longer serves the purpose of maintaining social equilibrium. Instead, it serves to facilitate constant change; it provides offers and propositions rather than restrictions and prohibitions; it oils the wheels of the consumer market rather than the nation state or the class system (Bauman, 2011, p. 13). Members of the liquid modern cultural elite have preferences that differ hugely from those expressed by the snobs depicted in *Distinction*. Their tastes change as swiftly and fleetingly as do the goods on the shelves offered up for consumption. They no longer pick exclusively from the lofty regions of legitimate culture, preferring instead to pick and mix more widely from the culture section in the department store of our consumer society. So it is that:

> The sign of belonging to a cultural elite today is maximum tolerance and minimum choosiness. Cultural snobbery consists of an ostentatious denial of snobbery. The principle of cultural elitism is omnivorousness – feeling at home in every cultural milieu, without considering any as a home, let alone the only home (Bauman, 2011, p. 14).

With this in mind, perhaps the archetypal figure of the cultural elite is no longer the *mondain*, surrounded by *old things* and garnering distinction through possession of the past in the form of inherited cultural capital. Instead, if we follow Bauman's logic, we find the new representative of the cultural elite in the person of someone like Charles Saatchi who has gained distinction by virtue of his ability to set trends in consumer society and to seduce others into adopting them. Saatchi

is no *mondain*; he does not come from a high bourgeois family; he left a state school at seventeen years old with meagre qualifications, and yet, with his populist touch, his extraordinary levels of wealth and his obsession with the contemporary, he has become one of the most powerful figures in the field of art. As Bauman (2005b, pp. 60–61) wryly observes, culture creators are aware that '[t]he contemporary equivalent of good fortune or a stroke of luck is Charles Saatchi stopping his car in front of an obscure side-street shop selling some bric-a-brac which the obscure side-street persons who made them dreamed of being and craved to be proclaimed works of art'. Saatchi & Saatchi, the advertising company Charles ran with his brother Maurice was the world's biggest advertising agency in the 1980s and ran each of Margaret Thatcher's election campaigns. The considerable economic and political capital at their disposal enabled them to gain entry into the cultural field. According to Robert Hewison (1995, p. 221), '[i]t is no accident that at the time when his company was becoming the country's most influential distributor of commercial messages and, with its work for the Conservative Party, political images, Charles Saatchi became the most important British private collector of contemporary art'; and dominance in this field yielded further economic capital by means of 'using art as a commodity' (Wu, 2003, p. 120). With Saatchi in mind, we might consider that key players in consumer society, in advertising, in public relations, in branding, have replaced the mondain at the forefront of the cultural elite. They are joined by wealthy private collectors who – in the words of Philip Dodd, a former director of the Institute of Contemporary Arts – 'have made their money and are now moving into culture' (cited in Sinclair, 2012, p. 12). For these people, 'culture' is another market to move into, another territory in which to establish connections. For example, the world's most prominent private collectors and gallery owners include the Chinese property developer Dai Zhikang, Mera Rubell (co-founder of the Rubell Family Collection in Miami), Anita Zabludowicz (co-founder of the Zabludowicz Foundation in London), Wang Wei, the husband of Chinese billionaire entrepreneur Liu Yiqian, and Sheikha al-Mayassa bint Hamad bin Khalifa al-Thani (named the most powerful figure in the art world in a recent *Art and Auction* list), the daughter of the Emir of Qatar (Sinclair, 2012). These members of the twenty-first century cultural elite have superseded the *mondain*, because they represent *the present* more than the past and are more omnivorous in their tastes than the *mondain*. However, they also have much in common with the *mondain*, including the exclusive possession of prestigious

artworks, a taste for conspicuous consumption, and high volumes of economic capital. Furthermore, with such capital at their disposal, they too are in a position to set members of the dominated fraction of the dominant class in competition with one another for patronage.

The notion of the cultural omnivore was developed by Richard Peterson in the 1990s on the basis of surveys on musical tastes of high status North Americans. According to Peterson (Peterson and Simkus, 1992; Peterson and Kern, 1996) there has been a 'historical shift from highbrow snob to omnivore' taking place. In comparing survey data from the 1980s and 1990s, he found that highbrows, defined as those expressing a preference for classical music and opera, were increasingly omnivorous in their musical tastes; they were broadening their palates, enjoying middlebrow and lowbrow as well as highbrow music. This does not mean that high status groups have become indiscriminate in articulating their musical preferences. Rather, their omnivorous tastes signify 'an *openness* to appreciating everything', an attitude that is quite contrary to the position taken by the cultural snob (Peterson and Kern, 1996, p. 904). So, the arguments provided by Bauman and Peterson seem to suggest that Bourdieu's model of taste is outmoded. However, this would be a mere surface reading of the situation. While the range and content of culture enjoyed by high status groups may have changed in line with the demands of a consumer society, one in which cultural hierarchies have lost their sense of permanence and their sense of inevitability, expressions of taste still affirm differences between social groupings. Let us consider an example in order to understand this point. Peterson and Kern (1996, p. 904) observe that country music is now enjoyed by highbrows in the USA. This is remarkable because until recently, this genre was considered to be vulgar and was shunned by high status groups. However, the *way* country music is enjoyed and understood by high status omnivores differs from the way it is consumed by its traditional fan base. When approaching country music, the high status omnivore will 'appreciate and critique it in the light of some knowledge of the genre, its great performers, and links to other cultural forms' (Peterson and Kern, 1996, p. 904). In consuming country music in this scholarly way, omnivores mark a symbolic boundary between themselves and 'ordinary' country music fans. The omnivore is analysing country music in a scholarly fashion, and is expressing an aesthetic disposition in doing so. This example, along with Bauman's observation that in today's society, cultural snobbery consists of a denial of snobbery, draws our attention to the fact that omnivorousness is itself a distinctive disposi-

tion expressed by high status groups and that taste is relational. This view is expressed by Beverley Skeggs (2004, p. 145), who argues that omnivorousness is a privilege restricted to those with 'the money, time and knowledge required to know what to access and how to use what has been accessed' and therefore, it is a *modus operandi* that is not available to less privileged groups. Other researchers have also drawn attention to the distinctiveness associated with omnivorousness (Bellavance, 2008; Warde *et al.*, 1999). Perhaps then, omnivorousness can be seen as an example of the aesthetic disposition adapting to the new rules of the game in the cultural field. The taste hierarchies that were dominant in the era of high modernism no longer hold sway, and if Bourdieu's research revealed such hierarchies to be arbitrary, Peterson's and Skeggs's research shows that in recent years, they have been reconfigured. Elite groups, for example, have extended their reach into genres of music that were out of bounds not so long ago. So, while it might be true that the *solidity* of taste hierarchies no longer pertains, it does not follow that there are no taste hierarchies, even if the hierarchies that do exist operate in accordance with shifting value systems and change with greater regularity, having more in common with consumer markets than with artworlds. To make the wrong choices, whether that means choosing a déclassé model of mobile phone or consuming a cultural object that is from the region of culture marked *untouchable* still means to be marked as having pathological taste. Scorn and snobbery is reserved for those who are not omnivorous or tolerant enough; it is reserved for those who draw from a narrow band of cultural forms, without the resources or time to acquire and enjoy, in a globalizing world, the multifarious cultural objects that have become for some so readily accessible. Those unable to adapt to changing cultural conditions and to respond swiftly to the trends in the consumer market lag further and further behind as the proliferation rate of cultural objects, enabled by new media-propelled consumer markets, accelerates. As we will see below, those making the wrong choices are denigrated, looked upon with disgust.

Stephanie Lawler (2005) has other reflections on Bourdieu's views on taste. She argues that a public bourgeoisie, that includes, for example, academics, journalists and social commentators, produces a normative, desirable middle-class identity which is in great part defined by *what it is not*. The desirability of this identity is therefore not attributed to any specific qualities associated with the middle-classes. Instead, it is defined in relation to the *otherness* of working-class culture, which is held to be abhorrent and disgusting. In the discourse created by the

public bourgeoisie, 'class' is rarely invoked explicitly, but the normalcy of middle-class identity is produced in opposition to what are perceived to be pathological traits associated with working-class taste and consumption choices. According to Lawler (2005, p. 443) there has long been a tendency among the middle-classes to veer between romanticism and disgust in their appraisal of working class culture. In recent years however, disgust has become the dominant mode of appraisal and the 'bad taste' of the working classes, as expressed in their consumption choices, has come to symbolize a repellent way of life:

> Everything is saturated with meaning: their clothes, their bodies, their houses, all are assumed to be markers of some 'deeper' pathological form of identity. This identity is taken to be ignorant, brutal and tasteless (Lawler, 2005, p. 437).

This attitude of disgust towards working-class aesthetics slips easily into a moral critique, and so the lack of taste becomes perceived as a lack of morals. According to Lawler (2005, p. 430), 'expressions of disgust can tell us a great deal about the ways in which middle-classness relies on the expulsion and exclusion of (what is held to be) white working-classness'. Along similar lines, Archer *et al.* (2007) found that although the consumption of designer sportswear, hooded tops and trainers generates locally prestigious value and worth for urban working-class young people among their peers, enabling them to challenge the negative connotations that derive from their marginal societal position living in 'rubbish' areas and attending 'shit schools', this 'performance of cool' is viewed by the middle-class dominated education system as negative and tasteless. Young people come into conflict with their schools when they adopt this style and are more likely to be viewed as 'bad' pupils. This in turn leads them to feel marginalized within the education system and to consider that post-compulsory education is not for them. These working-class style choices are paradoxical in that they accrue value for the individual at the local level but ultimately serve to reinforce the marginal position of the working classes within the educational system and in wider society (Archer *et al.*, 2007, p. 234). There is nothing inherent in sportswear that lends itself to negative appraisal but when it is attached to working-class bodies, it is viewed negatively. Similarly, Lawler (2005, p. 432) finds that tattoos and piercings are held to be repellent, threatening, disgusting, signifying a collective, mob-like existence when attached to working-class bodies (Lawler, 2005, p. 432). However, when the

middle-classes have tattoos or piercings, these cultural expressions are viewed as markers of individuality and so, when appropriated by middle-class groupings, the very same expressions of taste acquire value. This is because, as Beverley Skeggs (2004) argues, the middle-classes occupy a more mobile position in social space from which they are able to 'propertize' the resources of those below them. According to Skeggs, culture is a resource that is unequally distributed; the middle-class is better positioned to increase its value at the expense of others by plundering the resources of the less powerful. Whereas the middle-class is mobile and flexible, with resources at its disposal, the working-class is characterized by immobility: it is fixed in place and essentialized, unable to counter-plunder. When, for example, appropriating aspects of working-class culture as a resource, the middle-class only takes the fashionable bits, 'the bits that are useful, such as the criminal associations, the sexuality, the immoral bits', associated with the working classes (Skeggs, 2004, p. 187). What the middle-class leaves untouched is 'the constitutive limit', that which is considered to have no cultural value, but which serves as a boundary marker of taste (Skeggs, 2004, p. 170). So, for example, the distinctive, cosmopolitan tastes of the middle-class are defined in relation to pathologized tastes of the powerless white working class; and the hen party, the apotheosis of working class femininity done to excess, is viewed as 'the real from which tasteful distance must be drawn' (Skeggs, 2004, p. 169). As we can see from this example, and from those provided by Lawler and Archer *et al.*, there is much evidence to suggest that Bourdieu's relational model of taste continues to have resonance.

A further criticism of Bourdieu's theoretical model on taste is that it does not apply so readily elsewhere; it is specific to France, a country with a highly centralized education system and a capital city, Paris, which is the centre of cultural values; if applied elsewhere, factors such as age, gender, ethnicity and national differences need to be given greater consideration in the analysis of cultural reproduction (Bennett *et al.*, 2009; Jenkins, 2002, p. 148; Lamont, 1992; Turner and Edmunds, 2002). Furthermore, the restricted national focus of the theoretical model applied in *Distinction* poses problems for its wider applicability in an increasingly globalizing world where there is 'complex interplay between national, regional and global cultural connections' and where 'transnational identifications are ... key components of cultural capital' (Bennett *et al.*, 2009, pp. 249–250). Let us consider an example with which to illustrate this criticism of limited applicability. Bryan Turner and June Edmunds analysed in-depth qualitative data based on

interviews with members of Australia's elite and found that these highly educated, career high-flyers expressed no desire to appear high-brow and their cultural preferences tended towards the middle to lowbrow. They did not seek to distinguish themselves from those below them in social space, nor did they invest in cultural capital or seek to acquire symbolic goods (Turner and Edmunds, 2002, p. 234). If anything, they expressed a 'distaste of taste', meaning that they were actually unwilling to appear highbrow, which, for them, would be considered to be in bad taste, especially if expressed ostentatiously (Turner and Edmunds, 2002, p. 237). One explanation for the lack of fit between Bourdieu's model and the taste patterns expressed by Turner and Edmunds' respondents is the specificity of Australian culture, with its deep-rooted popular ethos of what is known as *larrikinism* which, even if ironically, valorizes the practical wisdom of 'bush culture' and derides urbanity and sophistication. Another reason, equally persuasive, is that the tastes of the respondents, who were primarily 1960s baby-boomers more attuned to popular culture and multiculturalism than previous generations, are expressive of a *generational* shift towards omnivorousness (Turner and Edmunds, 2002, p. 236). As we have seen above, omnivorousness is a privileged disposition that is not available to all and so we might conclude that the tastes of this section of Australia's elite are, after all, both distinctive and distinguishing. However, we can see from this illuminating example that the ways in which cultural distinction plays out differs from place to place.

A further criticism of Bourdieu's work is that it is deterministic (Jenkins, 2002; Lamont, 1992). Nicholas Garnham and Raymond Williams (1980, p. 222) argue that there is a 'functionalist/determinist residue' in Bourdieu's work on social reproduction which runs contrary to the possibilities for change which are actually evident in his research. For example, as education is 'democratized', with increasing numbers of young people attending university, the qualifications are devalued thus exposing the contradictory claims made regarding the benefits of widening participation. So, the rewards that hitherto accompanied a particular qualification (for example, an undergraduate degree leading to a graduate-level job) no longer pertain. Whereas those in a dominant position in social space have the resources to anticipate this situation and can increase their investments in education through further study, enhancing their distinctiveness, those in a dominated position, already in debt and unable translate their degree into a job, might become increasingly disgruntled. If they mobilized collectively in response to this situation, they might turn to political

action and seek change. According to Garnham and Williams (1980), the room for social and political change in Bourdieu's model could be better accounted for if we distinguish, 'within the process of reproduction between "replication" and "reformation"'. Whereas the former draws attention to stasis in the system, the latter draws attention to the spaces that are opened up in social structures when changes occur and contradictions emerge. Garnham (1993) has since extended his critique, arguing that Bourdieu's model does not allow for major social change. If, as Bourdieu asserts, individuals are constrained by the social structures embodied in their habitus and proceed to misrecognize them as inevitable, what room is there for alternative world views to emerge? How is it possible, in Bourdieu's model, for agents to think outside of *doxa* if their practices are nothing but strategies in a symbolic power struggle which serve ultimately to reproduce the dominant order? Where, in short, are the opportunities for change? Here, Garnham possibly overemphasizes the extent of rigidity in Bourdieu's concept of habitus. First, the practices and representations generated by habitus are regulated *improvisations* within defined limits; the concept therefore suggests what is *likely*, not what is *inevitable* in an agent's response to a given situation. It is important to bear in mind Bourdieu's (1993a, p. 87) distinction between *habit*, which is repetitive and mechanical and *habitus*, which is 'something powerfully generative', adaptive and transformative, and leads us to 'reproduce the social conditions of our own production, in relatively unpredictable ways'. Second, there is only ever a near-perfect adjustment of habitus to social reality when past experiences, which inform the anticipation of present conditions, match them perfectly. Furthermore, this pre-reflective anticipation of present conditions based on the past does not always work and there is a *hysteresis effect* when the social reality that an individual confronts differs hugely from the one to which their habitus has been adjusted (Bourdieu, 1990a, p. 62). There are, then, in Bourdieu's model, moments of disruption and there is, therefore, room for change. So, habitus has considerable conceptual versatility even if, perhaps, as David Swartz (1997, p. 109) observes, this versatility 'sometimes renders ambiguous just what the concept actually designates empirically'.

Perhaps Garnham's (1993, p. 185) most important observation is that Bourdieu reduces social action to power struggles between competing interests. Let us consider, in greater detail, this criticism in relation to Bourdieu's work on taste. According to Antoine Hennion (2001, 2004, 2007), Bourdieu's model of taste reduces the act of tasting to a symbolic struggle. As a consequence, the taster is reduced to a mere

actor in a symbolic game and the object of taste is lost from sight altogether. Although Hennion does not always specifically mention Bourdieu in his writings, it is clear that he has little sympathy for Bourdieu's approach to taste. Hennion (2007) argues that much 'critical sociology' reduces our personal preferences and passions to strategies in wider social struggles. Our expressions of taste are merely markers of our class backgrounds, prompted by hidden social forces; our choices are mechanical, unconscious, the product of social determinants. In addition to this, cultural objects are mere tokens in a symbolic game in which we seek to gain prestige or status. Hennion (2001, 2004, 2007) offers an alternative approach to taste, arguing that tasting is an *active* process, a series of performances in which we express our attachments towards objects. In order to substantiate these claims, Hennion researches the ways in which *amateurs* perform taste. The term *amateur* is chosen:

> because it is more appropriate and general than 'enthusiast' or 'fan', but is less about 'expertise' than the word 'connoisseur'. It is used here in a wider sense than the negative English one, of amateur as 'non-professional', and it designates any lay-person engaged in a systematic activity, which makes them develop, in various degrees, their sensitivities or abilities in that domain (Hennion, 2007, p. 112).

In order to 'free up' and encourage amateurs to discuss this systematic activity of tasting in interviews, Hennion (2001) encourages them to de-sociologize their responses. This is necessary because many of the respondents anticipate the kinds of responses that they expect sociologists will want to hear regarding taste, class and social origin. Some, for example, apologize for being middle-class, or for favouring types of music which accord with their class backgrounds. Hennion (2001) seeks rather to encourage his respondents to discuss the pleasures and passions that they derive from their love of music; he tries to get them to open up and to explain what music means to them and to provide detail regarding the inventive practices and methods they deploy in order to maximize their listening or playing experience. For example, he seeks to ascertain how they listen to music and with whom they share their experiences (Hennion, 2001, p. 3). He encourages them to discuss the moments of intensity, the emotional states they experience when listening to or playing music; he gets them to trace the individual and collective practices that enable them to conjure moments of

sublimity (Hennion, 2001). One might wonder what would be the nature of the data acquired in the course of Hennion's research. Would it be awash with countless subjective experiences with little to connect them? According to Hennion (2001), representative practices emerged from the data, and so even when individuals, in describing their music listening rituals, think them to be bizarre or unique, they are often typical of the rituals performed by thousands of others.

Hennion's approach to taste has the virtue of exploring the specific methods and techniques deployed by amateurs in order to engage with cultural objects. This might include, for example, the ways in which music lovers prepare themselves for the concert-going experience by means of individual or collective rituals; they get themselves 'in the right frame of mind' to maximize their enjoyment of the performance. For wine lovers, such ritualistic preparation might start well in advance of tasting. The bottle will be left standing upright for ten hours; the wine will be decanted into a carafe and then, after a certain amount of time, poured carefully into glasses that have been chosen to accord with the colour of the wine and the grape variety. Tasting, as we can see from these examples, is an active, conscious process, and Hennion draws attention to the meticulous care and attention which the actors devote to the performance of tasting. Furthermore, Hennion's (2007, p. 104) approach to taste also keeps the cultural object in sight; it is attentive to *what* is tasted. The cultural object is present in performances of taste and isn't merely a status symbol or token; it is something to which amateurs turn in *perplexed* mode, sensitized to the affect it has on them and others. Tasting is very much an act of co-production between the subject and object: it necessitates a willingness of the subject to be receptive and to be swayed by the presence of the object. Attentive to the cultural object, amateurs can discuss the tasting experience with others and their opinions might change as a result of this interaction. In this approach to taste, the cultural object has *presence* and it cannot be reduced to the level of the symbolic. It suggests that if we are attentive, cultural objects will 'deliver themselves, unrobe themselves, impose themselves on us' (Hennion, 2007, pp. 105–106). Let us return to the example of wine-tasting: here taste is not given, but is something that results from the taster's taking time to stop, pause and reflect on the qualities of the wine. The object of taste, in this case the wine in the glass, responds to the attention that is directed towards it, and so it 'shifts, advances a notch, to deploy itself and deliver its *richesse*, involving a more marked contrast and a rising in its presence' (Hennion, 2001, p. 105). This is an intense moment of contact in

which the self shifts towards the object and the object shifts towards the self. Without this attention to the glass of wine there is no such intensity of contact, and the drinker merely consumes the liquid without reflection. With the level of intensity dependent on the co-production, 'beautiful things only offer themselves to those who offer themselves to beautiful things' (Hennion, 2007, p. 106). This co-production in relation to music can be understood by means of the hypothesis of the *conditioned performativity of music* (Hennion, 2001, p. 3). This is 'a rich and inventive practice that simultaneously recomposes music and its practitioners *in situ*, according to the needs and with the various mediums, resources, devices and ceremonials available'. Such methods and techniques deployed might include, for example, the preparation of a listening zone for the solitary individual or for the group, the lighting of candles, the careful selection of the playlist, the closing down of all means of communication, the cranking up of the speakers. Paradoxically, this attention to detail, this meticulously controlled planning is at least in part designed to engender a loss of control and a surrendering to moments of sublimity. This is an example of tasting as 'a passivity actively sought' (Hennion, 2007, p. 109). The object of taste is not merely a symbol, it is something that 'acts and moves, in relation to other mediations; it transforms those who take possession of it and do something else with it' (Hennion, 2001, p. 3). Music responds to those who train themselves to be receptive to it.

Discussion

What is undoubtedly significant in Hennion's sociology of taste is that he shines the light of research back on the *object* of taste and he makes the crucial point that the act of tasting cannot be reduced to strategies of cultural distinction. His research draws attention to the fact that *amateurs* have passions and enjoy constructing situations in which they can allow themselves to be transported, as it were, whether they are creating or consuming culture. Hennion's research enables us to examine the ways in which we go in pursuit of the sublime, even if we seek it in the secular and hope to find a glimpse of it in a bottle of wine or at a concert. However, while bearing in mind the value of Hennion's critical points regarding Bourdieu's sociology of taste, it is not easy to discount the bodily dispositions associated with the habitus and the resources at our disposal which determine in great part *why* it is that we are likely to express certain tastes, the *ways* in which we express our

taste and *what* this says about us. These are significant insights that Bourdieu's research has provided. Perhaps more so than any thinker before him, Bourdieu has taught us to understand why it is that we like what we like, and there is a danger that in stripping back the 'critical sociology' research element to instead rely heavily on first-hand accounts by amateurs of their engagements with various cultural objects, we might forego some of the key sociological insights into an understanding of 'the intimate realities of ourselves in connection with larger social realities' (Mills, 1959, p. 15). That said, I would suggest that the seemingly contrary views of Bourdieu and Hennion in relation to taste are not necessarily incompatible and that Bourdieu's insight regarding the social causes of our expressions of taste can be productively combined with Hennion's insights into taste as performance.

We need to look then at whether the cultural object can be reintroduced into the analysis of the act of tasting rather than being treated only as a symbol in a wider struggle for distinction. This involves a more rounded sociology of taste, one that is attentive to *what* is consumed as well as the ways in which it is consumed. If, as Hennion (2001, 2004, 2007) argues, the object of taste is not inert or passive, we need to research the act of tasting at the micro-level. We might also consider the object at a more macro-level in relation to changing taste hierarchies. An analysis of the symbolic power struggles over the value of culture does not tell us the whole story. As Austin Harrington (2004, p. 37) observes, contingent shifts of institutional favour, the conditions of the artistic field and changing fashions might go some way to explaining why J. S. Bach's music was almost forgotten soon after his death, but do not help to explain to us why his work was reappraised some years later to enter and remain pre-eminent to this day. It would seem strange to suggest that the music itself has had no role whatsoever to play in this process and that Bach's reputation is based entirely on arbitrary conditions. We also need to look at the importance of providing a greater degree of empirical detail regarding *how* we taste, with attention to the moment in which we taste and the various factors that impact on that moment. Swartz (1997, p. 113) aptly points out that we should consider other principles governing practices alongside those generated by habitus. This is an important observation because we sometimes see in Bourdieu's work on taste, perhaps as a consequence of his deployment of his preferred research method (surveys), *the austere aspect of sociology*, which, in its pursuit of calculable laws that determine our cultural practices and influence our tastes, mirrors processes of formal rationality and so overlooks some of the *human*

aspects of tasting, especially those which are on the borderline of meaningful social action and are not so causally linked to social origin. So, we might consider the various *affectual impulses* that underpin the act of tasting. For example, in everyday tasting situations, we might respond in a purely affectual way, and regardless of whether our social position is lofty or lowly, we might be emotionally moved by something we see, watch, hear or feel. *Affectual impulses* in tasting might jolt our judgement towards extreme poles of like and dislike depending on whether we are moved by feelings of empathy or anger. Such impulses might make themselves known in the physical manifestations of delight or disgust as we buzz with joy at hearing the combination of strings and horns in some music that seemingly accords with every fibre in our bodies, or, when we recoil in horror at the sound of something that we find abhorrent and seek to avoid much as we would step over something distasteful in a city street. As Ben Highmore (2010a, p. 124) points out, distaste 'is not simply disagreement: even in its mildest form it involves the wrinkling of noses, turning the head away, and so on. At its most extreme, distaste is revolt, physical nausea, vomiting, and retching'. Highmore's (2010b, p. 155) notion of social aesthetics is instructive here, as it examines 'the empirical world of sensation, affect, and perception'. However, aesthetic experiences are not always characterized by extreme, cathartic feelings such as distaste, disgust, joy, delight, hatred or anger. Our feelings might be more 'ordinary' and so we might be mildly pleased rather than delighted and mildly irritated rather than angered during the course of our interaction with a cultural object. Sianne Ngai's (2005, 2012) draws attention to the significance of trivial or 'minor' aesthetic categories and she argues that most of our expressions of taste are not necessarily made with conviction. So, we need to consider *the differing levels of intensity* experienced in the act of tasting. This includes the extent to which we express extreme feelings or convey strong emotions or convictions. After all, when faced with a cultural object to which we are relatively indifferent, we are not likely to not care whether or not our indifference is shared by others. There will be little motivation to *prove* its worth or otherwise, which we would be keen to do if we were impassioned. Instead, we will quite happily watch it be carried away on the conveyor belt of consumerism.

We also need to consider *contradictory impulses, feelings and emotions* that emerge from the act of tasting. When we approach cultural objects, we might find that our feelings are equivocal, characterized by a commingling of desire and repulsion, or less dramatically, mild

attraction and milder indifference. We might find conflicts with our political or ethical sensibilities. We might feel revulsion at the appeals made in seductive television commercials whilst at the same time another part of our body or brain declares itself willing to be seduced. We might be moved to laughter by the witty script of a film but co-existent with our mirth might be a sense of distaste towards the film's depiction of women. We also need to consider *contrary impulses* that can underpin the act of tasting. We do not always seek to elevate ourselves above others or to find opportunities to display cultural capital. Sometimes, we might just feel a need to turn against a particular current, whether it is the political culture of the day, the zeitgeist of the moment or, more humbly, the tastes of a family grouping. In a memorable instance of such contrariness, Elspeth Probyn (2000, p. 28) describes how she wilfully cultivated a taste for fried garlic in order to rebel against her parents' belief that fried food was low-class (and hence vulgar) and that garlic, from their perspective, was a foreign abomination. Probyn's example highlights the fact that although tastes are very much markers of family background and the national cultures in which we are immersed, they can change as one generation succeeds another. This is because, propelled by contrary impulses, we try, even if in vain, to assert a sense of our individuality in the face of impersonal social forces. We might, therefore, be forgiven for our recalcitrance in the face of the overwhelming social pressure to *like* something.

So, it is important to supplement our analysis with a more qualitative, close-up and engaged, empirical examination of the act of tasting which, as Hennion observes in relation to music, 'enables us to formulate a theory of passion', but also, perhaps, a theory of pleasure or a theory of repulsion as well as a theory of indifference, of feelings commingled, of revolt or of contrariness. With these affective impulses in mind, we might also consider the significance of *creative impulses* in producing and tasting cultural objects. Jenkins (2002) argues that Bourdieu does not account for cultural production *or* consumption 'which successfully challenges the boundaries or contents' of existing cultural categories. How can we account for the impulses that have over time undermined legitimate art, whether in the shock of Stravinsky's *Rite of Spring* or in the innovative energy of Elvis Presley's *Sun Sessions* (Jenkins, 2002, p. 136)? These impulses cannot be reduced to symbolic power struggles over resources in the cultural field and nor can the ways in which these creative works are appreciated and enjoyed by music lovers. So, moments of passion, sublimity, empathy or creativity that are present in the act of tasting can only be analysed

if in the process of research we step aside, for a moment, from the laws of causality that determine, to such a great extent, why we like what we like and probe deeper into the moment of tasting. In the next chapter, we will consider sociology's problematic relationship with questions of aesthetic value and the activity of evaluating culture.

5
Evaluating Culture

Introduction

Having probed into matters of taste, let us now consider the evaluation of culture. This chapter surveys a number of existing contributions to the debate concerned with sociology and aesthetic value and explores the difficult task of formulating an alternative approach. It argues that sociology can inform an approach that is attentive to *how* people evaluate, and can consider the dynamic interplay between the individual or group or community and the cultural object. Awareness of the socio-historical context in which our judgements are formulated exposes the myth of aesthetic universalism, and institutional approaches highlight the ways in which certain cultural objects are imbued with value. However, by paying attention solely to contextual factors, there is a danger that the cultural object disappears. Therefore, in surveying the field, this chapter calls for a more balanced approach that considers value in terms of context, one which combines reflexive awareness of the position from which judgement is formulated with a renewed attention to the cultural object and, importantly, the *dynamics of the evaluative moment*. Pierre Bourdieu suggests that we should value cultural objects that have emerged as a kind of 'historical quintessence' from the 'merciless clash of passions and selfish interests' that is played out in the field of cultural production (Bourdieu 1996[1992], p. xviii). This mode of analysis rescues the cultural object (and the ways in which we perceive it) from a false 'eternalization' and seeks to understand the social conditions of its genesis (Bourdieu, 1987). However, Bourdieu's argument, neat as it may be, views the evaluative process *at a distance*, as a series of struggles over legitimacy (see Chapters 3 and 4). Therefore, it is useful to '*zoom in*' on the evaluative

moment because the prickly matter of value-judgement is an everyday practice, an active practice, dependent on a number of dynamic contextual factors. It is important to find ways of theorizing our day-to-day interactions with cultural objects through which our judgements – individual and collective – are formulated, and through which we decide what is to be prized. As we have seen, Antoine Hennion's (2007) work on the performative aspect of taste is highly instructive in this respect; he argues that the 'taster' (whom he calls the amateur) actively deploys techniques and methods so as to engage with and become sensitive to cultural objects, which 'deliver themselves, unrobe themselves' in response to such techniques (Hennion, 2007, pp. 105–106). Coming from a somewhat different position, Janet Wolff's (2008) work is useful in finding ways to approach value after the loss of certainty associated with critiques of aesthetic universalism; her 'return to beauty' in relation to the cultural object is post-critical, aimed at those who 'got' the feminist critique of patriarchal representations, and she alludes to community-based modes of evaluation. Though the views of these theorists diverge in many respects, they have in common context-driven approaches to aesthetic value that nevertheless have the cultural object 'in sight'.

Sociology and aesthetic universalism

Questions of value *matter*. After all, as John Fekete observes, 'we live, breath, and excrete values. No aspect of human life is unrelated to values, valuations, and validations' (Fekete, 1988, p. i). Art-gallery owners continue to make value-judgments; art-critics, journalists and cultural commentators continue to construct taste hierarchies, as do consumers of cultural objects. In addition to this, there is the 'judgement' of exchange value by means of which objects are ranked in accordance with the logic of profit, as commodities in relation to other commodities. One of the most useful contributions of sociology to an understanding of aesthetic value in recent decades has been made by Bourdieu (1984[1979]) (see Chapters 3 and 4). He challenges assumptions regarding the innate nature of taste, and has offered a sustained critique of aesthetic universalism, the notion that there can be any kind of 'pure' or transcendental use of sensibility open to everyone. Immanuel Kant's (2005[1790]) *Critique of Judgement* has been hugely influential in putting forward the argument that aesthetic judgments (as opposed to purely corporeal tastes such as preference for certain foods or wines) are formulated as a result of disinterested reflection. It

is possible, he argues, for such judgements to lay claim to universality. However, according to Bourdieu (2000[1997], p. 73) aesthetic universalism is a scholastic fallacy, and access to aesthetic pleasure is based on two key conditions: the first is the historical emergence of an autonomous field of cultural production that adheres to its own internal laws (such as 'art for art's sake'); the second is the ability of some to occupy positions in social space that enable them to develop the aesthetic disposition, the ability from an early age to 'consider in and for themselves, as form rather than function, not only the works designated for such apprehension ... but everything in the world' (Bourdieu, 1984, p. 3). As we saw in the last chapter, the ability to take up this position is not universally available. Those familiar with the aesthetic disposition will have been surrounded by 'legitimate' culture from an early age, so much so that the way they walk, talk and eat will bear the hallmarks of legitimacy, and the ability to discern that which is culturally prestigious is handed down from generation to generation as a form of inheritance. Bourdieu therefore problematizes the 'purity' of the aesthetic disposition, the notion of the gifted, charismatic individual able to enjoy an unmediated relationship with 'great art'. The 'pure gaze', whereby the 'talented' individual is able to spontaneously identify the inner logic of beauty, is shown to be the product of schooling. As Bourdieu (1984, p. 433) observes, 'the eye is a product of history reproduced by education'. In effect, Bourdieu's work highlights the weakness of context-less approaches to aesthetic value. However, as we have seen in Chapter 4, Hennion (2001, 2007) argues that Bourdieu's approach to culture has over-sociologized our understanding of aesthetics and matters of taste. He has made us attribute what we like to our family backgrounds, as though our cultural preferences are merely symbolic activities, games that we play as part of wider struggles in order to achieve societal status. We put ourselves in socio-economic categories in order to explain our preferences and therefore keep veiled our really deep seated pleasures and ways of appreciating and evaluating things. In this reading of Bourdieu, the cultural object is little more than a token in a wider symbolic game.

Context

Moving away from the notion of value inhering in cultural objects, George Dickie (1974) argues that works of art are distinguishable from other objects by the sole fact that they have had the status of art-object conferred on them by an institution. In Howard Becker's (1982, p. xi)

work on art-worlds he proclaims that his approach is 'social organiza-
tional, not aesthetic', and invites us to '[t]hink of all the activities that
must be carried out for any work of art to appear as it finally does'
(1982, p. 2). Similarly, Bourdieu's (1987) work on the field of cultural
production situates cultural institutions within their socio-historical
contexts. The field of cultural production, according to Bourdieu, is
characterized by struggle, and this struggle is not just something that
occurs between rival artists but one that involves 'all who have ties
with art, who live for art and, to varying degrees, from it' (Bourdieu
1987, p. 205). This means that those clamouring to ascend where
others have failed include managers, gallery owners, critics, middle-
people of various sorts and those making the tea. Therefore, glory does
not necessarily descend on those best able to conjure verses, put
together installation art or pluck the strings of their instruments: it
goes to those best positioned in the field to accrue value. This prob-
lematizes the notion of unilinear 'progress' in cultural movements,
highlighting that such movements emerge out of the historical condi-
tions of the field.

Institutional approaches have been highly influential in the socio-
logy of culture (and the subfield the sociology of art) in recent decades,
particularly in the United States of America where the field of the soci-
ology of culture constitutes one of the largest sections of the American
Sociological Association. As Wolff suggests, 'the rise and decline (and
possible revival) of a particular aesthetic has everything to do with
institutional practices and social relations' (Wolff, 1999). However,
there are serious weaknesses in some of the recent research in this field,
which adopts a 'precritical, sometimes positivistic' stance in relation to
method (Wolff, 2005, p. 92). Taking as its object of enquiry a cultural
institution such as an opera-company or an art gallery, such research
seeks to ascertain the social hierarchies of the institutional structures
and the decision-making processes that take place. Attention is also
paid to audiences, but, alas, in such work, 'the complex analysis of cul-
tural taste ... takes second place to the enthusiasm for surveys,
number-crunching, and what C. Wright Mills once denounced as
"abstracted empiricism"' (Wolff, 2005, p. 92). This form of cultural
analysis, according to Wolff, avoids any engagement with questions of
aesthetic value and, more seriously, carries out its institutional analysis
in a void, detaching the institution from its social and historical
context, thus making it both 'ahistorical and unsociological' (Wolff,
2005, p. 92). A consequence of focusing on context alone, reducing
everything to institutional conditions, is that the cultural object is

likely to disappear from the analysis thus eliminating any possibility of aesthetic evaluation. It becomes, therefore, impossible to compare one cultural object with another, to provide a reasoned argument regarding whether something is good or bad, striking or dull.

Disciplinary fears and tensions

In addition to the above-mentioned critiques of aesthetic universalism, there are a number of reasons why discussions of aesthetic value have proved difficult in sociology and related disciplines. A number of 'anti-monolithic theories' such as post-structuralism, postmodernism, post-colonialism, critical theory and psychoanalysis have whittled away the authority of what Jean-Francois Lyotard (1984) terms 'meta-narratives', overarching theories that are seemingly able to provide an explanation for *everything*. Such 'anti-monolithic theories' have led to a healthy questioning of what was considered to represent the highest values: the classical music canon, the literary canon, for example. Maybe the works that were in these canons weren't immortal after all, and as a consequence of this 'relativizing' there are a number of reasons why sociologists have subsequently struggled to make value-judgements of a normative kind. The first, I'd suggest, is *fear of elitism*, which is under-standable when one considers that many prominent sociological approaches to culture have sought to expose the ways in which presti-gious cultural forms are given legitimacy by dominant societal institu-tions. Therefore, to engage in normative value judgement is to possibly reinforce the kinds of hierarchies that sociology has long sought to dismantle. The dismantling of hierarchies has challenged assumptions within academia that had hitherto prevailed, namely that the only cultural artefacts worthy of study are those emanating with transhistorical force from the field of 'high' culture. A further consequence of the success of 'anti-monolithic theories' has been that scholars are often reticent to 're-engage' with 'legitimate' culture, with cultural objects imbued with institutional prestige and status: to do so would signal a return to a more 'bourgeois', reactionary form of cul-tural analysis.

Related to the fear of elitism is *inversion,* whereby sociologists and scholars from related disciplines (particularly in cultural studies), fearful of being 'bourgeois', avoid analysis of prestigious cultural forms and practices from the higher reaches of the various 'canons' and focus almost entirely on popular artefacts and popular cultural practices. Such lopsided attention means that all too often, only one region of culture

is explored, namely 'the popular', and therefore any sociological appraisal of aesthetic value is restricted to one area alone as scholars seek to stay aligned with the politicized project of redeeming previously disparaged cultural forms, forms that are supposedly aligned with subjugated social groups. This leads to a skewed form of cultural analysis that only focuses on a limited range of cultural objects, namely those traditionally from the 'lower' reaches of established taste hierarchies. A related reason is *bedazzlement*, where sociologists are caught in the headlights of the contemporary academic conditions, entranced by the postmodern logic of relativism, fearful that making a move towards the evaluative will make them vulnerable to criticism. They apprehensively contemplate a world of culture that has been liquidized to the point that, as Zygmunt Bauman (1992, p. 8) observes, 'the sharp edge of critique goes through it with nothing to stop it'. The result is a sociology that reflects and mimics the confusion, the uncertainty and the opaqueness of the cultural conditions which it seeks to understand.

These disciplinary tensions must be understood within the wider institutional context of the academy, and can be observed in the widely documented disputes between scholars working in sociology and in cultural studies. David Inglis (2007) describes sociology and cultural studies as 'warring twins', likening them to Tweedledum and Tweedledee, and as McLennan (2002, p. 632) suggests, each discipline strengthens its 'boundaries' by stating quite categorically what it is not, and 'they "agree to have a battle", because the battle brings certain gains in identity for them both' (Inglis, 2007, p. 118). Cultural studies foregrounds popular culture (Fiske 1989), and has 'rescued' previously disparaged cultural forms (Radway, 1991; Medhurst, 2007), thus proving that such artefacts are worthy of study, whether because of their intrinsic value or because of what they reveal about the wider societal practices of production and consumption in which they are embedded. According to many sociologists, however, this 'rescuing' seems to have led to a situation whereby the world is studied merely as a series of popular texts. The much trumpeted political activism of cultural studies is seen by such scholars as little more than 'semiotic guerrilla warfare': we are counter-hegemonic in our living rooms and on our sofas as we deconstruct television shows, armed with what John Fiske (1987, p. 316) terms 'popular cultural capital'. For example, Chris Rojek and Bryan Turner (2000) are dismissive of Fiske's (1989) reading of 'the youths that hang around shopping malls as "urban guerrillas"' (Rojek and Turner, 2000, p. 637), and they argue that much of the work emerging from the 'cultural turn' is ahistorical and obsessed with

the contemporary. Regarding the absence of cultural studies in France, Nathalie Heinich (2010, p. 259) says '[t]hank god'.

McLennan (2002, p. 632) suggests that for many cultural studies scholars, sociology is viewed as an 'outdated modernist and functionalist monologue', one that marginalizes the 'cultural' and neglects the significance of ideology. Sociology 'is presented as the quintessence of conservatism, narrowness and backward-looking reaction' (Inglis, 2007, p. 106). Criticisms of sociological approaches to culture have also come from 'within' the discipline. For example, Rojek and Turner (2000) have been critical of the tendency in sociology – since the 'cultural turn' – to practice what they term 'decorative sociology'. This is driven by a tendency towards theoreticism, one that replaces a history of human interaction with a history of theoretical perspectives and places an exploration of intertextuality over historical and comparative analysis. The reading of life as though it is made up of a series of texts is accompanied by theoretical jousting and endless, futile terminological disputes that serve to perpetuate a 'commitment to relativism' (Rojek and Turner, 2000, p. 639).

Reflexivity and scholarly positioning

So, approaches that focus on context alone (particularly in institutional approaches grounded in sociology) have a tendency to lose sight of the actual cultural object; excessive attention to the 'popular' (particularly in cultural studies) means that the *range* of cultural objects is overlooked; and the theoretical jousting that characterizes 'decorative sociology' perpetuates relativism. However, David Inglis (2007) finds that sociology and cultural studies actually have much in common. Significantly, they share the same epistemological dispositions, the same 'dogma' that all forms of reality are social fabrications, cultural constructions. Both disciplines follow a post-Kantian line of enquiry, abandoning Kant's belief in noumenal perception (essence beyond human perception) and focusing on phenomenal perception, seeing the world as a series of phenomena, each group perceiving the world through its own cultural lenses (Inglis 2007, p. 117). This awareness of epistemological positioning opens up evaluative possibilities. According to Inglis, the function of much sociology of the arts has been to bring art 'down to earth', to strip it of its wondrous inexplicability (Inglis, 2005). This has been done, for example, by explaining the social, economic and cultural conditions that have created 'geniuses'. However, sociologists are often reluctant to apply the same

type of critique to their own position which resides seemingly 'above' the cultural conditions that they seek to explain. Inglis calls for a 'reflexive turn' (2005, p. 109), arguing that if sociologists perform the same kind of analysis on themselves as they have performed on art they 'will become more sensitive and appreciative of other modes of perception and other means of knowing'.

Reflexive awareness of scholarly positioning might therefore open up evaluative possibilities grounded in sociology, and not just those that bring art 'down to earth'. Pierre Bourdieu's work on the scholastic point of view offers a useful example of such reflexivity. Bourdieu (2000) argues there is a tendency for scholars to detach themselves from the phenomena that they are studying, but to refrain from subjecting the presuppositions inherent in their own position as scholars to the same detached scrutiny. To practice this kind of structural reflexivity requires what Bourdieu terms the objectification of the act of objectification, 'one that dispossesses the knowing subject of the privilege it normally grants itself' (2000, p. 10). This is not easy because entry into an academic way of thinking is something that takes place insensibly, something that is the result of years of schooling and the imperceptible conversion of the scholar's habitus so that it meets the requirements of 'the game'. Entry to 'the game' requires not only the relevant qualifications but also a sense of what is important and what is at stake in the particular academic field, and the scholar's immersion in the field of sociology, for example, will inevitably lead to her/him adopting certain positions in relation to cultural phenomena, hence Inglis' observation that 'examined sociologically, the sociology of art's ways of construing the nature of artistic matters, are themselves revealed as products of history and social contingency' (2005, pp. 107–108).

Opening up evaluative possibilities

If aesthetic value-judgements need to be contextualized by socio-historical considerations and scholarly positioning, what room does this leave for the evaluation of cultural objects? Let us look at some key contributions to the debate that open the way to alternative evaluative approaches. Austin Harrington (2004, p. 5) argues that 'value-judgements about works of art can have intersubjectively generalizable defensibility', and it is to Harrington's work that we now turn. Harrington (2004) argues that social theory should mediate between value-distanciation and value-affirmation. His advocacy of value-distanciation

is based on a qualified adherence to Max Weber's (2011[1917]) notion of value-freedom in the social sciences. For Weber, social scientists, as far as they are able, should try to carry out the difficult task of excluding value-judgements from their observations. The social scientist 'should keep unconditionally separate the establishment of empirical facts ... and *his* own practical evaluations' (Weber, 2011, p. 11). Harrington argues that value-distanciation has a role to play in evaluating aesthetic forms, and yet alone it is insufficient. Therefore, he highlights the significance of value-affirmative approaches, which have their roots in what he loosely terms 'liberal-humanistic' art scholarship. Drawing inspiration from antiquity and the European Enlightenment, scholars working in this tradition argue that art plays an essential role in providing society with its educational impetus and spiritual nourishment. Certain artistic works that have 'stood the test of time' (often created by those termed 'geniuses') have come to speak for universal values of society. It is with confidence that such scholars will speak of the universality of 'great works'. Only a tiny percentage of cultural artefacts are esteemed in this manner, and the history of various cultural forms is often depicted as one of progression, a patriarchal lineage stretching back to the 'founding fathers'. This perspective is limited, not least because advocates of such a normative approach to aesthetics tend 'not to consider ways in which the prestigious value it awards to certain cultural objects relates to conditions of power and hegemony in society' (Harrington, 2004, p. 41). Nor do the claims for the disinterestedness of aesthetic contemplation take into consideration the ulterior motivations that might lead people to consume various art-forms. This notwithstanding, it is still possible, in fact desirable, to look for aesthetic value in artistic forms, and 'while the normative thesis of aesthetic autonomy needs to be *contextualized* by sociohistorical and sociological considerations, it is not *refuted* by these considerations' (Harrington, 2004, p. 101). Sociological analysis should be capable of recognizing the utility of social scientific scholarly detachment and the need for normative aesthetic evaluation. Harrington argues that 'social theory needs to mediate between these two standpoints of investigation and seek ways of resolving the antinomy' (Harrington, 2004, p. 111). Why does the antinomy need to be resolved? Well, if it isn't possible to form any rational judgement so as to distinguish one cultural object from another, it would not be possible for academics to assess students' work, for publishers to assess the relative merits of the literature submitted to them, for galleries to choose the work of one artist over another, for music colleges to award

qualifications to their students. Of course, it should be noted that in all of the examples cited above, the institutional decision-making processes are influenced by a range of extra-aesthetic considerations, situated as they are within certain socio-historical and economic conditions.

While assertions of hierarchies across 'high' and 'low' culture are no longer defensible, it is still possible to argue the case that one play is better than another, that one song is better than another, or that one painting is better than another. In order to make this move, Harrington's distinction between *categories of cultural production* and the qualities and merits of *individual objects* of cultural production is useful (2004, p. 106). Whereas it is no longer defensible to compare one category of cultural production with another (comparing, for example, cinema with theatre) it is possible to compare one particular cultural artefact with another (comparing, for example, the Ealing Studios version of *The Ladykillers* with the more recent Coen Brothers interpretation). Harrington thus finds room for some kind of normative aesthetic evaluation of cultural forms and his motivation for doing so is clearly to avoid the ultimate irrationality of cultural equivalence or cultural relativism:

> We may conclude that value equality in respect of *categories* of cultural production does not entail value equality in respect of individual *object members* of these categories. If it were not possible to discriminate differences of aesthetic value in individual cultural objects, there would be no rational basis for aesthetic judgement. If no individual cultural object could be judged as being higher or lower in aesthetic value than another, there would be no basis for use of positive predicates in ordinary language such as 'elegant', 'brilliant', 'inspiring', in distinction to the negative predicates such as 'mediocre', 'dull', 'average'. It would follow from this that any person could produce any object which no other person could criticise, or even praise (Harrington, 2004, p. 108).

The ability to distinguish between individual objects of cultural production provides a further means of strengthening evaluative approaches. He is taking a cue from Stuart Hall and Paddy Whannel's (1964) assertion that it is not worth comparing different forms of cultural production to one another because they each operate according to their own standards. It is futile to compare Cole Porter to Beethoven, because Porter was not attempting to make music that is

comparable to Beethoven's. One has to 'recognize different aims and to assess various achievements with defined limits' (Hall and Whannel, 1964, p. 38). The comparative model put forward by Hall and Whannel and later by Harrington, opens up evaluative possibilities, but needs to be further developed. In Harrington's 'blueprint' for such analysis, he doesn't explicitly refer to the criteria which one could utilize in making such cultural comparisons. Although he is correct regarding value equality in respect of *categories* of cultural production, he fails to observe that the dividing lines between such categories are often blurred. To take an obvious example, some of Shakespeare's most famous drama is treated as poetry and compared to other poetry. Nevertheless, Harrington's work paves the way for renewed attention to cultural objects and for contextualized modes of evaluation.

Regarding the specific qualities of the cultural object, Janet Wolff's (2008) work can be seen as representative of a growing (and important) trend in the sociology of culture (and sociology of the arts) of scholars returning to aesthetics (for example, see De La Fuente, 2007, 2008; Highmore, 2010b), to an evaluation of the cultural object, and even returning to 'beauty' (Hickey, 1993). Wolff addresses questions of value in a discussion of her work as a curator for an exhibition of the paintings of Kathleen McEnery, an artist and salonniere in Rochester, United States in the 1920s. Her 'discovery' of McEnery's realist paintings was part of a wider feminist project, one that sought to rescue the work of women who had been marginalized by a hegemonic, patriarchal modernist aesthetic, and yet her curatorship of the exhibition threw up a rather fundamental question that begged to be answered: is McEnery's work 'good' (Wolff, 2008, p. 27)? In a similar vein, Wolff (2008), in an essay on post-Holocaust art, seeks to ascertain whether her long-time preference for abstract or allusive art over excessively literal work is just a personal preference, or whether it can be explained by means of aesthetic evaluation. In formulating her answers ('yes' to McEnery, for example), she found herself borrowing from other disciplines in order to complement her understanding of the socio-historical conditions under which such cultural objects gained prominence.

Having spent years researching the social production of the aesthetic, Wolff (2008) seeks, in parallel, to pursue criteria for aesthetic judgement. Such criteria might involve attention to form, content and subjective response, and more contentiously, a reconsideration of beauty. She attempts to go beyond the feminist argument epitomized by Laura Mulvey (1975) in the 1970s that beauty must be destroyed. This feminist 'anti-aesthetic' was based on the argument that the

concept of 'beauty' is one which serves to perpetuate the interests and institutions of patriarchy, reinforcing the subordination of female subjects in wider society. Wolff does not reject Mulvey's stance, but rather appeals to those who 'got the point' of the anti-aesthetic, and are now, perhaps, in a position to reconsider the politics of representation (Wolff, 2008, p. 71). According to Wolff, this means 'rethinking the assumption that political art is obliged to disrupt aesthetic pleasure' (Wolff, 2008, p. 17).

In recent years, art scholars have made a case for a return to beauty (see, for example, Hickey, 1993), arguing that 'beauty' has been treated with suspicion not only because of gender politics but also because of its association with art dealers and the wider commodification of art. Dave Hickey (1993) and others have sought to draw attention to the need for a return to beauty, arguing that beauty need not be antithetical to critical or political projects. However, the 'return to beauty' has also been championed by more conservative art critics and scholars who have used it as a means of returning to discredited notions of universal values and pre-critical aesthetics (Wolff, 2008, p. 18). In contrast, Wolff argues that that there *is* a place for beauty as part of post-critical aesthetics, an aesthetic stance that takes as its starting point the anti-aesthetic, but seeks nevertheless to find a way to evaluate artistic works. She asserts that beauty can be appreciated even in the contentious area of post-Holocaust art, and she articulates a preference for work in this 'genre' that is 'allusive and indirect, realist but not literal, perhaps semi-abstract while avoiding total abstraction', and for work 'that also gives visual pleasure and manifests its own particular beauty' (Wolff, 2008, p. 72).

Aesthetic evaluation cannot be taken out of the precise moment in which it is formulated; aesthetic contemplation is never disinterested or entirely separable from the socio-historical context within which it takes place. Looking again at Wolff's discussion of McEnery's paintings, her evaluation of such work is difficult to separate from her commitment to feminist politics, which is, in turn, difficult to disentangle from her role as a sociologist and the social and historical context and artistic/institutional environment within which she was operating when given the opportunity to curate the exhibition. Wolff admits to leaving aside questions of how exactly beauty is defined, focusing instead on a defence of the return to beauty as a post-critical move (Wolff, 2008, p. 29). However, she does suggest that the criteria she deploys in making such judgements are borrowed from older, normative approaches to aesthetic value. Although the latter have their own

social and political histories, they are nevertheless 'in play at every stage in curatorial and critical decision making and … retain the strength of their discursive structures against the crude interventions of interest-based judgements' (Wolff, 2008, p. 27). In deploying these evaluative criteria, it does not matter if they are motivated by personal or social interests; Wolff's (2008, p. 50) argument is that 'the important project is to make transparent the grounds for judgement'. This is therefore a 'principled aesthetics', one that takes epistemological uncertainty as its starting point: In the face of uncertainty, it is nevertheless possible to achieve consensus regarding questions of value if we are able to locate value in the context of communities, aware of the complex relation between our judgements and social structures. This is, therefore

> a model that engages with the canon in terms of the very specific operations of communities and social groups whose choices and values find expression in the negotiation and production of such aesthetic hierarchies (Wolff, 2008, p. 26).

Quite how this community model would work is not made explicitly clear, but it is an intriguing starting point for further exploration. How would such inter-subjective judgments be formulated? Certainly, it goes against sociological thinking to assume that it is possible to 'make transparent the grounds for judgment', and there is a danger in this 'return to beauty' that we end up awash with the subjective opinions of various thinkers informing us of their personal preferences. Would this community model be based on an advocatory approach, one that involves evaluative judgments that are promulgated and contested? Would such evaluation can take place in microcosmic contexts, perhaps in social settings far more modest and less grand than the relatively autonomous fields of cultural production which 'generate' judgements over time? These questions need to be addressed, though some useful pointers can be found in Denise D. Bielby and William T. Bielby's (2004) empirical research which situates aesthetic evaluation within the context of fan communities. In their research on audience aesthetics and popular culture, they find that because the role of professional critic has not been institutionalized within the genre of soap operas, audiences 'directly engage industry producers about issues of quality' (Bielby and Bielby, 2004, p. 302); they evaluate the successfulness (or otherwise) of plot and narrative developments, and consider the extent to which they are unnaturally contrived or spuriously

introduced. A related example of empirical research can be found in Annemarie Kersten and Denise D. Bielby's (2012) study of the aesthetic criteria deployed by film critics in a globalizing era in which film production is increasingly commercialized and digitized. In both pieces of research, evaluative discourse is publicly expressed, whether in the letters pages of magazines, in the review sections of broadsheet newspapers, or in the more fluid, open-ended conversations found on Internet forums. It is, therefore, readily observable and ripe for empirical investigation (Bielby and Bielby, 2004, pp. 310–311). These microcommunities, whether made up of soap opera fans or film critics, have in common a shared understanding of the aesthetic codes and conventions associated with the cultural objects that they are evaluating.

Bourdieu's notion of 'historical quintessence' avoids specific attention to formal qualities of the cultural object altogether. It does, however, provide a means of evaluating objects that have emerged from the field of cultural production. With all its imperfections, relations of domination and struggles for legitimacy, the cultural field has a delicate logic of its own and as Bourdieu (2003, p. 71) observes, it has been carved out of centuries of struggle. It took painters 'nearly five centuries to achieve the conditions that made a Picasso possible', and there is 'a sort of historical quintessence, that is, the product of a long and slow work of historical alchemy which accompanies the process of autonomization of the fields of cultural production' (Bourdieu, 1996, p. 139). This autonomization has only been possible as a result of struggle that has enabled the artists or writers – the agents in the field – to free themselves from the burdens of seeking feudal patronage and in the contemporary era, to be as independent as possible from the logic of the neo-liberal market. The latter poses an acute threat, and Bourdieu (2003, p. 67) argues that 'the hard-won independence of cultural production and circulation from the necessities of the economy is being threatened, in its very principle, by the intrusion of commercial logic at every stage of the production and circulation of cultural goods'. The position of autonomous cultural producers is increasingly uncertain, and left to fend for themselves in a free-market economy, they increasingly find it difficult to secure funding or means of distribution. There is a danger that the autonomy of the field will regress to heteronomy (Bourdieu, 1996, p. 367). The position of cultural innovators (such as avant-garde film-makers) has never been so vulnerable, and yet in the face of the threat of extinction, their contributions have 'never been so rare, useful, and precious' (Bourdieu, 2003, p. 81). And so, rather bizarrely, the most 'formal' producers of culture find themselves 'often unwittingly, at the

forefront of the struggle for the defence of the highest values of humanity. By defending their singularity, they are defending the most universal values of all' (Bourdieu, 2003, p. 81).

What Bourdieu's notion of a historical quintessence offers is a more mundane and grounded sociological means of evaluating the achievements of the works of the 'great artists' or indeed of any cultural producers. For example, and as mentioned, Bourdieu makes it clear that Picasso didn't come from nowhere: his 'genius' was only possible because of the historical conditions of the artistic field which he entered and negotiated. Nevertheless, such achievements are to be highly prized, and Bourdieu's notion of historical quintessence is the closest he gets to affirming normative aesthetic judgement. Therefore, his contribution is 'to offer a vision more true and, ultimately, more reassuring, because less superhuman, of the highest achievements of the human enterprise' (Bourdieu, 1996, p. xviii). Bourdieu's approach enables us to situate debates about value within a socio-historical context, a key element that was missing from much of the pre-critical normative work on aesthetic value. However, it contains within it an intriguing paradox: on the one hand, Bourdieu affirms that the field of cultural production is one which serves to reproduce symbolic domination and to legitimize social inequalities, and on the other hand, this very same field of cultural production is something that should be cherished and protected because what emerges from the 'often merciless clash of passions and selfish interests' is 'the sublimated essence of the universal' (Bourdieu, 1996, p. xviii). In making this move, Bourdieu has been accused of functional sociological analysis, and his assessment of value-generation has been seen by some as the outcome of a Hobbesian power-struggle which favours the dominant. According to Jeremy Lane (2005), for example, Bourdieu ends up valuing precisely the artistic output that was already valued in liberal-humanistic scholarship. However, Bourdieu's delineation of the field of cultural production and his notion of the historical 'quintessence' is an attempt to explain sociologically how and why certain cultural forms have become celebrated over the years. His model seeks not only to trace the genesis of cultural objects, but seeks to find a way of valuing (and defending) that which has emerged from within the field. Far from leading to relativism, Bourdieu's field-analysis 'rescues' cultural objects (as well as our ways of perceiving them) from an 'eternalization' that sees them as existing outside of history. This enables us to understand cultural objects in the light of the social conditions of their genesis (Bourdieu, 1987, p. 207).

The dynamics of the evaluative moment

As can be seen from the above, in rescuing 'valued' cultural objects, Bourdieu looks at aesthetic value *from afar*, as part of a wider historical process. In order to gain closer proximity to matters of evaluation, I'd suggest that it is important to work towards an approach that is more detailed, perhaps *even less* superhuman than Bourdieu's approach; such an approach should be able to *zoom in* on aesthetic evaluation as a quotidian activity and not something confined to the games and power dynamics of the cultural field. As already established, the judgements that we make and the modes of perception we deploy need to be contextualized and historicized. In addition to this, a detailed consideration of the specific ways in which we approach matters of aesthetic value is required, and this means paying close attention to the *dynamics of the evaluative moment*. The precise moment – or passage of time within which the evaluation takes place – will be the starting point of analysis, and there are various dynamics that affect this moment. One is *the presence of other people and the influence that they bear*. Our evaluation of a cultural object is often something that is at least in part a result of dialogue with peers as well as with wider societal forces, and our judgment will be influenced by the presence of others. This model of evaluative judgment would have to consider that opinions are passed from wife to husband, from partner to partner, from father to son, from friend to friend and from stranger to stranger; aesthetic judgments are formed inter-subjectively as much as individually. Of course, we cannot consider the influence of others without considering power dynamics and the fact that our evaluations will be, at least in some way, affected by social currents that hold sway, or by the dynamics of the group in which we are situated. For Georg Simmel (1950[1902], p. 145), for example, the arrival of a third person on the scene will profoundly alter the social interaction between two people and the group formation will occur in ways that are not possible in a dyadic relationship. It might be the case that the third person mediates between the other two; it might be that s/he gains advantage by taking the side of one or the other in a quarrel or discussion between two parties; it might be that the third person actively creates conflict between two parties so as to gain a dominant position in the interaction (Simmel, 1950, p. 162). If we apply this to cultural evaluation, we can see that the number of other people with us at the precise moment of evaluation will have a significant bearing on the outcome. It might mean, on the one hand, that we are able to formulate some kind of co-

authored inter-subjective judgement of a cultural object, or, on the other, that our evaluations diverge, that we take sides, that differences emerge out of the conflict of opinions, that we find ourselves in the minority or majority, in the weaker or the stronger party.

Thinking about evaluation along these lines will enable us to consider 'the emergence and development of shared discourses of value in the context of community' (Wolff, 2008, p. 23). However, communities or aggregations of people are made up of individuals with varying levels of socially valued cultural competence (Bourdieu, 1984). Those with high levels of cultural and educational capital at their disposal are more likely than most other social groupings to have their evaluations legitimized. In addition to this, they are well-positioned to confer legitimacy on a cultural object. With this in mind, Stephanie Lawler's (2005, p. 442) notion of classed relationality can be fruitfully applied to matters of evaluation. According to Lawler, the aesthetic stance adopted by the middle-classes is defined in relation to a negative reference point: working class taste, which is, in its least prestigious region, considered to be a no-go area, the constitutive limit of taste (Skeggs, 2004, p. 172). Lawler (2005, pp. 441–442) argues that 'in a sense, it matters little what working-class people actually do since their role is to act as a foil'. Prestigious social groups give themselves value in relation to a valueless other; in contrast to their taste, 'an assumed ignorance and immorality is read off from an aesthetic which is constituted as faulty' (Lawler, 2005, p. 437). If Lawler is right, research attentive to a dynamic concerned with the presence of other people is likely to find struggles for distinction as much as instances of co-authorship. We might also consider the dynamics of crowds. The rapt enthusiasm of the theatre crowd of which we are one member will have an impact on our individual engagement with the drama to which we are exposed; this enthusiasm might enhance our appreciation or it might – if in conflict with our mood – set us at odds with the majority. In 2011, when the entire theatre spontaneously joined in with *Va' pensiero* at a performance of Verdi's *Nabucco,* conducted by Riccardo Muti, in protest at the reduction of cultural funding in Italy, the emotional intensity brought about by the audience's response shifted their orientation towards the cultural object. To be part of a crowd, one that is listening with rapt attention to a performance, might draw us closer to the cultural object, and the emotional intensity that can come with being part of this crowd is likely to make us respond in ways that we wouldn't if alone.

A second (and related) dynamic is *the pressure to stand out and to fit in.* In expressing opinions in relation to aesthetic matters, we are acutely

aware of being judged by others. So, we might feel a sense of comfort in making judgements that accord with the prevailing consensus and the opinions of those around us. This socialistic adaptation brings us closer to other people and also relieves us of the need to come to conclusions of our own. It also circumvents the anxieties associated with having attention drawn to us for putting forward opinions that differ from those commonly held. So, in a group situation, when contemplating an art installation or some spoken-word poetry, we might be forgiven for allowing ourselves to be carried away on the current of consensus, especially if we do not feel too strongly about the cultural object in question. On the other hand, so that we do not feel ourselves to be mindless dupes of the undifferentiated crowd, we might feel the urge to step apart from the group and make a potent statement that conveys our feelings in relation to a cultural object. We might use this self-assertion in order to distinguish ourselves from others and to accentuate our personality. We might in great part define ourselves by our ability to judge: the extent to which we are discerning, knowing and discriminating in relation to aesthetic matters. How can we reconcile these contradictory tendencies – the desires to fit in and to stand out in formulating evaluative judgements? It is impossible to do so with any sense of finality, though according to Simmel (1971[1904], p. 323) these tendencies can be assuaged by fashion. He argued that fashion 'releases the individual of all responsibility – ethical and aesthetic' but also provides the chance, within these limits to express 'individual accentuation and original shading'. Fashion remains concerned with the externals of life and therefore it leaves untouched the very core of our being and our more fundamental beliefs. However, in our modern culture, which increasingly turns to the present, and where 'the great, permanent, unquestionable convictions are continually losing strength', fashion plays an increasingly significant role. The ability to change one's opinions and to adapt to new trends becomes more important than to identify the durability or the 'greatness' of a cultural object. Where fashion holds sway, what is considered to be distinctive or desirable changes swiftly, and fashions go to their doom as soon as they spread. As Bauman (2010, p. 63) points out, fashion in the twenty-first century, driven by consumer markets, 'acquires more and more impetus and ability to accelerate as the volume of its material, tangible impact, and the number of objects it affects, rises'. Where the influence of fashion spreads to the evaluative moment, opinions are likely to change quickly. So researchers will need to ascertain the extent to which we are unburdened of the *heaviness* of conviction and

certainty in relation to aesthetic matters; they might also consider the frequency with which our cultural preferences are cast aside and replaced. With a keen eye, they might ascertain the extent to which our evaluative stances are characterized by *lightness* as we attempt to keep up with new developments in the field and are as ready to discard as to adopt an opinion.

A third dynamic is *the level of our engagement with the cultural object*. This level will be situated on a continuum ranging from distraction to intense concentration. Our evaluation of the cultural object might take place in a distracted state of the kind that we enjoy when watching a film and we might dismiss something in passing without giving it serious consideration just as we decide whether or not to take note of the trailers that are flashed before our eyes before the main feature commences. Back in the 1930s, Walter Benjamin (1968[1936]) argued that 'mechanically produced art' such as film is consumed in a distracted manner. The *exhibition value* that characterizes the experience of the film-goer replaces the *cult value* that surrounds the unique work of art. When a new film is released, there is no *original* copy to be coveted in the way there is for a painting such as the *Mona Lisa*, which has an *aura* deriving from the fact that it has become the pilgrimage destination for so many art-lovers around the world. The *aura* of art thus disappears and this has democratic consequences: a great number of people can simultaneously enjoy a cultural object (in this instance, a film) without the quality of the experience being in any way impaired by the fact that it is a shared experience. Art, therefore, ceases to be an elite experience and it is liberated from its cultish dependence on the rituals associated with the art gallery (Benjamin, 1968, p. 224). Whereas the painting demands absorbed concentration from the individual, film offers multiple fragments of reality 'assembled under a new law' and consumed in a distracted manner by the collective (Benjamin, 1968, p. 234). The latter mode has much in common with the ways in which the public 'consumes' architecture in a distracted state, learning by use and perception, by touch and sight. So, '[t]he public is an examiner, but an absent-minded one' (Benjamin, 1968, p. 241). This means that we are able to engage with cultural objects by means of habit as much as by absorbed contemplation. If we extend this analysis out towards the interactions with cultural objects we enjoy via digital technologies, we might find a similarly distracted *modus operandi*, especially if we are simultaneously watching a film, answering an email, checking the news headlines on a separate webpage and formulating a SMS message. Research into the evaluative moment needs to be attentive to

the fact that very often we engage only with fragments of culture, and we might do so in a distracted manner. For example, we might cast aside a novel after ten or so pages or switch off a television programme that we have engaged with for a minute or less; we might skim through a photography magazine while listening to part of a symphony. What we articulate in these instances, in our distracted interactions with the various cultural objects, is a series of micro-judgements each of which, in isolation, might be considered to be of little significance. It is only when viewed as part of a wider pattern that they can be analysed as meaningful. We can also consider evaluation in its distracted mode in the art gallery. For example, when we walk around the gallery we might glance up at the paintings much as we would at the adverts between television programmes. We notice them, but we do not bother to pay them much attention, for our focus is elsewhere: we might be enjoying a conversation that is concerned with a completely different matter, or our concentration might be more focused on the music that is being channelled into our ears via our headphones. With these examples in mind, we can see that our evaluative responses might not always be laden with superlatives. Very often, we might express our opinions by way of a brief gesture, a raised eyebrow, a smile or a murmur of discontent. We might simply be indifferent. Such opinions will have more in common with whims and transient emotions than with judgments which contribute to iron laws or rigid taste hierarchies. In distracted mode, our evaluations might be subject to quick-fire alteration, readily adapting to the content that emerges from the flow of images and sounds in which we are immersed, whether in public places or in our own aestheticized, private spaces.

Alternatively, our evaluation might be one of scholarly concern with form (Bourdieu, 1984) as we compare one painting with another by the same artist; or we might pause in the midst of a meal for a momentarily reflection on the qualities of a particular glass of wine (Hennion, 2007) and compare its exuberance – without lingering too much on such detail – with that of a wine we had earlier in the evening. When engaging with the cultural object, our level of concentration might be so high that we are carried away by the experience. Along similar lines, the level of engagement might be intense, bodily and sensuous, if we are drawing attention to a qualitatively unique eating experience (Highmore, 2010b) or if our engagement with the cultural object is motivated by a longstanding commitment to an artistic movement, to the work of a particular artist or culture creator. In such cases, our evaluation might well be formulated as a passionate response, one that

forcefully draws attention to the merits of the cultural object. This might mean that when we observe, we do not miss a line, a curve, a detail; so that when we listen, we carefully register each note, each intonation; so that when we feel, we feel the full force of the experience and perhaps the collective effervescence that arises from the crowd of which we are a part if we are at a music concert, or if we are at a sporting event. So, if we are attentive to the moment of evaluation, we see that it might be intense and passionate, detached and scholarly, or carried out in a semi-distracted state. We might vociferously make the case for a particular art-installation or we might, in passing, with very little emotional register, find reasons to dismiss it.

A fourth dynamic is *the methods and practices deployed in order to engage with the cultural object*: listening to music, reading books, attending concerts all contain ritualistic elements which are deployed in order to maximize the pleasures involved. For example, the wine-enthusiast will meticulously prepare the wine-tasting experience by standing the wine bottle upright for ten hours, decanting the wine into a glass carafe so as to maximize the aroma and flavour, and when the wine is ready – at the suitable room temperature – pouring it into glasses with the correct shape for the colour of the wine and suitable for the particular grape variety. This preparation has a ritualistic quality. Similarly, avid music fans formulate intricate concert-going rituals so as to enhance the concert-experience. Hennion (2001, p. 14) draws attention to this 'getting in the right frame of mind' that is associated with concert-going, which 'exploits a well-orchestrated technique that is both personal and collective, and involves the sophisticated use of space and time, a voluntary receptivity to certain states'. In each of the above examples, the space for aesthetic evaluation is opened up by means of a certain amount of pre-planning and anticipation. As a result, like-minded individuals, sharing rituals and similar methods of preparation and engagement, will be in a position to compare notes and share modes of evaluation, to discuss what is preferable and what is disagreeable, and to formulate a kind of co-authored inter-subjective judgment in relation to the cultural object(s).

A fifth dynamic is *the impact of location on the moment of evaluation*. Listening to an interpretation of a particular piece of music that is blasted forth from speakers in a carefully prepared, comfortable and warm room, in isolation from others, in a familiar environment, with candles lit, will enable an intense engagement with the cultural object and these dynamics may well sway one's judgement favourably. However, the cultural object has its own force, and the however nicely

prepared the location, a poorly written novel is as likely to meet with critical resistance in a candle-lit room as in an austere, wind-swept railway waiting room. For those not 'trained' to be familiar with what Bourdieu (1984, p. 273) terms the 'obligatory exaltation of the austere severity of the museum and the "meditation" it encourages', the museum might be a hostile, cold and unwelcoming place, and the impact of this imposing temple of the legitimate might detrimentally affect the evaluation of its contents for some. In contrast, individuals hailing from the upper echelons of the middle-classes for whom 'extra-curricular' cultural practices and a certain freedom from economic necessity have been the norm, are likely to feel at ease when evaluating in art galleries or other legitimate cultural institutions. However, it is important to register that for high status groups just as for the rest of us, the cultural object has its own presence and it can surprise us, in the most unlikely places, as we go about our everyday business performing mundane tasks. This is, some might say, the value of street-theatre or of community art events that shake us out of our complacency and encourage us to view the world differently, at least for the moment. It is also the case for events that surprise us with their sense of inclusiveness, whether on a small-scale, such as when a flash-dance erupts in our city centres, or on a grander scale, when we are faced with a spectacle on the global stage, such as the opening ceremony of an Olympic Games or a musical event that – for a moment at least – draws us in, allaying hierarchies and differences.

A sixth dynamic is *the material qualities of the cultural object*. As Wolff (2008, p. 27) suggests, we might, in our evaluative practices, deploy criteria 'inherited and learned from aesthetics – questions of form, colour, and composition, judgements as to whether one portrait succeeds more than another in portraying character, and so on' (Wolff, 2008, p. 27). Alternatively, the evaluation of the cultural object can be less about form in the traditional sense, and more concerned with the corporeal, involving touching, tasting and smelling. As Ben Highmore (2010b, p. 160) observes, the experience of a Vindaloo curry cannot be adequately described 'without … recognizing its intense sensual effects and affects'. Taking heed from this example, it is clear that the cultural object – in this case a Vindaloo curry – cannot merely be assessed in the abstract, in terms of its formal properties or its cultural history: it has a direct bodily impact. Along similar lines, Tia DeNora's research into individuals' specific uses of music highlights the fact that the specific properties of music 'may contribute to or colour the shape and quality of social experience, self-perception and emotion' (DeNora,

1999, p. 53). According to DeNora, music can play a key role in relation to emotional self-regulation; it is also a technology of the self, which enables people to 'find themselves' and elaborate a sense of self-identity. For the purposes of this chapter, however, we can also consider how the rhythms, harmonies, modalities and melodies of music impact upon the evaluative moment. These properties reach out to us and move us, sometimes literally, as the sound waves hit our bodies. In the twenty-first century, we have centuries of music at our disposal and hence an unprecedented degree of choice in what we listen to. However, because of the seeming ubiquity of music in everyday life – in restaurants, in shops, in bars, in elevators, in shopping malls and in health clubs – we are also *subjected* to more music than ever, music that we haven't chosen to listen to. So, music is both a material that we willingly utilize in order to render a sense of self-identity and something that is imposed on us. One way of prioritizing the former version is to block out other sounds and to 'aesthetically colonize' urban spaces by taking control of what one hears. As Michael Bull (2005, p. 350) found in his study of iPod users, 'they find it difficult to aestheticise the street without their own individual soundtrack playing as a spur to the imagination'. However, it is not always possible to block out sounds and so, in this struggle between our self-imposition of our own life's soundtrack and the multifarious ones that have been set in play by others, the specific properties of *other* types of music reach our ears setting in play an automatic, perhaps unavoidable, process of evaluation. Aside from factors relating to the specific context (the volume of the music or its irritating insertion into the particular moment) and its resonance with our own personal histories, we might respond to the music's material properties and, before proceeding to more formally aesthetic questions, if indeed we do, we might ask the simple questions: do we like it or not? Why?

Attention to the dynamics of the evaluative moment at an individual level can enable a more sociologically grounded approach to aesthetic value. However, so that we do not end up with an excess of subjectivity – after all, reading about a sociologist's preference for one cultural object over another might not always be interesting – empirical work on aesthetic judgements of various social groupings similar to that which Hennion (2001) carried out on music lovers would be necessary, perhaps going some way to realize Wolff's notion of locating value in the context of communities. And whereas Hennion (2001, p. 3) is interested in what he terms the conditioned performativity of taste – 'a rich and inventive practice that simultaneously recomposes

music and its practitioners *in situ*, according to the needs and with the various mediums, resources, devices and ceremonials available' the focus of this empirical research would be specifically *aesthetic evaluation*. There are an infinite number of ways in which the dynamics of the evaluative moment play out, but this does not mean that we would be awash with incomprehensible data. It is important to identify patterns and themes within the evaluative responses.

Concluding remarks

All too often, debates about aesthetic value that pay heed to only the socio-historical dimension leave the 'culture' behind, and aesthetic evaluation without context-awareness is prone to aesthetic universalism. There are no values that transcend the socio-historical contexts in which they are embedded, and sociologically grounded approaches demonstrate that aesthetic universalism is not possible; they highlight the range of complex factors that play a role in determining the value of a cultural object. Such value is generated within institutional contexts and more broadly, within the cultural field. Our perception of the value of cultural objects is also conditioned by our positioning in social space, dependent on the extent to which we are able to adopt an aesthetic or scholarly disposition and thus judge cultural objects in the light of field-specific criteria. However, despite these considerations, I argue that to focus on context alone is limiting. Institutional or field analyses provide an illuminating understanding of how an object *becomes* art, but there is a danger that in analysis that is entirely context-driven, the 'culture' and more specifically, the 'cultural object' disappears. This chapter therefore points to a new, more balanced approach that will involve considering aesthetic value in terms of context and in particular examines the dynamics of the evaluative moment. Attention to such dynamics, whilst keeping the cultural object in sight, can reveal shared values that derive from our common humanity. Why does any of this matter? The consequences of failing to address aesthetic value are to face cultural relativism or to accept uncritically the stamp of legitimacy bestowed on cultural objects by institutions that are driven by the logic of profit, and where culture is measured unambiguously in terms of quantities, in Pounds, Euros, Yuan and Dollars. In an era of cuts to government spending on culture (in its general and restrictive senses) across Europe and the dominance of the discourse of *value for money*, this discussion of sociology and aesthetic value is part of a broader attempt to pay heed to what people

value, to be cognizant of *other values* alongside the economic. Since Weber drew attention to the disenchantment of the world as a result of processes of rationalization, sociologists have played a key role in drawing attention to *other values*, values threatened by the logic of formal rationality as exemplified by the quantitative logic of money and calculable rules which operate 'without regard for persons' (Weber 1968[1913], p. 975).

6
Culture in a Globalizing World

Introduction

In this chapter, debates regarding cultural heterogeneity and homo-
geneity are considered, and the argument is made that there is a
conflict or tension between impersonal forces and creative, aesthetic
impulses that can never be entirely contained. Even if many of the cul-
tural objects that we consume in our globalizing world are created and
disseminated by transnational corporations which operate on the basis
of the logic of profit, these objects, whether films, books, songs or tele-
vision programmes, are *cultural* objects, they have aesthetic properties
which are interpreted and evaluated by consumers and audiences in
very different ways. These properties enable them to escape the
confines of mere product, imbuing even the most commercial cultural
object with at least a dash of ambiguity. Furthermore, as will be
demonstrated in Chapter 7, even the most commercial cultural objects
may need to be 'glocalized' in order to travel successfully across borders
and to be adopted by consumers.

Framing the debate: Globalization and the compression of
the world

It has been suggested that 'globalization' is a new word that refers to a
process that began with the launch of the colonial era five centuries
ago (Ellwood, 2006). However, a strong case can be made that global-
ization stretches back even further, and that the Roman Empire was
'global' both in terms of outlook and reach. In the second century BC,
Polybius wrote that '[f]ormerly the things which happened in the
world had no connection among themselves ... But since then all

events are united in a common bundle' (cited in Robertson, 1992, p. 54). Furthermore, as Held *et al.* (1999, p. 333) point out, the spread of world religions such as Christianity, Islam, Confucianism, Hinduism and Buddhism 'unquestionably constitute one of the most powerful and significant forms of the globalization of culture in the premodern era, indeed of all time'. Along similar lines, Jan Nederveen Pieterse (1995) draws attention to 'the deep history of intercivilizational connections including, for instance, the influence of the world religions' (1995, p. 53). However, even if some of the processes associated with globalization are not new, it is only relatively recently that we have been able to conceive of the world as a single society, and much of world history before then can be considered as 'sequences of "miniglobalization"', in the sense that, for example, historic empire formation involved the unification of previously sequestered territories and social entities' (Robertson, 1992, p. 54). Globalization can thus be understood as a complicated, uneven process or a series of related processes, which have led – in relatively recent history – to 'the increasing acceleration in both concrete interdependence and consciousness of the global whole' (Robertson, 1992, p. 8). A concern with 'the world' in sociology is not entirely new, and is evident in much classical social theory. To take a key illustrative example, a number of 'global openings' can be found in *The Communist Manifesto*, in which Karl Marx and Frederick Engels (1967[1848], p. 84) noted the relentless expansion of capitalism across the globe in search of new markets, finding that '[i]n place of the old local and national seclusion and self-sufficiency, we have intercourse in every direction, universal inter-dependence of nations'. That said, the extent to which classical social theorists were cognizant of processes associated with globalization can be overestimated, and, for example, Roland Robertson accuses Weber (in his discussion of Hinduism and Buddhism) and Marx (in his discussion of the Asiatic mode of production) of downplaying the role of the 'Orient' in their understanding of world history and human 'progress' (2001, p. 460).

So as to better understand how this consciousness of the global whole has come about, let us consider Robertson's (1990, 1992) conception of a 'temporal-historical path' to the high degree of global density that we experience at present. Robertson attributes the heightened sense of the world as one place to the shifts in relations between four reference points of the global field (or what he terms the global-human condition). These reference points are *individuals, national societies, international relations,* and *humanity.* The increase in global

density over the centuries is a consequence of the crystallization of these reference points, of their dynamic interplay and their relative autonomy. However, in spite of this autonomy, each reference point is constrained by the others and 'overemphasis on one to the expense of attention to the other three constitutes a form of "fundamentalism"' (Robertson, 1992, p. 28).

Regarding his notion of a 'temporal-historical path', Robertson (1990, 1992) argues that during *the Germinal Phase*, which lasted from the early fifteenth to the mid-eighteenth century, it was significant that the notion of the 'individual' came to the fore, as did ideas regarding 'humanity'. During this phase, an understanding of human geography developed and the use of the Gregorian calendar spread. The heliocentric theory of the world, the idea that the earth and planets revolve around the sun (thus meaning that the earth was no longer seen as the centre of the universe) took hold. The 'transnational' medieval system declined as national communities started to emerge. During this period, voyages of discovery led to 'early forms of transoceanic connectivity and colonial subjugation' (Giulianotti and Robertson, 2009, p. 3). During *the Incipient Phase*, which lasted from the mid-eighteenth century to the 1870s, the concepts of the individual and humanity were given further definition, inspired by Enlightenment thought and spurred on by the political ideals of the French Revolution. With the formalization of international relations and the development of a number of international and transnational legal conventions, notions of citizenship increasingly took hold. Communication systems (such as the telegraph system) developed, and the Lisbon earthquake of 1755, which killed around 100,000 people and decimated the city, was an example of a 'global moment' (Giulianotti and Robertson, 2009, p. 3). There were tensions and problems regarding the 'admission' of non-European societies to what was conceived of as 'international society'; there was, concurrently, a '[t]hematization of [the] nationalism-internationalism issue', and a 'near-global model of homogeneous nation states' emerged during this phase (Giulianotti and Robertson, 2009, p. 3; Robertson, 1992, p. 58). During *The Take-off Phase*, which lasted from the 1870s to the mid-1920s, several of the key globalizing tendencies of previous phases became further pronounced. For example, ideas regarding the correct outline of a national society were promulgated and national traditions were invented. With non-European societies increasingly part of international society there were attempts to formalize conceptions of humanity. The Gregorian calendar and world time were widely

adopted and some key globalizing institutions such as the Nobel Foundation (2000), the League of Nations (1920) and the International Olympic Committee (1894) emerged. Concurrently, global competitions, prizes and events such as the Nobel Prize and the Olympic Games were staged. Global communication technologies developed at a fast rate during this phase and the number of these technologies increased. A less welcome expression of these globalizing tendencies, the First World War, occurred towards the end of this phase.

During *the Struggle-for-Hegemony Phase*, which lasted from the mid-1920s until the late 1960s, the principle of national independence was established and the notion of the Third World took hold. Organizations such as the League of Nations and subsequently the United Nations were founded. This phase, as suggested by the title, was characterized by struggle between various power blocks for dominance over territory, natural resources and international trade. Competing conceptions of modernity were put forward and fought over, whether it was those put forward in the name of fascism and communism, capitalism or socialism. Such disputes ran from the end of *the take-off phase*, from the First World War through to the Second World War and culminating in the Cold War, leaving behind a train of horrors including the Holocaust and atomic bomb attacks.

During *the Uncertainty Phase*, which began in the late 1960s and ran to the early 2000s, the Cold War came to an end with the collapse of the Soviet Union. As a consequence, the bipolar international system was rendered more complex and there was no longer a clear power balance such as that which existed between the United States of America and the Soviet Union. From the late 1960s onwards, communications technologies developed rapidly, culminating in the foundation of the World Wide Web, the use of which became widespread in 'connected' parts of the world. This period also witnessed an acute rise in the level of global consciousness, which led, for example, to a greater sense of awareness regarding the fragility of the planet. Responding to the perceived threats of environmental catastrophe and nuclear war, a number of protest movements emerged. The 'uncertainty' aspect of this phase extended to conceptions of individual identity, which 'were rendered more complex by gender, sexual, ethnic and racial considerations' (Robertson, 1992, p. 59). During this phase, attention to civil rights and human rights took hold on a global scale and there was a sharp rise in the number of global institutions. At the same time as the certainties associated with homogenous national

society broke down, there was a rise in de-globalizing movements rooted in the re-assertion of nationalist or in religious (and religious fundamentalist) agendas. Ironically, there was also a burgeoning of anti-globalization movements and protests, many of which were (and continue to be) oriented towards apprehending the world in a way that is global.

Robertson's (2007, p. 412; Giulianotti and Robertson, 2009) delineation of the sixth phase of globalization, the millennial phase, which he has added in recent years, is marked by a notable reversal of trends towards secularization with '[t]he apocalyptic declarations of Jewish, Christian and Islamic groups ... prominent in millennial thinking' (Giulianotti and Robertson, 2009, p. 27). With a sense of fear and insecurity spreading, individuals are subjected to heightened levels of state monitoring, and at the same time, they are pressured to self-monitor their bodies, bombarded with media-conveyed images of the 'ideal body' and messages regarding ideal lifestyles. In response to perceived terrorist threats and data hacking fears, nation states have ramped up levels of surveillance so as to manage borders and to negotiate a simultaneous opening and closing of national societies, with increasing transnational interconnectivity and movement across borders on the one hand, and increasing fears regarding migration levels and national security on the other. The intensification of data gathering has been accompanied by heightened concerns regarding the failure of information systems and their vulnerability to cyber-attacks. As though parodying this culture of surveillance, individuals are increasingly turning to 'reality self-mediatization', which means revealing aspects of their personal lives on social networking sites and in reality television programmes (Giulianotti and Robertson, 2009, p. 28). In the early twenty-first century, international relations were dominated by the globalist 'crusade' led by the USA against the 'axis of evil' and Islamic fundamentalism, triggered in part by the terrorist attacks of September 11th 2001. This led to disastrous, bloody wars in Iraq and Afghanistan. Since Robertson formulated the sixth phase, this 'crusade' changed direction somewhat and, for example, the 2011 NATO-led bombing campaign in Libya was carried out in alliance with former 'terrorist' enemies such as Abdel Hakim Belhaj in order to take the initiative in the 'Arab Spring'. At the level of humanity, Robertson argues that the millennial phase has been characterized by a rise in awareness of impending environmental catastrophe, a more acute awareness of the threat to various animal species, and a crystallization of global civil society involving ever-more attention to issues of human rights, corporate responsibility

and development. At the same time, millennial thinking has seen a surge in ethno-national and religious fundamental movements (Giulianotti and Robertson, 2009, p. 28).

Global 'finanscapes'

So, Robertson's temporal-historical model of globalization enables us to understand the heightened sense of the world as one place. What is missing from this multidimensional model is attention to economic factors. This is acknowledged by Robertson (1992, p. 29), and he argues that it has been his intention to shed new light on existing debates on globalization by providing a more specifically cultural focus. Refusing to give primacy to economic factors, he argues that there has been no single driving force of globalization over the past centuries and that historical analysis reveals that at various times, religious, cultural, economic and political factors have predominated (Robertson, 2001, p. 462). That said, the increasing significance and complexity of global 'finanscapes' (see Appadurai, 1990, 1996), the dominant role of transnational corporations in driving cultural flows and questions regarding the unsustainable nature of the USA-derived model of a consumption driven economy are perhaps serious omissions from the model. However, this omission might in part be explained by the fact that the global financial downturn in 2008 occurred after Robertson had initially formulated his ideas regarding the latest phase of the temporal-historical path to global density. If Robertson's cultural model explains how the heightened sense of the world as one place has taken hold, approaches which give primacy to economic factors in relation to global processes can help us understand the fate of culture which is increasingly perceived, like any other value-laden sphere, in terms of market criteria which are formally rational. Let us now consider some of these approaches.

Much of what has contributed to the growth in global density outlined above has been driven by economic factors, and most economies of the world, with a few exceptions such as North Korea, are networked with other economies of the world, and so seen in this light, 'globalization is shorthand for the cultural changes that follow when societies become linked with, and in varying measures dependent upon, world markets' (Gray, 2009, p. 57). Although we are witnessing the increasing interconnectedness of global economic networks, these interconnections have not enabled equal integration. Quite the contrary: world markets are characterized by hierarchical relations and dominant

powers can set the rules of the game (Bourdieu, 1998, p. 38). Drawing attention to these hierarchical relations, Bourdieu (2003, p. 9) writes that 'globalization' is a misleading term that stands in for 'the imposition on the entire world of the neo-liberal tyranny of the market', which is foisted upon us by the dominant economic powers; it is a new myth of our times, seen as an inevitability, but 'is in effect the justificatory mask sported by a policy aimed at universalizing the particular interests and the particular tradition of the economically and politically dominant powers (principally the United States)' (Bourdieu, 2003, p. 75). The 'neo-liberal' model of economic globalization to which Bourdieu refers is based on the projection of a single global market, which 'assumes that the economic life of every nation can be refashioned in the image of the American free market' (Gray, 2009, p. 4). While it is difficult to describe a typical neo-liberal state, neo-liberal theory asserts that the state prioritizes 'strong individual property rights, the rule of law, and the institutions of freely functioning markets and free trade' (Harvey, 2005, p. 64). This model prioritizes economic growth, productivity and competitiveness at all costs, and is corrosive to social and cultural institutions (Bourdieu, 1998). It takes as its inspiration the kinds of self-regulating markets that were set up in England in the late eighteenth century and throughout the nineteenth century. 'Freeing' the market in that period entailed an institutional separation of the economy from social and political spheres, with many safeguards removed at great cost to the most vulnerable in society. 'Free markets' do not emerge spontaneously, nor do they evolve. Rather, they are created by means of state intervention (Polanyi, 2001[1944]). Gray points out that '[e]ncumbered markets are the norm in every society, whereas free markets are a product of artifice, design and political coercion' (2009, p. 17).

What differentiates twenty-first century economic globalization from the international economy of the nineteenth century is that there has been a huge expansion of world trade; there has been an unprecedented growth in the power of multinational corporations, which freed from the constraints of locale are able to move at will around the world so as to find favourable tax conditions, lax regulatory environments and cheaper labour costs; there has arisen a vast and complex virtual economy that threatens the real economy (as exemplified by the 2008 financial crisis); and labour conditions are characterized by a greater degree of flexibility, meaning instability and (job) insecurity (Beck, 2000). Overall, it can be said that 'the speed, size and interconnections of movements of goods and information across the globe … are enor-

mously greater than any that have existed in any previous period of history' (Gray, 2009, p. 61). A perverse consequence of the current state-engineered free markets is that governments lose much of their control over economic policies as a result of policies of deregulation. This is not to suggest however, as some 'hyperglobalizers' have done, that the role of the state is no longer of significance. Evidence for this can be seen in the fact that transnational corporations go to great lengths to curry favour with national governments at the same time as states compete for their investments by creating a good business climate (Gray, 2009, p. 70; Harvey, 2005, p. 79).

The impact of economic globalization varies hugely from country to country, depending on a range of social, cultural, political and historical (as well as economic) contextual factors, and there are a number of models of economic globalization. For example, the resurgent economic success of China demonstrates the viability of alternative, centralized models of capitalist activity, and the post-Second World War German business model takes into account many stakeholders in addition to those on a company's board. The German stakeholder model ensures that a wide scale withdrawal of a large company from its native land is much less likely than would be the case with a company in the USA which only has to appease the shareholders represented on its board (Gray, 2009, p. 59). For individuals, the consequences of economic globalization are equally variable. With mobility one of the key stratifying factors in a globalizing world, there is increasing disparity between those able to move at will from country to country, from airport lounge to airport lounge – those for whom space and time have lost their constraining qualities as a consequence of the increasing ease of travel, the instantaneity of communication and financial flows enabled by relentless technological innovation – and those stuck in the 'local', their immobility all the more apparent when viewed alongside the mobility of global elites (Bauman, 1998).

Cultural funding

In many countries, the imposition of the 'utopian' model of free markets has led to the involution of the social state which means the cutting back of relatively recently acquired social rights such as welfare, housing, employment protection and education, many of which are associated with Keynesian policies that were implemented in response to the market crises of the 1930s and the devastation caused by the Second World War. More pertinently for the purposes of this chapter,

the 'ecological' conditions of the cultural field that enable artistic pro-
duction to continue unhindered by the need to generate profit have
been (and continue to be) threatened (Bourdieu, 2003). After the global
financial crisis of 2008, a number of complex and often contradictory
trends emerged in relation to cultural funding across Europe. In some
instances, cultural funding actually increased. For example, in France,
in 2010 President Sarkozy was keen to position himself as a defender of
the arts and his Minister for Culture and Communications Frédéric
Mitterrand argued that France differentiated itself from other countries
in Europe which were cutting back on their budgets. The French
budget for the arts increased by 2.7 per cent in 2010 (Inkei, 2011, p. 8)
though analysts argued that while France spent on large-scale projects
such as the Philharmonie de Paris concert hall, tax cuts and funding
cuts to regional administrations meant that many smaller arts organ-
izations faced collapse. In other parts of Europe, increases in funding
occurred: for example the German Cultural Policy Association found
that of sixty German cities canvassed, 57 per cent reported increases in
their cultural budgets (Inkei, 2011, p. 8). Increases were even more
emphatic in Slovenia in great part as a result of European Capital of
Culture nominations. For example, the city of Maribor's cultural
budget rose from 3.5 to 9.7 million Euros between 2008 and 2010,
during times of austerity across Europe (Inkei, 2011, p. 6). On the other
hand, there were substantial reductions in funding in countries in
crisis such as Italy, which was increasingly turning to market-solutions
to cultural funding. In Italy, the culture budget was cut by almost
50 per cent over a three year period, from $603 million to
$340 million, including a 37 per cent reduction in performing arts sub-
sidies. Italy's Culture Ministry (like its UK counterpart) turned to phil-
anthropists with the hope of making up some of the shortfall (Nadeau,
2011). In the UK, as a consequence of the Government's spending
review in 2010, the total budget for the Department for Culture, Media
and Sport was reduced by 24 per cent to £2 billion. In 2010, it was
announced that there would be a 30 per cent reduction in the funding
of Arts Council England from £449 million to £349 million per year by
2015, and hundreds of arts organizations lost their funding altogether
(Arts Council England, 2012). The contradictory nature of these trends
can be explained by the conflicting roles the twenty-first century state
has to play (Harvey, 2005). On the one hand, it is expected to take a
back seat in regard to cultural matters. In many countries, neo-liberal
political-economic theory and practice, which has been in the ascen-
dancy since the1980s, has sought to hollow out the state and reduce its

social function to a minimum, limiting its role to protecting property rights and the rule of law, and facilitating free trade (Bourdieu, 1998; Gray, 2007; Harvey, 2005). On the other hand, in order to be competitive on the global scene, the state continues to play an active role in creating conditions that are favourable for trade and for tourism (Harvey, 2005; Urry, 2002, p. 158). The state needs to devise various strategies that will foster the loyalty of its citizens and one such strategy is an appeal to sentiment rooted in nationalism (Harvey, 2005, p. 85). We see, therefore, that alongside the slashing of cultural budgets in some areas, there continues to be lavish expenditure in others, especially on grand projects that serve to create and maintain a sense of cultural heritage such as in the case of the Philharmonie de Paris, or tell the story of a nation's urbanity on the global stage, as celebrated in the opening ceremony of the 2012 Olympics in London.

It is important to observe that even in countries where cultural funding has increased, there has been a tendency to ideologically orientate cultural policies so that they accord with wider social processes of commodification and a privatization agenda formulated in response to a perceived crisis in the welfare state model (Gray, 2007; Harvey, 2005). This tendency is highlighted again and again in cultural policy literature. For example, Victoria Alexander's (2007) analysis of cultural funding in the UK demonstrates that business jargon has now thoroughly permeated the world of cultural administration. She argues that from 1979 onwards, the direction in cultural funding changed as the new Thatcher-led government sought to dismantle the public sector and formulate policy that reflected a wider trend towards 'enterprise culture', embodying minimal state-intervention, the liberty of individuals and a belief in the efficiency of the free-market (Alexander, 2007, p. 4). Along similar lines, Bourdieu (2003[2001]) has drawn attention to the 'intrusion of commercial logic at every stage of the production and circulation of cultural goods'; he argues that the most autonomous region of the cultural field is under threat as culture is increasingly 'subsumed under the term of "information" ... conceived as a mere commodity, and consequently treated as any other product and subjected to the law of profit' (2003, p. 68). Clive Gray (2000) finds that a process of commodification increasingly dominates the relationship between the state and the arts, and cultural products are valued in terms of their exchange value rather than their use value. As a consequence, the arts are not considered in terms of their use – 'providing pleasure for individuals ... or provoking thought ... but as commodities that can be judged by the same economic criteria as cars, clothes or

any other consumer good' (Gray, 2000, p. 6). Like Bourdieu, Gray sees aesthetic concerns marginalized by the logic of the marketplace, with, therefore, 'a veritable censorship by money' (Bourdieu, 2003, p. 69) because cultural objects are judged in terms of their exchange value.

Transnational corporations

According to Harvey (2005, p. 68), one of the fallacies of neo-liberal theory is the presumption of a level playing field and equal access to information for all competitors in the global market. In fact, global markets are characterized by asymmetrical power relations and by an increasing concentration of wealth (Harvey, 2005, p. 68). For example, since the 1980s, there has been a tendency across the world towards media deregulation which has enabled large transnational corporations to expand their power through mergers and acquisitions, through horizontal and vertical integration (Herman and McChesney, 1997). *Horizontal integration* involves corporations increasing their power by taking over or merging with rival companies in their sector. Domination of the media sector can enable companies to run similar content across a range of media platforms. For example, Disney takes advantage of this horizontal integration by creating a number of 'synergies' across its various media platforms with which to promote its films; it produces soundtracks, associated Internet content, books, comics, video games, amusement park rides, clothing lines and other merchandise related to its films (Herman and McChesney, 1997, p. 54). In 1994, the box-office receipts for *The Lion King* were $300 million, but the total revenue stream generated from the film and its associated synergies exceeded over $1 billion in profit (Herman and McChesney, 1997, p. 54). *Vertical integration* involves corporations taking ownership of the production of media content *and* the means of distribution. This means that they can control the content that is produced and they can make sure that it gets distributed. For example, when Disney produces a film, it is disseminated across the globe via the corporation's distribution networks and is shown on television networks owned by the company (Herman and McChesney, 1997). Disney dominates the global media landscape alongside a number of other transnational media corporations, each of which has its own distribution network and a strong foothold on every continent (Held *et al.*, 1999). These corporations include Vivendi, News Corporation, Time Warner, Thomson Reuters and Viacom. In 2011, according to the Forbes list of top global media companies (based on sales, profits, assets and market value)

eight of the top ten transnational media corporations had their base in the USA (Hoyler and Watson, 2011). If we examine two examples from this list, we can see that they own a number of media properties across sectors and that they control the means of production and distribution. The Paris-based conglomerate Vivendi creates, publishes and distributes media content across a range of platforms and its portfolio includes Activision Blizzard (video games), Universal Music Group (music), Canal + (cable television), telecommunications and broadband operators (SFR, Maroc Telecom and GVT) and a number of electronic ticketing companies. In 2011, its total income was 28.8 billion and it employed 58,300 people around the world (Vivendi, 2013). In one of the biggest mergers in recent years, Vivendi was involved in a merger with Canal + and it acquired Universal Studios from the Canadian firm Seagram, creating what was at the time the world's biggest media group Vivendi Universal (Cohen, 2011). News Corporation's portfolio includes BSkyB, Blue Sky Studios, Shine Group, Fox News Channel, National Geographic Channel, 20th Century Fox, Fox Television Studios, Harper Collins Publishers, *The Wall Street Journal*, *The Sunday Times* and *The Australian* and its total turnover in 2012 was $33.7 billion (News Corporation, 2013). These examples are indicative of trends towards the conglomeration of ownership and concentration of power which prohibit the development of any kind of 'free' market in which equitable cultural exchanges can occur. They suggest that flows of media content across the world are often less multidirectional than we are led to believe (Martell, 2010, p. 83).

Cultural diversity

Let us now consider the *range* of cultural objects available and the extent of cultural diversity in an era dominated by the above-mentioned economic trends, with transnational corporations in the ascendancy. In 2003, a report produced by the Cato Institute, a public policy think-tank based in Washington D.C., which is 'dedicated to the principles of individual liberty, limited government, free markets and peace' (Cato Institute, 2011), contained an intriguing debate between Tyler Cowen and Benjamin Barber about the fate of culture in a globalizing world. In the debate, Cowen, an economist very much aligned with the Cato Institute's pro-market approach, puts forward the argument that economic processes associated with globalization have increased the range of cultural objects that we are able to enjoy. Benjamin Barber, in contrast argues the opposite, maintaining that

these processes have led to a proliferation of cultural sameness (Cato Policy Report, 2003).

Let us look in a little more depth at Cowen's argument so as to understand the pro-free-market position. Cowen's first major point is to suggest that trade creates more (not less) cultural diversity. He draws attention to the 'gains from trade' that creators are able to enjoy when their culture trades with another (Cato Policy Report, 2003, p. 8; Cowen, 2002, p. 15). Such trade can enable artistic revolutions and can engender creative innovation. For example, Cowen argues that Cuban music flourished in the 1950s as a result of the presence of American tourists visiting Havana; there was renewed production of Persian rugs in the nineteenth century when Europeans started to buy them in order to sell them on to North American markets. Cowen (2002) argues that global free markets provide opportunities for artists to express their creativity and reach wider audiences. If we take the example of music, we can see that there is certainly much evidence for a growth in the number of music genres of which we are aware, if, that is, we have the money, time and technology at our disposal with which to research such matters. We can go to an online music store and order *reggae* from Kingston, *tango* from Buenos Aires, *morna* from Cape Verde, *fado* from Lisbon, *son* or *rumba* from Cuba, or any number of fusions involving the above styles. Furthermore, in virtually any global city there are performers of countless genres, permutations of genres and sub-genres of music that derive from rock and roll or rhythm and blues. According to Cowen (2002), it is specifically *trade* which enables this diversity, and in a globalizing world, the range of cultural forms to which we are exposed will only increase as market activity across borders intensifies. Cowen refers also to the example of food to make his point that even if the places that we visit seem to be increasingly similar, they are alike in their diversity (Cato Policy Report, 2003, p. 8). For example, when we visit Paris or Berlin, we will have at our disposal a range of culinary styles. Even if '[t]his makes France and Germany more alike ... [it] is closer to being an increase in diversity than a decline in diversity' (Cato Policy Report, 2003, p. 8). In addition to enhancing the range of foods available, the free exchange of trade intensifies cross-cultural exchanges thus challenging accepted notions of authenticity. As culinary ingredients are transported across borders, we lose track of their provenance. So, we might forget that the red dye in tandoori comes from European culture, we might forget that tomatoes originate in South America; we might not realize that many of the spices in Indian food come from the New World (Cato Policy Report,

2003, p. 10). One of the intriguing consequences of the intensification of global trade is that it might now be possible to get a better curry in London or Singapore than anywhere in India (Cato Policy Report, 2003, p. 10).

Cowen's second major point is more contentious. He argues that cultural diversity is more likely to occur in countries such as the USA where there are free markets than in countries that are not sufficiently 'opened up'. He provides the example that in the USA in particular, a burgeoning range of music genres has developed over the past century, ranging from blues to Motown to heavy metal to rap. This proliferation of genres can be attributed to the existence of developed markets. He contrasts this with the lack of diversity in countries – such as the Congo – that have relatively undeveloped markets:

> If you go to pygmy society in the Congo, for instance, the pygmies produce splendid music; it's truly beautiful. But the pygmies really have just one kind of music, and the richer societies with more markets have given us more diversity, more competing kinds of music (Cato Policy Report, 2003, p. 8).

The music culture of Congo is portrayed as having a kind of naïve charm, but ultimately, is seen to be rather monolithic. Conditions enabling trade, pitting creative artists in competition with one another in a commercial environment and providing them with outlets for distribution, are those which are best able to foster cultural diversity. On a broader scale, such diversity is fostered by the intensification of global financial flows and the breaking down of barriers between nation states. So, Cowen (2002, p. 18) concludes that '[t]he "creative destruction" of the market is, in surprising ways, *artistic* in the most literal sense. It creates a plethora of innovative and high quality creations in many different genres, styles, and media'.

Cultural homogenization

Cowen's adversary and interlocutor Benjamin Barber argues that rather than creating diversity, the processes of trade associated with globalization are leading to a proliferation of sameness, which is referred to in this context as cultural homogenization (see also Barber, 2003). According to Barber, the net result of the globalization of culture is that diversity is increasingly simulated. For example, while it is true that we can procure a great range of foodstuffs in any global city, the

restaurants in which we dine all too often have the characteristics of theme-parks and the food offered is 'increasingly synthetic ... increasingly distanced from the authentic origin' (Cato Policy Report, 2003, p. 9). According to Barber, globalization speeds up this tendency towards simulation, and this has some bizarre consequences. For example, American restaurant chains, which specialize in making crepes, have now extended their reach to Paris, 'selling the American version of crepes to people in Paris who don't make them anymore because there's a much cheaper global product they can get in place of what they've had' (Cato Policy Report, 2003, p. 9). This is an example of restaurant franchises imposing an inauthentic *fast food* culture that forces out long-standing culinary traditions including those that value *slow dining* as a way of life. Fast food culture poses a threat to long-established practices (for example, the aperitif, the three-hour meal, the digestif, the siesta) and values (family values, social values, religious values associated with food consumption and a particular way of life) (Cato Policy Report, 2003, p. 9). It seems likely that Barber would sympathize with surrealist film-maker Luis Bunuel's (1985, p. 46) pronouncement that 'the decline of the aperitif may well be one of the most depressing phenomena of our time'.

Whereas Cowen argues that trade is characterized by a coming together of equals, Barber draws attention to systemic inequalities that exist between the various trading partners on the global scene. As Harvey (2005, p. 68) points out, the belief in 'perfect information and a level playing field for competitors' in global markets is 'either innocently utopian' or based on 'deliberate obfuscation'. Transnational corporations that find themselves in a monopolistic market position are able to dominate new markets and expel local competition. With these power relations in mind, Barber (Cato Policy Report, 2003, p. 10) provides an interesting analogy with which to illustrate the nature of cultural exchanges in a globalizing world:

> The problem is that when America meets another culture, it's not ... just two guys in the woods. It's not an American wearin' his Nikes and eatin' his burgers meeting up with a Nigerian who's singing a different kind of music, and they have a little exchange, and when it's done the American's a little different – a little more Nigerian – and the Nigerian's a little different – a little more American – and we're all the better off for it. Rather, you've got to imagine the American armed, sort of like the soldiers in Iraq are armed, with all of the goods and brands of modern technology, modern commerce,

hard and soft power, hegemonic economic power over the globe. That's the culture that's meeting up with some little Third World culture that's got some Navajo blankets or some fusion music that we'd kind of like to collect.

Cultural homogenization and the logic of profit

Barber's comments highlight the unequal nature of cultural exchanges and his analysis helps us to understand why it is that we are more likely to stumble across cultural products that derive from the USA (even if they are physically assembled elsewhere) than from developing countries. However, it is not merely the unequal nature of cultural exchanges that worries theorists concerned with the fate of culture in a globalizing world. They are concerned that culture is increasingly reduced to its formally rational function of generating profit (see Chapters 1 and 2). Social analysts drawing attention to this aspect of cultural homogenization are indebted to Theodor Adorno and Max Horkheimer's (1979[1944]) analysis of the culture industry. In the mid-part of the twentieth century, Adorno and Horkheimer (1979) expressed scepticism regarding the supposed diversity of choice on offer in the emergent consumer society of the 1940s. Having fled Nazi Germany during the Second World War, they were alarmed to see that many of the propaganda techniques deployed by the Nazis were mirrored in the USA in what they termed 'the culture industry', which represented a fusion of culture and monopoly capitalism. Like any other commodity, culture was utilized as a vehicle for profit rather than a harbour for critical thought; it was to be measured in terms of its exchange value rather than in accordance with aesthetic criteria. Furthermore, culture was created in the same manner as any other commodity in the increasingly rationalized, mechanized world of industrial capitalism. On the surface, the culture industry presented a wide array of products, each of which was tailored for a particular social type. Individuals were therefore expected to make their choices as though spontaneously, expressing their free will even if, in reality, the outcome of the choice was already pre-determined (Adorno and Horkheimer, 1979, p. 123). The seeming diversity of cultural forms available cloaked the fact that agents were urged to pick from a marketplace of commercial products that were in many respects identical. The purpose of marketing and image control was to manufacture difference where in fact there was little or no difference. The pronouncements made by 'experts' and 'connoisseurs' served to create a semblance of

difference between otherwise identical products. To consider the contemporary significance of this observation, think of the amount of money and expertise that is utilized in distinguishing Coca Cola from Pepsi Cola, Adidas from Nike, Samsung from Apple, when, in fact, there is often very little qualitative difference between the products offered by these brands. Adorno and Horkheimer (1979, p. 154) argued that the technique of pseudo-individuality was deployed by the culture industry in order to claim a sense of innovation, originality or flair in a product. In actual fact, it often meant little more than 'a standardized jazz improvisation' or a film star 'whose hair curls over her eye to demonstrate her originality' (Adorno and Horkheimer, 1979, p. 154). In sum, these expressions of pseudo-individuality did not represent a diverse flowering of human creativity but were devices used to cloak the sameness of the cultural products on offer.

It has become something of a truism to say that in our globalizing world, constrained less by nationally bound culture, there is no longer a single, monolithic propagandistic culture industry but that there is a series of profit-seeking *culture industries* (Inglis and Hughson, 2003, p. 54). Furthermore, it has been argued that it is no longer reasonable to consider that cultural objects, forms and images make up a totality or a system 'which is uniform as a whole and in every part' (Adorno and Horkheimer, 1979, p. 120). Instead, the global cultural economy is a 'complex, overlapping, disjunctive order', and there are increasingly multi-directional flows of media and culture (Appadurai, 1990, p. 296; 1996; Curtin, 2003). However, the contemporary relevance of Adorno and Horkheimer's argument lies in their exposition of culture as a vehicle for profit, and this is arguably more pertinent than ever, even if this vehicle is now being driven across borders in an increasingly interconnected world. According to Zygmunt Bauman (2011), 'culture' serves consumer markets and has long since ceased to be a tool utilized for the purposes of civilizing, cultivating or stabilizing people in given national contexts. With value defined in terms of consumer market criteria, it follows that:

> The line dividing 'successful' art (read, art catching the public's attention) from unsuccessful, poor or ineffective art (read, the art which did not manage to get through to well-known galleries or auction houses frequented by the right clientele) is drawn with reference to sales statistics, frequency of exposure and profits (Bauman, 2011, pp. 111–112).

When such success is found, the reasons justifying the high profit value are not to be found in the cultural object but rather in the name of the art gallery or media outlet that promoted the work. A consequence of culture serving consumer markets is that *duration* is sacrificed in the pursuit of short-term profit (Bauman, 2011). Culture therefore has to compete, along with other consumer market products, for the increasingly fleeting attention of potential clients. There is a quick turnover of products, and so cultural objects, like any other commodities, are designed in order to create a significant impact before being consigned to oblivion (Bauman, 2011). Along similar lines, Bourdieu (2003, p. 69) argues that 'commercial concerns, the pursuit of maximum short-term profit and the "aesthetic" that derives from that pursuit, are being ever more intensely and widely imposed on cultural production'. The desire for profit that motivates commercial cultural production means that in the pursuit of high audience ratings, 'omnibus products' are valued at a premium because they are designed to be consumed by audiences from all backgrounds, from all over the world. According to Bourdieu (2003) such products are stripped of distinctive or challenging content in order to appeal to the greatest number of people possible. Therefore, the type of products that succeed under free-market conditions tend to be banal and non-distinctive cultural forms such as Hollywood blockbusters, soap-operas, reality television shows, crime shows, computer games, commercial music, and best-seller novels. These cultural forms are interchangeable forms of 'information' produced for the world market and are treated as commodities, subject to the law of profit, especially the maximization of short-term profit. The globalization of culture means, for Bourdieu, that there is an *involution* of the cultural field taking place. This entails a regression from art-work to product, with the logic of profit flooding into a field that was until recently, in its most autonomous sector, relatively insulated from its flow. This *involution* reverses the centuries-old process of *evolution* which the cultural field had been going through as a result of its gradual autonomization (1996[1992], 2003). With culture increasingly subject to the law of commercial calculation and measured in terms of audience ratings, sales figures and advertising revenue generation, culture is in danger of being entirely debased by 'the imbecile forces of the market' and by 'the mercenary spirit' of the rule of money (Bourdieu, 2003, p. 64). With this in mind, Bourdieu (2003, p. 68) argues strongly that '[f]ar from promoting diversity, competition breeds homogeneity' in cultural production. However, the extent to which culture can ever be entirely

homogenized and reduced to calculable, numerical terms will be considered below.

So, according to Barber and Bourdieu, processes associated with globalization (and so-called 'free-trade') are resulting in increasing levels of cultural homogenization. What evidence is there for this? At the experiential level, if we stroll down to our nearest city centre we are more than likely to see the same global brands that we will see in many of the cities in the world. If we visit our nearest multiplex cinema, there is a good chance that it will be screening a number of the latest Hollywood blockbusters. If we want somewhere to eat or to drink in our local shopping centres, we are very likely to stumble upon a McDonald's restaurant, a Starbucks coffee shop, or a KFC. When we get back home, if we have cable or satellite television, there is a good chance that we will find MTV, CNN and the BBC. Beyond the anecdotal, let us now examine the evidence in greater detail with reference to an example often associated with cultural homogenization: the cinema industry, which is, according to Held *et al.* (1999, pp. 353–354) 'both the oldest of the cultural industries ... and the industry which was globalized earliest in terms of organization and genre'.

Cultural homogenization and cinema

Evidence for cultural homogenization can be found in the cinema-going data published by the European Audiovisual Observatory (EAO)[1] (2011), though there are also some interesting counter-trends. It is clear from this data that the most successful films in Europe (if we measure success in terms of box-office receipts) have predominantly been *omnibus products* that have as their country of origin the USA even if, as Miller *et al.* (2001) point out, an increasing number of Hollywood films are now 'runaway productions', meaning that they are made abroad so as to circumvent union wage restrictions and enjoy the benefits of exploitative labour conditions. Therefore, as Michael Curtin (2003, p. 212) observes, Hollywood is now 'an important node for the "face-work" of the industry' rather than the central material location of production. Regarding recent trends, the EAO (2011, p. 2) report found that the market share for European films in the European Union (EU) countries declined from 28.3 per cent in 2008 to 25.3 per cent in 2010; meanwhile the market share of USA-derived films rose from 65 per cent to 68 per cent in the EU in the same period. Films made in European countries other than France, United Kingdom, Italy, Germany and Spain collectively accounted for only 4.6 per cent of total EU admis-

sions (EAO, 2011, p. 3).[2] Countries such as Ireland (1.3 per cent), Portugal (1.9 per cent), Estonia (2 per cent), and Slovakia (2.2 per cent) garnered a very low national market share, meaning that only a fraction of films seen in cinemas in those countries were nationally produced. 3D blockbusters dominated the top 20 films by admission in the EU, with 10 out of the 20 films falling into this category; the starker statistic is that with the exception of UK inward investment films such as *Robin Hood* and *Harry Potter and the Deathly Hallows*, there was not a single European film in the top 20 films by admission (EAO, 2011, p. 4). It is quite remarkable to compare the admissions figures: *Avatar*, the most successful film seen in the EU (in quantitative terms), attracted 43,309,016 cinema-goers. In contrast, the French film *Les petits mouchoirs*, the most successful European film without USA funding, attracted an audience of 5,401,353.

The picture presented by the EAO (2011, p. 3) does highlight some interesting counter-trends to what appears *prima facie* to be evidence of the *Americanization* of European cinema. For example, the number of feature films made in the EU rose to a new high (from 1,045 in 2006 to 1,203 in 2010) and countries such as France, Italy and Germany continued to make an abundance of films thus garnering an impressive EU market share (9.4 per cent, 4.1 per cent and 3.1 per cent respectively). 203 feature films were made in France in 2010, and this figure represented a historic high, and the French national market share was 35.5 per cent. Other European countries with strong film-making traditions also had strong national market shares (Czech Republic, 34.8 per cent; Italy, 32 per cent) (EAO, 2011, p. 2). So, we might say with some certainty that while European cinema-going is dominated by films made in the USA, there are strongholds of film production in some EU countries, especially those that benefit from state support. Awareness of these contradictory tendencies runs through the UNESCO Institute for Statistics (UIS) (2012) report on the international film industry, which surveyed 115 countries. It found that new technologies have altered the ways films are produced and consumed, and it argued that the increasing number of international co-productions rendered the conventional notion of 'national cinema' problematic (p. 1). However, based predominantly on admissions figures, the report found that 17 of the 20 most popular global films in 2009 were either made in the USA or were co-productions involving a USA studio. The five most popular films were *Ice Age: Dawn of the Dinosaurs* (USA); *Harry Potter and the Half-Blood Prince* (Great Britain/USA); *2012* (USA); *Avatar* (USA); and *The Twilight Saga: New Moon* (USA). Although the top 20

also included *Slumdog Millionaire* (Great Britain); *Millennium 1: The Girl with the Dragon Tattoo* (Sweden/Denmark/Germany); and *Millennium 2: The Girl Who Played with Fire* (Sweden/Denmark/Germany) (UIS, 2012, p. 5), the UIS data overall indicates a trend towards homogenization for a number of reasons. First, 17 of the top 20 in 2009 were English language films. Second, the majority (67 per cent) of the top 20 films in the years 2007, 2008 and 2009 were sequels or franchise properties produced by large transnational media corporations. This means that characters and storylines already familiar to global audiences were revisited, and the films' associated 'synergies' were exploited across other media platforms (Herman and McChesney, 1997; McDonald and Wasko, 2008; Miller *et al.*, 2001). Furthermore, the UIS report (2012, p. 7) draws attention to the disproportionate might of transnational media corporations:

> The ability to develop such works, and to exploit their familiarity over time, disproportionately resides with the largest international media conglomerates. Corporate entities like Comcast, Disney, Fox, Sony, Time-Warner, and Viacom have holdings in different media in addition to their film units. They can risk large investments on properties – including production and promotion budgets for single films that surpass comparable film spending in most countries – and can withstand losses in one media format (feature film theatrical release) in the expectation of profits from distribution in other formats (DVDs or other merchandise).

However, this evidence for homogenization based on the admissions figures is heavily distorted by what is shown in official, commercial and public screening facilities, which is, much of the time, extremely limiting. It is not possible to say conclusively what films people in the EU are actually watching on the basis of cinema-going data alone. The majority of films are not watched in cinemas, but are watched across a range of media platforms, whether on television, on DVD or on laptop or desktop computers. To take just one example, most of the films made in Nigeria's burgeoning Nollywood film industry go straight to video format and are viewed in domestic settings (UIS, 2012, p. 9). In addition to this, there is a growth in 'on demand' film consumption and the increasing availability of 'new media' technologies has meant that film production facilities are more readily available to small scale film makers, many of whom are not making the kinds of films that are captured in the EAO data. How can we explain these contradictory

trends? According to Henry Jenkins (2004), on the one hand there is an increasing concentration of ownership in the media environment; on the other hand, there is a reduction in the costs of production. In terms of media consumption, if we visit the nearest multiplex cinema, we are likely to find a limited selection of 'omnibus products'; but if we stay at home, and if we have the resources and technologies at our disposal, increasing media convergence allows us to 'multi-task', watching a film on the television whilst also juggling four or five computer windows, 'scanning the web, listening to and downloading MP3 files, chatting with friends, wordprocessing a paper and responding to an email' (Jenkins, 2004, p. 34). As new media technologies are developed, conglomerates proceed now boldly, now with uncertainty and caution to find ways to reach audiences across the new platforms. At the same time as conglomerates are pursuing such strategies, audiences respond by finding ways to 'bring the flow of media more fully under their control' (Jenkins, 2004, p. 37). If we place emphasis on the consumption rather than the production of culture, it is apparent people consume culture in ways that are never entirely predictable; therefore, it is important to consider the structural locations and lived experiences of culture, and to be attentive to the ways in which people utilize the materials available to them (Fiske, 1989, 1991; Hall, 2007[1973]; Hebdige, 1979; Strelitz, 2004). As John Fiske (1989, p. 98) argues, although cultural texts (and cultural audiences) are shot through with dominant societal ideologies, it is an important task for scholars to identify elements of texts that enable negotiated or oppositional readings. Texts are not self-contained and their meanings are only activated by audiences and in relation to other texts. Therefore, even the dominant meanings encoded in cultural texts can be contested and audiences can resist them.

It is useful to make an analytical distinction between media and culture even if they are often inseparable in practice. Culture cannot be reduced to media; it is broader in scope, and includes 'values and beliefs ... alongside ways of life and traditions' (Martell, 2010, p. 93). Differences rooted in culture, including those specifically rooted in class, ethnicity, gender and sexuality structure the complex interplay between individuals and cultural objects. Furthermore, a key argument that is often overlooked in debates about homogenization needs to be made here: despite the domination of transnational corporations and the non-distinctiveness of 'omnibus products', cultural objects have *aesthetic properties* which complicate the extent to which they can entirely fit purely economic, rational categories. These properties

render them, to some extent at least, ambiguous and complex. Cultural objects can never be entirely homogenized, and even the most cynically produced cinematic offering will have aesthetic properties that can be interpreted and evaluated in a number of contradictory ways. So, even if transnational corporations are primarily motivated by profit, sought through the impersonal, formally rational, matter-of-fact mechanisms of the market, which, in principle, do not adhere to any *human* or *artistic* obligations, the commodities that they produce, or arrange to be produced, travel across the globe and are received in relatively unpredictable ways precisely because they are not simply units of currency: they are *cultural* objects. Of course, although every such object is cultural, some are distinctive in terms of formal innovation; some are more visually captivating than others; some are more emotionally powerful. Some objects in a particular category of cultural production, we might conclude, are simply better than others. As we have seen (in Chapter 5) our engagement with and evaluation of cultural objects is dependent on a range of socio-historical and contextual factors as well as the various dynamics impacting on the moment of evaluation. However, once released into the world, cultural objects, to some extent, have a force of their own.

So, even if buyers and sellers of cultural objects are not in the least interested in substantive considerations of artistic merit, they will have to be attentive to some *cultural* considerations if their product is to be taken up by anyone in the global market. They will have to be aware that the aesthetic properties of cultural objects will resonate differently depending on context. This is a lesson painfully learnt by Rupert Murdoch when he attempted to set up a pan-Asian/pan-Chinese network to further extend the reach of his Sky Satellite services. Murdoch's plans to extend the reach of his corporation at this stage were scuppered as a consequence of his lack of 'local knowledge'. He did not, for example, consider the variance in internal taste markets or the significance of language differences in China. When he reformulated his strategy, he entered the Chinese market by 'establishing multiple smaller, more culturally specific channels' (Bielby and Harrington, 2008, p. 179). A similar story can be told regarding the programme format of *Who Wants To Be A Millionaire?* in Japan. This format, which was first screened in England in 1998, was an overwhelming success around the world and was adapted in over 80 countries. In Japan, however, audiences reacted against the aesthetic properties of the show, finding the key theme of ordinary people in pursuit of big money distasteful and unappealing (Bielby and Harrington, 2008,

p. 114). In their analysis of global television, Denise D. Bielby and C. Lee Harrington's (2008, p. 53; Bielby and Bielby, 2004) draw attention to the significance of aesthetic properties in determining the ways in which programmes are received in different contexts. For example, they found that the aesthetic properties of soap operas, such as emotional authenticity and popular open-ended narratives concerned with family life and relationships, have a universal appeal. Such properties enable the genre to transcend cultural differences. In contrast, the aesthetic properties associated with situation comedies tend to be more nationally specific, being made up, as they tend to be, of jokes and observations that are lost in translation when applied elsewhere. Situation comedies are, therefore, often re-made or re-interpreted by 'local' producers in order to find success in foreign contexts. The same format can be applied in a number of different contexts as long as its aesthetic properties are tailored accordingly.

Bielby and Harrington (2008) found that the aesthetic properties of television programmes are evaluated by audiences on the basis of their common understanding of the forms and conventions associated with genres. However, this evaluation is not just something that occurs within the ranks of audiences; it occurs right across the culture world, as all the participants in the production, distribution, regulation and consumption of television content, including network executives, producers, buyers, sellers, agents, distributors, advertisers, critics and policy makers, anticipate which television programmes will resonate with audiences. So, for example, sellers of television content anticipate the aesthetic properties which might appeal to audiences, and buyers 'lay claim to being privileged interpreters of viewers' tastes, much like book reviewers' (Bielby and Harrington, 2008, p. 16). Applying Bielby and Harrington's findings more broadly, we can see that even if there is a proliferation of 'omnibus products', the fate of cultural objects depends not only on the degree of economic might enjoyed by corporations but also on the ways in which audiences and numerous other people involved in the culture industries evaluate objects on the basis of aesthetic properties. More significantly, we can see that even omnibus products can never be entirely homogenized or calculable. Precisely because they are *cultural*, all these objects contain aesthetic properties, signs, symbols and elements that are ambiguous, intangible and which, successfully or otherwise, serve to entertain, persuade, edify or amuse us. As we have seen, in Chapter 5, cultural objects have presence, but their various properties mean different things to different people in different contexts.

Complex trends in film production

The above examination of cinema admissions data indicates trends towards cultural homogenization, but also demonstrates that global cultural flows are complex and are by no means unidirectional. This complexity is all the more apparent when one examines film production data. Despite the 2008 global financial crisis, world film production increased by 27.8 per cent from 2005 to 2009. The UIS report reveals that the top five countries with major film production were as follows: India, 1,288; Nigeria, 987; United States, 734; China, 475; and Japan, 448 (UIS, 2012). We can see from this that India produces more films than any other country, tailored not only to India's population of an estimated 1.21 billion but also to the Indian diaspora from continent to continent. In 2000, Indian film exports generated over $100 million for the first time, and what has become known as the Bollywood film industry became a global force in the 1990s. 'Bollywood', which refers to the Hindi-language-based cinema industry of Mumbai, is just one production centre among many in the Indian film industry, though it is the most famous. 'Bollywood' became a new term in the English language, and according to Govil (2007), it became globally relevant through its deployment of nostalgic, primordial national sentiment in mass cultural forms. More specifically,

> [t]hrough the heterogeneous deployment of folk forms, Indian cinema offered a way to indigenise global mass culture through the matrix of the popular; at the same time, cinema repackaged the vernacular into mass cultural forms that allowed entry into the global modern (p. 78).

Cinema-going is a popular pursuit in India and the total admissions figure for 2009 was an estimated 2,917,000,000. This is more than twice the number of people going to the cinema in the USA in the same year (UIS, 2012, p. 17). With 987 films made in 2009, Nigeria's Nollywood industry continues to produce a large number of films. In 2007 it made 1,559 films, more than any other country (UIS, 2012, p. 9). China's cinema-going audience (263,800,000) grew by 67.8 per cent from 2005 to 2009 and the number of films made in China nearly doubled from 2005 to 2009 (UIS, 2012, p. 18). The Chinese film industry is likely to become more prolific as it is encouraged by the Chinese government's ambitions to increase China's cultural influence in the world. As Miller *et al.* (2001, p. 49) observe, Hollywood's success

'has been a coordinated, if sometimes conflictual and chaotic, attempt by capital and state to establish and maintain a position of market and ideological dominance, in ways that find US governments every bit as crucial as audiences and firms'. This conflictual combination of capital and state is increasingly evident in China, where the political elite is seeking to enhance the country's *soft power*. For example, in 2012, President Hu Jintao expressed concern over the dominance of cultural forms derived from the USA and the fact that China's home-grown culture was in no way commensurate with its growing economic might (Wong, 2012). According to Hu (cited in Wong, 2012):

> We must clearly see that international hostile forces are intensifying the strategic plot of Westernizing and dividing China, and ideological and cultural fields are the focal areas of their long-term infiltration.

In 2012, at around the time Hu wrote this article, China had demonstrated an increasingly heavyweight political role in international relations. As the twenty-first century unfolds its political role is certainly matched and enabled by its economic power. A Standard Chartered Bank Report in 2011 predicted that China's GDP (gross domestic product) would surpass that of the United States by 2020 and thus would have the biggest economy in the world: Its GDP was $5.7 trillion in 2010 and was predicted to rise to $24.6 trillion, driven by consumer growth. This means that it would move from being the second largest to the largest economy in the world (the USA economy was predicted to rise from $14.6 trillion to $23.3 trillion in 2020) (Rapoza, 2011). This is part of what scholars have termed a *re-emergence* of China as an economic force, highlighting that it had played a central role in the world economy before 1800 (Frank, 1998) and drawing attention to its growing consumer class. With this increasing wealth, and an emerging consumer class to court, President Hu sought to divert the Chinese public away from USA-derived cultural products that he perceived to be infiltrating the Chinese cultural terrain and promoting American values. He sought to wrest back control over the cultural terrain and to encourage home-grown Chinese cultural productions. In 2012, the Chinese state news agency Xinhua (2012) reported that the government had cut the number of entertainment shows on the country's 34 satellite channels by two-thirds so as to reduce the amount of 'excessive entertainment'. A number of shows were identified which were based on adaptations of American-influenced television formats and were considered to be of 'low taste'. These included talk shows, dating

shows and talent contests, and their number was cut from 126 at the end of 2011 to 38 after the restrictions came into place in early 2012. The State Administration of Radio, Film and Television made the changes so as to improve the quality of programming and to 'promote traditional virtues and socialist core values' (Xinhua, 2012). These directives are part of a defence of national Chinese culture, one that seeks to challenge the hegemony of American culture with China's own cultural productions. However, it is by no means a straightforward task to persuade the Chinese television audience, the largest in the world, estimated at 95 per cent of its 1.3 billion people, to wean themselves off USA-derived popular culture, and to engage with more 'local' content. Certainly, the Chinese government is aware that it is currently losing the 'culture battle' to the USA, and in recent years, the films that have generated the largest box-office numbers in China have been predominantly USA-derived products designed to appeal to '*audiences of all backgrounds in all countries* because they are weakly differentiated and differentiating' (Bourdieu, 2003, p. 68). This is because, as Wasko (2003) writes, Hollywood writers have been encouraged to think globally and to create 'transparent texts' that can be readily comprehended and enjoyed by audiences from country to country as though they are indigenous products. This strategy has worked in countries such as China in recent years, and *omnibus products* hailing from the USA such as *Avatar* and *Transformer 3* have so far proved to be far more popular with Chinese audiences than state-sponsored productions. However, even where the state is able to provide alternatives to the cultural offerings of transnational corporations, the cultural objects it fosters might be equally homogenized and homogenizing, and, for example, serve the interests of dominant groupings within a particular society at the expense of less powerful groupings. As Tehri Rantanen (2004) observes, the 'national' may favour the dominant ethnic group over minorities, or it might operate in favour of the dominant political class of a given nation.

Concluding remarks

Notwithstanding the dominance of USA-based transnational corporations in producing and disseminating the films that we are likely to find at our local multiplex cinemas, it would be incautious to suggest that it is primarily *Americanization* that is threatening the heterogeneity of cultures around the world. According to Arjun Appadurai (1990), the fact is that smaller nations have more to fear from their

powerful neighbours, so that, for example, Koreans might be more concerned about Japanization; Sri Lankans about Indianization; and Cambodians about Vietnamization (Appadurai, 1990, p. 295). Furthermore, Robertson (2001, p. 464) makes the point that what is termed 'Americanization' 'is really a pastiche of American popular culture, unrecognizable in its crassness as "American" to anybody who has lived in the USA for any length of time'. It is also worth noting that Hollywood was in great part shaped by the inward flows of Jewish immigrants to the USA from Central and Eastern Europe. The USA is not in itself a homogeneous culture and the interactions of its many migrant groups, whether from European, Asian, African or Latin American countries, serves to increase its cultural heterogeneity (Giulianotti and Robertson, 2009, p. 52; Robertson, 2001, p. 465). Arguments regarding the prevalence of Americanization, it seems, can be over-simplified to the point of being meaningless. The real argument remains, however, that there is an intractable conflict between the impersonal forces marshalled by the logic of profit and the impulses of creativity and aesthetics.

This is a perennial struggle, but it is one which is exacerbated where attempts are made to treat culture in formally rational terms in the same way as any other commodities. It is exacerbated because transnational corporations are increasingly at liberty to impose 'omnibus products' on the planet. It is exacerbated during times of economic crises and where a process of commodification dominates the relationship between the state and the arts. However, as Appadurai (1990, 1996) points out in relation to globalization and culture, there is a tendency of sameness and difference 'to cannibalize one another', thus ensuring that global culture will always be characterized by disjuncture rather than by any kind of uniform pattern. Cultural objects shift in meaning as they are embedded in new contexts, and even the most uniform cultural products disseminated by transnational corporations are nevertheless *cultural* objects and so have aesthetic properties that burst out of the straightjacket of calculability. When engaging with these objects, as Bielby and Harrington (2008) have demonstrated in relation to television programmes, audiences make evaluations of aesthetic criteria on the basis of widely held genre codes and conventions. Applying this insight more broadly, we can see that there are countless online forums where heated discussions take place assessing the variable qualities of, for example, blockbuster films, operas, popular songs, novels, video games as well as television serials. Is the plot of A engaging? Did the soprano capture the pathos of B? Is the characterization

convincing in C? Was there suitable clarity and pace in the orchestra pit of D? How well choreographed are the dance moves in E? How good is the idea behind video game F? What does painting G tell us that we didn't already know about human existence? Such questions are concerned with aesthetic criteria, which always rise up in contradistinction to formally rational criteria, even if they might ultimately inform the extent of the cultural object's popularity (or lack thereof), sales figures (or lack thereof) and audience ratings (or lack thereof), and feed back into the production process. In the next chapter, we will consider the co-existence of sameness and difference in a globalizing world and the ways in which culture creators utilize the resources at their disposal in order innovate and to put forward *their* aesthetic, *their* unique take on things, even if, paradoxically, they are tapping in to repertoires of images and sounds that are, access notwithstanding, commonplace and globally available to us all.

7
The Local on the Global Stage

Introduction

Informed by Roland Robertson's work on *glocalization*, which he refers to as 'the intensified interpenetration of the local and the global, the universal and the particular' (Giulianotti and Robertson, 2007, p. 168), this chapter examines the inventive strategies deployed by light-footed and relatively powerless *culture creators* as they project their visions of the 'local' onto a global stage and display their talent in forms of embodied cultural capital which audiences, it seems, are willing to read as unique. These creators inventively borrow and consciously adapt 'global' cultural forms in order to voice their own concerns; or, more ambitiously, they steal, in the mode of Picasso, in order to make something entirely their own. This applies to 'local' producers adopting 'global' television formats or music genres as much as it applies to archetypal garret-ensconced artists daubing paint on their canvases. However, the latter part of the chapter focuses on musicians and artists who consciously and semi-consciously project their cultural habitus, in their work and in their person. They are, therefore, *complex carriers of signs projected for audiences willing to recognize them as embodying the apotheosis of particular styles or genres*. So, for example, the nonagenarian Cuban musician Compay Segundo, who rose to fame in the 1990s, shrewdly and swift-footedly (especially for a man of his age!) projected himself as the embodiment of Cuban music history and in his recordings and concert performances, he re-imagined and re-invented Cuban *sones*, *danzones* and *walzes* from bygone years for audiences that found a source of inspiration in the element of the 'local' that he projected onto the global stage. The ability to convey this style is clearly not something anyone could do, and Segundo absorbed particular Cuban

musical traditions so that he carried them with him in his every moment and utterance. His physical presence and his style came to symbolize Cuban music as much as have the pieces of music he recorded.

Hybridization and glocalization

Before we return to the above-mentioned examples, let us consider the *complexity* associated with culture in a globalizing world. Jan Nederveen Pieterse (1995, p. 53) asks the following:

> How do we come to terms with phenomena such as Thai boxing by Moroccan girls in Amsterdam, Asian rap in London, Irish bagels, Chinese tacos and Mardi Gras Indians in the United States, or 'Mexican schoolgirls dressed in Greek togas dancing in the style of Isodora Duncan' ... ?

His answer is simple: we see these strange cultural phenomena because culture in a globalizing world is increasingly subject to processes of *hybridization*. This is evident in 'the ways in which new forms become separated from existing practices and recombine with new forms in new practices' (Rowe and Schelling, cited in Pieterse, 1995, p. 49). The concept of *hybridization* is closely related to the concept of *creolization*, which, in the Caribbean and North America, refers to the mix of European and African influences. This can be seen, heard and tasted, for example, in the music and food cultures of New Orleans, with its gumbo dishes and its hot jazz. Hybridization is also related to the Latin American concept of *mestizaje* which is also concerned with mixing and boundary-crossing. However, whereas *creolization* and *mestizaje* are specific to the Americas, *hybridization* is a global concept; it refers to a global melange (Pieterse, 1995). In contrast to concepts of multiculturalism and cultural diversity, which indicate that a range of cultures co-exist alongside one another, hybridization involves the syncretism of different cultures out of which emerges a new, hybrid, third culture. For example, in the case of migration, we often find that second or third generation immigrants create a new lifestyle forged out of the mix of influences deriving from their 'home culture' and their host culture. According to Pieterse (1995, pp. 56–57), differing power dynamics underpin the various forms of cultural syncretism, and there is a continuum of hybridities involving 'an assimilationist hybridity that leans over towards the centre, adopts the canon and mimics the

hegemony, and, at the other end, a destabilizing hybridity that blurs the cannon, reverses the current, subverts the centre'. Although processes of cultural mixing are longstanding, and therefore we are witnessing the hybridization of already hybrid cultures, Pieterse argues that there is an accelerated process of hybridization associated with globalization, fuelled by migration, by diasporas, by border-crossing, and informed by historical processes of colonialism and trade (1995, pp. 63–64).

Pieterse offers some useful critical points in relation to the cultural homogenization thesis (see Chapter 6). First, he argues, it downplays the significance of the counter-currents: the forms of non-Western culture that influence the West. Second, it fails to account for the ways in which Western culture is received in non-Western countries; namely, the ways in which it is indigenized, blended with 'local' cultural forms. Third, it overlooks the influence that non-Western countries have on each other. Fourth, it doesn't account for cross-over cultures that emerge when different cultures meet. Fifth, it fails to recognize the culturally mixed nature of what we consider to be Western culture: it 'overlooks the fact that many of the standards exported by the West and its cultural industries themselves tend to be of culturally mixed character if we examine their cultural lineages'; furthermore, it is not sufficiently aware that Western hegemony is, in the scheme of things, a relatively recent phenomenon, dating from around 1800 (Pieterse, 1995, p. 53). However, the hybridization perspective has in turn faced some criticism. For example, Giulianotti and Robertson (2009, p. 42) are critical of hybridization as a biological metaphor, arguing that 'it may promote the false assumption that phenomena which are "hybridized" had been initially in a state of distinctive cultural purity'. It has also been argued that the extent of cultural hybridization is exaggerated and that it is predominantly an elite experience, confined to the jet-setting global business-class and conference-hopping academics able to travel from one metropolitan region to another, from conference to conference, from hotel to hotel, mixing with a great range of people and developing a cosmopolitan disposition (Bauman, 1998, p. 101; Friedman, 1997). In a related point, Martell (2010, p. 103) argues that there is a danger that in drawing attention to the important issue of reverse cultural flows and human agency, the hybridization perspective can easily gloss over the significance of Western power, whether cultural, political or economic. Therefore he argues that '[i]t may be better to see hybridization as a development within the dominant power of the West and the process of homogenization,

rather than something that overturns the latter' (Martell, 2010, p. 103). As we have seen in the previous chapter, it would be folly to underestimate the ubiquity of cultural objects (in the broadest sense of the term, referring not only to films, music and art but also to food and drink) produced and disseminated by transnational corporations or to ignore the might of these companies in setting the cultural agenda. Let us now turn, then, to the concept of glocalization which has more flexibility in enabling us to understand that *there are* homogenizing tendencies in this globalizing world, but that there are also, paradoxically and simultaneously, tendencies towards diversity. There are also elements of ambiguity even in the most standardized cultural object.

The concept of glocalization derives from the Japanese marketing term *dochakuka* which translates as 'global localization' and hence *glocalization* (Robertson, 1992, p. 168). It originally referred to the adaptation of agricultural techniques to local conditions, but by the early 1990s, *glocalization* was a buzzword in marketing, and Robertson popularized its use in sociology. In this context, it refers to '"real world" endeavours to recontextualize global phenomena or macroscopic processes with respect to local cultures' (Giulianotti and Robertson, 2007, p. 168). When pursuing new markets across the world, marketers relying on a standardized product with a homogenous target group in mind are likely to fail. For example, jeans are marketed all over the world and have become something of a ubiquitous leisure uniform. However, there is considerable variety in the ways in which they are worn and so, *glocalizing* strategies are required, enabling marketers to contextualize generic global products so that they are suitable for specific local conditions (Robertson, 2001, p. 464). Let us consider the example of McDonald's, which has extended its reach around the world in recent years. There are now more than 34,000 McDonald's restaurants worldwide, and there are McDonald's restaurants in 119 countries (McDonald's, 2013). In 2011, McDonald's total revenue was over $27 billion, and 40 per cent of its sales were in Europe, 32 per cent in the USA, 22 per cent in Asia/Pacific, Middle East and Africa, and 6 per cent in other countries (McDonald's, 2012c). The restaurants serve an estimated 68 million people every day (McDonald's, 2012a). Barber's (2003, p. 23) observation still holds that McDonald's serves more people daily than the total population living in Greece, Republic of Ireland and Switzerland combined. Despite times of austerity, McDonald's (2012b) reported in March 2012 that their global sales had risen by 7.1 per cent, and this included a 9.1 per cent rise in the USA, a 4 per cent rise in Europe and a 5 per cent rise in Asia/Pacific, Middle

East and Africa. McDonald's fastest growing market is in China where a new restaurant is said to open every other day (Yan and Jones, 2010). There are 14,098 McDonald's restaurants in the USA, 7,156 in Europe, 8,865 in Asia/Pacific, Middle East and Africa, and a further 3,391 in other countries (McDonalds, 2012c). McDonald's success has been in great part a result of its glocalizing strategies. For example, in India, where Hinduism is the majority religion, the Chicken Maharaja Mac replaces the beef-derived Big Mac; in Germany, which is renowned for the quality of its beer, partly as a legacy of the sixteenth century German Beer Purity Law, it is possible to buy beer in McDonald's restaurants; in Japan, the place of origin of the *glocalization* concept, McDonald's has adapted to particularistic, local criteria and now sells Ebi Filet-O (shrimp burgers), Ebi-Chiki (Shrimp nuggets), Koroke burgers (consisting of mashed potato, cabbage and katsu sauce) and green-tea flavoured milkshakes; in Chile, avocado paste is offered as an alternative to tomato ketchup; in Costa Rica, Gallo Pinto (rice and beans) is on the menu; in Hong Kong there are Rice Burgers; in Greece there is the Greek Mac, where the burger is wrapped in pita bread (Adams, 2007). These examples are devised as part of a corporate marketing strategy out of which emerges new foodstuffs which are expressive of sameness *and* difference. Here we see examples of glocalization in action, expressly serving corporate interests.

The global and the local

The concept of glocalization also enables us to understand the complex interaction between the 'global' and the 'local'. As we have seen, Robertson is critical of accounts of globalization that place excessive emphasis on economic factors; along similar lines, he refutes the hyperbolic claims that we have entered a global age as part of an epochal change (see Albrow, 1996). According to Robertson (2003), we are living through a glocal age rather than a global age and this involves the mutual interpenetration of the global and the local. This serves to undermine the widely held understanding of the global-local as a continuum, with the global at one end, the local at the other and with the global perceived to be an overwhelming force, likened to a great tide that threatens to wipe out the local, the indigenous and the small-scale. To Robertson (1995, 2001, 2003), the local is itself 'an extra-local product ... the local is globally – certainly translocally – produced'. What we understand to be 'local' is itself a phenomenon of globalization (Robertson, 2001, p. 465) and '[t]o subscribe to the idea

of "the local in itself" – without contextualization or framework – makes no sense' (Robertson, 2003). We can gain a better understanding of the ways in which the local is globalized (just as the global is localized) by returning to one of the four reference points (see Chapter 6) that have been crystallized during the course of the past few hundred years as we have experienced a higher degree of global density: national societies, sometimes seen as the apotheosis of the particular or the local resisting the global, have themselves gained definition as part of an international process. Countering Albrow's (1996, p. 81) claim that globalism tempers the particularism of nationalism, Robertson (2003) argues that nation states, which have very similar features, increasingly need to emphasize their uniqueness, giving 'a particular gloss ... locally to the more generally similar' and thus distinguishing themselves from others. Modern nations 'have tended to promote discourses concerning their own unique difference, a practice much encouraged in and by the great globalizing thrusts of the late nineteenth and early twentieth centuries' (Robertson, 1995, p. 41). In this light, nationalist sentiment, and, by extension, the assertion of particular ethnic identities can be seen as an outcome of interplay between the global and the local. So, national or ethnic particularities, and the cultures of diasporic groups, are forged as part of an essentially global process; the 'local' is thus trans-locally produced (Robertson, 1995, p. 30).

Along similar lines, it is ironic that a number of organizations that have sought to counter the influence of globalization have 'gone global' in order to do so. For example, anti-globalization (as laissez-faire economics) sentiment is also expressed by a number of social movements and activists, including, for example, those who organize the *Anti-Marketing* campaign (Anti-Marketing, 2011). In contrast to the common-held belief amongst economists (see, for example, Dornbusch, 1992) and the Western political classes that the way out of poverty for developing countries is the pursuit of economic growth, structural reform, the reduction of trade barriers and, more broadly, trade liberalization in alignment with globalizing trends, the Anti-Marketing campaign argues that globalization is '[t]he process of exploiting economically weak countries by connecting the economies of the world, forcing dependence on (and ultimately servitude to) the western capitalist machine'. The campaign puts forward an anti-globalization agenda that seeks to counter the harmful effects of globalization 'and to reform unbridled capitalism' (Anti-Marketing, 2011). They argue that organizations such as the WTO and the IMF have over-

seen an era of rising global inequality. There is much evidence for this: A 2011 report by the Credit Suisse Research Institute found that the bottom 50 per cent of the world population possesses 1 per cent of global wealth. In contrast, the top 1 per cent owns 44 per cent of global assets, and the top 10 per cent owns 84 per cent (Anti-Marketing, 2011, p. 10). Three years after the financial crises of 2008, a Forbes report found that the global billionaire class was ever-growing, having risen from 497 in 2001 to 1,210 in 2011 (Petras, 2011). With a total net worth of $4.5 trillion, this class owns more than the combined worth of 4 billion people in the world. Reflecting on these figures, James Petras (2011) writes that '[t]hanks to trillion dollar ... bailouts, the billionaires class has recovered and expanded, even as wages in the US and Europe stagnate and "living standards" are slashed by massive cutbacks in health, education, employment and public services' (Petras, 2011). Alongside this billionaire class, there exists a growing slum population, often living in close proximity to the gated communities of the wealthy. According to the United Nations report (2010) *State of the World's Cities*, the estimated figure of slum dwellers is currently around 830 million, and this figure is likely to rise to 900 million by 2020. These stark contrasts between rich and poor bring to mind Plato's warning that: 'if a state is to avoid ... civil disintegration ... extreme poverty and wealth must not be allowed to rise in any section of the citizen-body because both lead to disasters' (cited in United Nations, 2009, p. 57). Increasing public awareness of these global inequalities is undermining the credibility of the Anglo-American model of economic globalization. Indeed, many have issued strong critiques of the world of 'free-trade' (see, for example, Stiglitz, 2002) having been part of that very world. However, a further paradox that emerges out of the anti-globalization movement is that the USA is considered to be 'the *home of opposition and resistance to globalization*, in spite of the widely held view that globalization is an American project' (Robertson, 2001, p. 459). Many anti-(or alter[1]) globalization organizations – including Anti-Marketing – utilize global communications media such as the Internet in order to promulgate their arguments, and their intended audience is global rather than national. Therefore, we can see that, as Robertson (1992, p. 10) states, 'just as ostensibly anti-modern gestures are inevitably in a sense modern, so are anti-global gestures encapsulated within the discourse of globality. In *that* particular sense there can be no foreseeable retreat from globalization and globality'. This is not to suggest that the missions of anti-globalization organizations are necessarily contradictory. For example,

the International Forum on Globalization (IFG) (2011) is a global citizen movement that is nevertheless anti-globalization. It manages to resolve the seeming awkwardness of this position by drawing attention to its opposition to a *particular aspect* of globalization: it opposes the economic globalization characterized by so-called 'free-trade' which, in the name of 'development' or 'poverty alleviation' favours transnational corporations over workers, rich nations over developing nations and is dominated by institutions such as the World Trade Organization, the International Monetary Fund and the World Bank, which are not democratically accountable. We can see from these examples that in drawing attention to inequalities in the twenty-first century, protest movements increasingly turn to the discourse of globality in order to make their case. Similarly, organizations that seek to promote 'local' rights and to protect the rights of native or indigenous peoples increasingly turn to global organizations such as the United Nations (with its Permanent Forum on Indigenous Issues) in order to make their case heard (Robertson, 2003).

Glocalizing strategies

Let us consider glocalizing strategies in the field of cultural production. As we have seen, culture creators employed by transnational corporations pay keen attention the aesthetic elements of the cultural objects they produce; they are aligned with the cultural sensibilities of the buyers that they hope to sway in global markets, who in turn try to anticipate the tastes of the audiences. In the example that follows, we see how Viacom glocalized its media content in order to access new markets in East Asia. This corporate-driven strategy of glocalization enabled the company to further consolidate its dominant global position. One of its brands is MTV, which is a music television station launched in 1981 that reaches an estimated half a billion households, including 107.1 million in Asia-Pacific and 270.4 million in North America. The channel is aimed at young people and works across TV, mobile and online platforms. Although famous for its music videos, it also airs popular television programmes such as *Awkward, Beavis and Butthead, Jersey Shore* and *Teen Mom*.[2] In recent years, Viacom, along with other transnational corporations, has taken advantage of trends towards the deregulation of global media ownership and the privatization of television and has sought to enter new markets (Cho and Chung, 2009; Herman and McChesney, 1997). However, as research on the glocalization of cable content in China, Korea and Japan by

Seungho Cho and Jee Young Chung (2009, p. 322) demonstrates, Viacom's success in Asia has been by no means straightforward. The standardized products it initially offered were not successful; viewing figures stagnated, and it was found that audiences in the main preferred local media content. So, Viacom, along with other transnational corporations facing a similar challenge, 'began responding to the local environment by transforming their product and/or business models, relying heavily on local cultural factors to determine the most successful business and programming models in a local market' (Cho and Chung, 2009, p. 322). Their strategies, which involved hiring local staff (including local producers) and blending global and local content (Cho and Chung, 2009, p. 325) were constrained by and formulated in response to political and legal issues, currency exchange rates, and the cultural policies of the host governments (Cho and Chung, 2009, p. 324). For example, when MTV began broadcasting in East Asia, it edited its content so as to avoid upsetting Asian audiences with material that might be considered offensive (Cho and Chung, 2009, p. 326). In their analysis of MTV's entry into East Asia, Cho and Chung (2009, p. 327) tested four hypotheses:

H1: MTV's prime choice of business structure will be joint venture when localizing in Korea, Japan and China, rather than other business models.
H2: MTV Korea, MTV Japan and MTV China use more local content than foreign content.
H3: MTV Korea, MTV Japan and MTV China hire more local than foreign staff members for hosting a programme.
H4: As regards location, the production of programmes is more local than global.

They found that with some qualifications, each of these hypotheses was supported. Joint-business ventures were pursued by MTV in these areas of Asia in order to offset the financial risks of investing in a region which is, for Viacom, culturally and politically distant. They found that the majority (66.4 per cent) of music programmes on MTV Korea were concerned with local popular music even if this could be explained, at least in part, by Korea's longstanding cultural isolationism (Cho and Chung, 2009, p. 337). Furthermore, although MTV China showed few local music programmes (2.9 per cent) due to the undeveloped nature of China's music industry and its reliance on neighbouring countries for its media content, the channel offered a

number of music programmes from Taiwan, Korea and Japan, thus suggesting that 'these genres are preferred to Western music, due to cultural proximity'. In Japan, Western music (17.1 per cent) was preferred to local genres (5 per cent), this arguably reflecting Japan's adaptation of and openness to Western popular culture. However, the dominant genre on MTV Japan was multinational music, which accounted for 40.7 per cent of programmes.

Cho and Chung (2009, p. 337) found that local staff were widely deployed across the region. 86 per cent of MTV Korea's VJs (video jockeys) were Korean; 67 per cent of MTV Japan's VJs were Japanese. In China, only 34 per cent of the VJs were Chinese, owing to the fact that MTV China was dependent on other countries' programmes, Taiwan's in particular. It was revealed that MTV Korea and MTV Japan produced the majority of their programmes locally (95.9 per cent and 71.4 per cent respectively), even though 25 per cent of the programmes shown on MTV Japan derived from the USA. MTV China produced a minority of its content (20.7 per cent) and was reliant on programmes made in Taiwan (31.7 per cent), USA (16.3 per cent) and Singapore (15.4 per cent) (Cho and Chung, 2009, p. 334). In sum, Cho and Chung's research highlights that even as transnational corporations such as Viacom extend their reach around the globe in pursuit of new markets, they need to adapt glocalizing strategies in order to appeal to local audiences. Even in the case of China, which is dependent on other countries' media production, 'audiences are more likely to watch or listen to culturally similar media content, or music from countries which are geographically close, such as Taiwan' (Cho and Chung, 2009, p. 338). We can see in this example that the cultural objects produced by Viacom were altered so that their aesthetic properties were aligned with local tastes. What is missing from this research, as the authors acknowledge, is a probing of the extent to which the music and the music programmes on these channels are standardized even if they are made in response to local conditions. In other words, even if MTV *glocalizes* its content in China, Japan and Korea, it might nevertheless be peddling aesthetically re-aligned, locally modified versions of what are nevertheless omnibus products. It is all too easy to overemphasize the level of creativity or innovation involved in the glocalizing process, even if the professional culture creators employed by Viacom are canny, sophisticated and successful in targeting audiences.

If the above example of glocalization is led from the top down, the emphasis of the next example is more 'bottom up', representing an attempt by 'local' musicians to make a global music style their own,

utilizing it as a vehicle with which to express their own worldview, their own particular political preoccupations. The songs *La Rage* (which has been viewed more than two and half million times on the YouTube website) and *V pour Verites* by Keny Arkana provide rich examples of the interpenetration of the global and the local, as envisaged by Robertson. The songs are rooted in the hip-hop genre, which has been a prominent urban music genre in the USA since the 1980s, and is now very much a global cultural form. Arkana has Argentinean heritage, and grew up in Noailles, a poor immigrant neighbourhood in Marseilles which is a French sea-port with a population of 820,000 and has a long history as a destination for immigrants. The population includes 200,000 Muslims, 80,000 North African Jews and 80,000 Armenians, and it has become one of the centres of hip-hop music in France (Kimmelman, 2007). The Marseillais brand of hip-hop, which incorporates elements of flamenco, reggae and blues, differs from the more aggressive style that emerges from the *banlieues* (housing estates on the outskirts of the city) of Paris both in terms of musical and lyrical content. At face value, Arkana's 'French rap' could be seen as another example of Americanization. However, she gives a particular 'local' gloss to this global genre: her lyrics are expressive of tensions in French society and, for example, she cautions against the branding of French ghetto youth as terrorists, arguing that 'every new shoot of change is cut off by sergeants' truncheons, the armed cops of colonial racism' (in *V pour Verites*). Furthermore, she uses a global genre to express 'alter-globalization' sentiment, and in calling for an uprising in *La Rage*, she expresses her opposition to a Western world which 'still wears its colonial dress'.

Discussion: Culture creators and cultural habitus in a glocalizing world

Robertson's argument regarding the co-presence of sameness and difference in a globalizing world is persuasive because, as we have seen, even the most powerful global corporations have to 'glocalize', to adapt their cultural production to local conditions so as to gain the approval of local populations and thus gain access to new markets (Robertson, 1992). Furthermore, what we consider to be the 'local' is in fact something that is created or recreated at a trans-local level. New cultural forms emerge out of the global-local dialectic, imaginatively reconfigured out of existing materials. However, the concept needs to be utilized and applied carefully. There is a danger that, like the world

of marketing from which it derives, it can be applied in a way that is all too seductive and slick, without regard for the disproportionate power relations that underpin each instance of the interpenetration of the global and the local. For instance, many of the above-mentioned examples of glocalization represent the creative and flexible strategies of transnational corporations pragmatically adapting in order to extend their reach and to penetrate into new markets. So, at a macro-level, we have seen that global media flows, though complex and to some extent multi-directional, are often disproportionally guided by transnational corporations. It should come as no surprise then, that the field of cultural production is dominated by those with the most significant stores of economic capital, hence the proliferation of relatively undifferentiated 'omnibus products' designed to appeal to everyone on the planet or carefully tailored but mass produced glocalized products. It is easy to overlook the fact that a great many of these cultural objects are created in accordance with an aesthetic of short-term profit and even if they are, inevitably, made up of at least some ambiguous aesthetic elements, the success of such objects is measured in formally rational terms: in terms of consumer market criteria, box-office receipts, viewing figures and sales figures. With this in mind, it is important to *zoom in* on each example of glocalization, to consider specific *ingredients* involved. This means developing research that explores the *intentions* of the actors involved: the complex mixtures of instrumental and value rationality motivating the various parties; the *power relations* that underpin the engagement and the resources involved; the types and degrees of *cultural creativity or inventiveness* that enable each moment of culture. This is no easy or straightforward task because to research the *ingredients* of glocalization in this way is to set forth on a research project without bounds if we bear in mind that for Robertson, glocalization *is* globalization.

As we have seen, the strategies deployed by transnational corporations often succeed but they often fail; they rely on 'local' expertise in order to expand their reach. Even though as they lighten the weight of their business practices so that they are, increasingly, purveyors of brands that indicate lifestyles and experiences (Klein, 2000), such corporations are nevertheless, at times, ungainly and heavy-footed. Individuals, on the other hand, representing one of the crystallized reference points of Robertson's (1992) model of global density, are far more light-footed. They inherit and learn, they adapt, they borrow, they steal, they assimilate, and they make cultural things their own even if not, to paraphrase Marx, under circumstances of their own

choosing. Most *culture creators*, whether filmmakers, sculptors, short-story writers or musicians are completely outgunned and outmanned when they enter the field of cultural production and prepare to compete against already established, well-resourced competitors. Nevertheless, as Walter Benjamin (1973[1938], p. 41) writes, with reference to Balzac, 'artistry ... is tied to a quick grasp'. So, as we saw in the example of Arkana, culture creators use the materials they have at their disposal; they indigenize styles that are imported from elsewhere; they deploy aesthetic elements that are globally familiar but add elements of strangeness; and so, they take up their positions in what is a complex and disjunctive cultural order (Appadurai, 1990, p. 295). This is not to say that they are morally superior to those who pursue, without reservation, instrumentally rational ends. However, they do operate in accordance with a different logic and, of course, the particular motivation in each case is a complex commingling of conscious and semiconscious motives and affects that need to be untangled. In examining culture in a globalizing world, we need, therefore, to research the fleet-footed movements of creativity as much as we need to be attentive to the significance of economic might. As we have seen with the example of music, the intensification of cultural flows across the globe has enabled the proliferation of music styles and repertoires that simultaneously reflect an engagement with global styles and enable room for the inclusion of local preoccupations. However, these flows, as seen in the *ethnoscapes* of the global cultural order, involving people on the move – whether as tourists, migrants, guest-workers or refugees, mean that diasporic musicians also have to be on the move, both literally and creatively, utilizing cultural forms they have inherited or learnt, assuaging and rekindling a longing for their homeland and triggering similar sentiments in the minds and hearts of diasporic communities (Appadurai, 1990). For example, Jocelyne Guilbault (2001, p. 183) provides insight into the transnational lives of Caribbean calypso musicians 'which both shape and are shaped by the global music industry' and by patterns of migration stretching back for 150 years from the colonization to the decolonization of Trinidad to the present day where many Trinidadians emigrate in response to their marginal position in the global economy. As a consequence of their migration and their touring and recording itineraries as musicians, it becomes difficult to say exactly where they belong. Guilbault describes how they live as transnationals, their lives stretching across borders and networks. To take one example, the musician Arrow – a calypso artist from Montserrat, a professional culture creator, frequently records in

New York City at a studio owned by a Jamaican, where he works with musicians and arrangers from the United States and various parts of the Caribbean. As well as forming transnational relationships and leading transnational lives, musicians such as Arrow appeal to transnational audiences many of whom are rooted in places other than Trinidad, Antigua, London and New York. But in making the connection with these audiences, the musicians reinforce ties with diasporic communities and with their country of origin. As the musicians move across borders, their music as much as their identities is marked by the politics with which they engage and their interactions with different people, whether Caribbean diaspora or Western audiences. The various musical styles and forms of instrumentation that they encounter on their travels impact on their creativity. Nevertheless, as part of this process, their own particular conception of calypso music is given definition; it is re-imagined and renewed; it is neither swallowed up by Western musical styles nor is it wiped off the face of the planet. As the genre is deterritorialized, it feeds the homeland nostalgia of diasporic Trinidadians as well as providing a source of inspiration or fantasy for Western audiences and newly converted fans. We can see from this example that as musicians form part of the ethnoscapes, they borrow or indigenize global sounds as much as they reinvent their own traditions; they take aesthetic elements of host cultures; and out of cultural syncretism they forge new music. The globalization of culture is as much an interpenetration of the old and the new as it is of sameness and difference. Out of these cultural flows and inter-cultural fusions develop new musical forms bearing the marks of old styles.

Considering musical performance in its broadest sense, from the singer in a folk band to the *ultra* football fan leading a chant on the terraces, individuals semi-consciously and strategically make much of their cultural habitus, their embodied cultural capital or their bodily capital, whether it is the singer expressing pain and joy in a manner we can all recognize or in the group-inspiring bellicosity or joviality that the leader of a football chant embodies. In each case, the creative act is an example of a regulated improvisation, rooted in the conditions of the past and responding within the confines of the specific context within which it takes place. If the performance fails to convince its audience, they will probably let the singer know, whether through jeers or stony silence. In the case of the first example, the singer might work within and perhaps steps beyond the rules of the particular expression of folk music. This type of creativity involves the recreation and re-invention of the aesthetic elements of existing ethnic cultural

forms, a process that is mirrored around the world in relation to various folk genres. It is, therefore, a translocally produced 'local' style, created in relation to but distinguished from other similar styles. However, for the singer's particular mode of expression to work and for it to appear to be genuine, this creativity has to be expressed in a recognizable mode: the singers have to carry themselves in ways that indicate and embody the traditions they represent: they have to operate as carriers of signs, bearers of specific forms of cultural capital that will be recognized by knowing audiences. Their every utterance, their every gesture will have to be recognized as signs representing the essence of the style. Such signs do not, of course, refer to any kind of transhistorical essence of authenticity: they are *socially* and not naturally produced. Furthermore, they are (re)defined in the course of the interaction between the viewer and the culture creator. The same can be said of the song-starting *ultra* at a football match. Even if he represents what seems like an entirely different cultural form with a wholly different aesthetic, he is, nevertheless an interpreter of a particular folk genre. Drawing on a repertoire of songs with which his fellow football fans are familiar, he is the one who has the power to conjure crowd song and to mobilize the voices of his many beer-soaked companions. However, starting a chant and watching it take hold among the throng is not easy. It requires the deployment of certain gestures and signs, and a certain commanding presence and deep tone of voice which will be semi-consciously recognized by his peers as authentic and masculine. Many of his companions will know their role, which is to join in with rather than to start the songs. Their role might be to assist in creating the spectacle, by jumping up and down, dancing, singing and even letting off fireworks. For the *ultra*, the aesthetic conventions of this genre are such that to be shirtless and in shorts is more sartorially appropriate than to be suited and booted. The ultra is indeed a light-footed culture creator, and even if he supports an economically powerful football team, it is likely that the pursuit of his particular aesthetic is self-funded and his legacy will not extend far beyond the particular moment upon which he presses his cultural habitus.

When listening to singers, audiences expect to hear the requisite evidence of musical prowess and technique. However, what also impresses is the cultural habitus of an individual which accords with and perhaps exceeds the expectations associated with particular musical genres. For example, in the singer Compay Segundo (1907–2003) we recognize the embodiment of Cuban musical history because Segundo semi-consciously, strategically, conveyed signs which, for non-Cubans (and

perhaps for Cubans too) represented a uniquely Cuban style. These were recognizable in the cultural objects he created (in recordings, in performances) and in his cultural habitus, in the ways in which he carried himself. Segundo was in his early nineties when he became famous in the late 1990s for his key role performing on the *Buena Vista Social Club* album, which was a global success, selling more than six million copies and launching the solo careers of many of the septuagenarian, octogenarian and nonagenarian Cuban musicians who featured on the album. He also featured in the Wim Wenders directed film *Buena Vista Social Club* (1999), which won 'Best Documentary' in the European Film Awards and was nominated for an Oscar in 2000. In her analysis of the *Buena Vista Social Club* project, Tanya Kateri Hernandez (2002) argues that the album and the film put forward a narrative that is rooted in an ahistorical nostalgia for pre-revolutionary Cuba. In doing so, a misleadingly romantic vision of Cuba was conjured, one that ignores the racial prejudices and economic inequalities of the pre-Castro era. The key consequence of this narrative is that it provides justification for the corporate interests of the United States to stake a claim in Cuban affairs. Hernandez argues that the portrayal of the musicians and the music as unspoilt treasures, largely forgotten by the public and waiting to be discovered is likely to trigger a 'feeding frenzy' amongst corporate interests seeking to gain access to this Cuban exotica and to exploit its commercial potential. In fact, the film, the promotional material surrounding the album, and much of the media coverage omitted to mention that the Afro-Cuban musicians were actually rather well known in Cuba, and were admired by the public. They had already been mobilized, by the band leader of the Afro-Cuban All Stars, Juan de Marcos Gonzalez, and were ready to appear on a forthcoming album. Hernandez argues that Gonzalez consented to the colonialist-tinged portrayal of the musicians as unspoilt treasures because he was aware of the commercial potential of the project (Hernandez, 2002, p. 64).

In her analysis, Hernandez underplays the *agency* of the musicians. For example, Juan de Marcos Gonzalez's consent in allowing these specific representations of the musicians was strategic. It indicates the extent to which he realized that he had a successful project in the making, one which would enable him to convey his particular vision of Cuban music on a global stage. Furthermore, Segundo, when viewed in a glocalizing light, seemed to thrive on the opportunity to project his cultural habitus, which involved deploying his particular version of Cuban musical history embodied in his swagger, in his every move-

ment, in his way of telling stories, and, of course, his singing, his song writing and his performances on the Cuban trova guitar – the impression heightened by his considerable musical talent and technical ability. When the album gained momentum, images of Segundo, dressed in a dapper suit, bedecked in a Panama hat and smoking cigars, became ubiquitous, and he took advantage of a unique opportunity to project his 'local', urbane style on a global stage. If this was a carefully and consciously cultivated image, it was one which we, as listeners and audiences, were, it seems, willing to recognize and appreciate. Segundo, a professional culture creator in light-footed mode, was an unlikely but profoundly successful glocalizer. The same can be said of the Cape Verdean singer Cesaria Evora (1941–2011), who according to Anandam Kavoori (2009, p. 84) drew on a 'discourse of authenticity ... located in a gendered account of African locality', a creole music style which travels across continents and diasporic socio-spatial contexts, reflecting the complex emotional experiences and longings of the many Cape Verdeans who left the islands for émigré communities in Europe and the USA as well as those who stayed behind. Evora spent much of her life out of the limelight, and later on, despite success and mastery of her art-form, her compelling stage presence was characterized by a cultural habitus which expressed a cool, detached nonchalance which spoke of 'personal intimacy and local "embeddedness"' (Kavoori, 2009, p. 88). She trod the stage barefoot, lit up cigarettes, sat down to smoke mid-performance, paused for drinks at will. Her slight, precise movements were, of course calculated for theatrical effect, but, it seemed, they were duly noted and appreciated by audiences keen to recognize the signs and gestures that they associate with a style of music characterized by a melancholic lilting and an overwhelming, seeping sense of *saudade*. Another example of a light-footed culture creator can be found in Saban Bajramovic (1936–2008), known as 'the king of the gypsies', whose trouble-soaked, sobbing voice excelled in fulfilling audience expectations regarding the 'essence' of Romany music from the Balkans. He was described as 'every inch the gypsy lounge lizard in a white suit, and sunglasses that masked a scarred and lived-in visage' (Lusk, 2008). He combined, in his performances, a sense of locality commingled with a more global 'jazz style', and his swagger, and the tales of his life history projected onto the global stage by documentary makers such as Milos Stojanovic, were as much a part of his perceived authenticity as were his vocals and song-writing abilities. He gained a reputation as scarred, 'hard drinker, gambler and "consumer of life" who sported gold-capped teeth and left a string of

wrecked cars in his wake' (Lusk, 2008). He was punished for deserting from the army and was imprisoned by the Yugoslav authorities (during Tito's reign) on the notorious Adriatic island of Goli Otok, a destination for political dissidents and hardened criminals. During his five year stay there, he earned the nickname 'The Black Panther', led a jazz band and learned how to read and write. Throughout the course of his life, he oscillated between a comfortable life and pennilessness, and though he received critical recognition at various times in his career, he was very much an *intransigent* culture creator. Although, presumably, he did clearly enjoy making money and, on occasion was able to purchase expensive cars and bodyguards, he certainly did not pursue success in a manner that could be described as instrumentally rational. He came to deeply distrust anyone associated with the music industry, and he rarely made any significant money from his art (Lusk, 2008). Perhaps one of the reasons why a musician such as Bajramovic has received such plaudits in the years since his death is that he not only created cultural objects with aesthetic properties that were praised by audiences and connoisseurs accustomed to evaluating and assessing *gypsy music* on the basis of its codes and conventions, but because, in his voice, and in his cultural habitus, his appearance, his swagger, his presence, we recognize, on the global stage, the embodiment of the intransigent culture creator, hailing from a long-persecuted ethnic group and, like Evora and Segundo, representing all that is *incalculable* about culture.

Conclusion

This book has examined the tensions between formal and substantive rationality; between courses of action which are instrumentally rational and those which are formulated with particular cultural values in mind; between impersonal forces and creative impulses; between the logic of profit and the ambiguity of aesthetics; between a tendency to like what we are trained to like and affective or contrarian impulses; between taste as power and taste as an individualized performance; between the steely logic of the measurable and the qualities of all that is human and immeasurable. Within each person, there is a complex meshing of motives that underpins every instance of social action. As Weber (1968[1913], p. 27) wrote, '[i]t would be very unusual to find concrete cases of action, especially of social action, which were oriented *only* in one way or another'. Similarly, in each cultural object, there is a complex meshing of elements. Those which are replicable, calculable and standardized exist alongside those which are ambiguous, aesthetic and unique. Even when an object, sold on the global culture market, becomes a failure or success when measured in the terms of sales figures or revenue generation, it might nevertheless achieve failure or success on entirely different terms as audiences evaluate its aesthetic properties in relation to other similar objects that belong to the same category of cultural production. Cultural objects contain elements of the incalculable: they are, after all, *cultural* objects. Furthermore, every cultural object contains different properties. Within each micro-community, within each fan-base or community of critics, interpretation and evaluation takes place relentlessly as individuals assess the extent to which cultural objects are worthy of praise or condemnation.

The world rings to a cacophony of culture creators trying to find their voices and to express themselves. But it is not the purpose of this book to promulgate a romantic vision of undiscovered or celebrated artists. It is, however, to draw attention to the persistence of that creativity that occurs in workaday existence in contradistinction to the formally rational. This creativity is mostly more mundane than heroic, and consists of people *making* culture. This might occur as a form of sublimation or as an edifying or amusing pastime the end result of which is not intended to be beheld by an audience larger than can fit in the back room of a bar. After all, culture is not just made for stadiums full of people or for internet sites that are visited by millions. Culture is also made by the few, for the few, for select circles of friends, for community groups, for fellow devotees and connoisseurs, for adherents of particular styles or genres. Culture confronts the logic of formal rationality even without heroic or oppositional intent because it has an entirely different *modus operandi* and because its manifestations are intangible. Culture consists of sounds, images, flavours, symbols and rituals, including those which might be considered to be contributing to the (re)enchantment of the world as well as those which seek, through technical innovation, to find more imaginative ways of making things. Its practitioners might be professional cultural creators strutting on the global stage, projecting their cultural habitus for audiences who might be willing to read them as authentic; they might be employed by transnational corporations, managing, at times, to create moments of beauty out of the combustible mix of artistic will and the logic of profit – as we have seen, the formally and substantively rational, though inevitably at odds, occasionally serve the same purpose when their interests commingle; or they might be among the ranks of the ignored, the powerless, the globally immobile, firing forth their cultural visions in the hope that they will affect somebody, somewhere, some day. Whether these visions are good, bad or indifferent is another matter, but even this is within the remit of sociology to discuss.

A central argument of the book is that sociology can contribute to debates about aesthetic value and to an understanding of how people evaluate. Everyday life is a site of countless evaluative judgements, ranging from the tiniest, seemingly inconsequential micro-judgements, as we sit opposite someone on a train and make assessments regarding the music that the headphones of the personal stereo fail to contain, to the macro-judgements in accordance with which we carve out our identities, situate ourselves in relation to others, and project a sense of

who we think we are. As we have seen, evaluation cannot be considered in isolation from socio-historical contexts, such as the influence of family and educational background, our possession of the various forms of capital, our ability (or otherwise) to adopt an aesthetic disposition, and our positioning in relation to the games of power that stem from expressions of taste. However, there are also a number of dynamics which affect the precise evaluative moment, ranging from the presence of other people to the methods and practices deployed in order to engage with the cultural object. Sociology is well-positioned to explore these contextual factors and these dynamics, and this book calls for empirical research that will examine precisely how individuals engage with and evaluate cultural objects as an everyday activity. As we have seen, cultural objects have a force of their own, which can be apprehended by those attentive to their properties. So, the dynamic between individuals and cultural objects is a fruitful area for sociological inquiry. There are a number of related areas of research that can be further explored in relation to sociology and aesthetic value, including the ways in which culture creators assess each other's work; the ways in which critics deploy aesthetic criteria and decide what to value; and the impact of the various dynamics of the evaluative moment on policy makers and academics. This book seeks to contribute to alternative approaches that draw attention to *other values* and to *other ways of valuing*.

Notes

Introduction

1 According to Raymond Williams (1977), 'culture' gained its current meanings at a similar time and in tandem with concepts such as 'economy' and 'society'. In early modern times, 'society' referred to fellowship, company and common-doing, and it was not until the eighteenth century that it came to refer to a general system or order. Similarly, 'economy' had a more restrictive usage, and was used to describe the management of household and community. Only later did it come to mean a system of production, distribution and exchange. 'Culture' began as a noun of process, referring to the cultivation of crops, animals and then, by extension, minds (Williams, 1981, p. 10). 'Culture', in this sense, was conceived 'inside the family of concepts that included terms like "cultivation", "husbandry", "breeding" – all meaning improvement, either in the prevention of impairment or in the arresting and reversing of deterioration' (Bauman, 2005b, p. 52). The concept of culture was thus utilized as a call to action, a means of steering the course of humanity in accordance with the idea that people needed to be trained and educated (Bauman, 2011, p. 7). It also became increasingly associated with the 'inner process', with the arts, and came to define what Matthew Arnold termed 'the best which has been thought and said in the world' (Arnold, 1994, p. 5). With the world divided into the cultivators and the cultivated, the educators and the educated, the managers and the managed, the colonizers and the colonized, 'culture' in the eighteenth century it became synonymous with 'civilization', thus contrasting with that which is 'barbarian' and uncivilized. As a reaction to this attempt to make 'culture' synonymous with notions of civilization and rationality, it was taken by German Romantic intellectuals and artists to mean the unique attitudes and ways of thinking characteristic of a particular group of people or nation. Norbert Elias (2000[1939]) draws attention to the antithesis between 'civilization' and the German concept of *kultur*. According to Elias (2000, p. 5), 'civilization' 'refers to a wide variety of facts: to the level of technology, to the types of manners, to the development of scientific knowledge, to religious ideas and customs'. It represents the consciousness of the West and the progress of humanity. However, whereas 'civilization' was considered to be central to the mindset of the French and the English in the eighteenth century, Elias finds that in Germany, it was only of secondary significance. Germans found a greater sense of achievement in the concept of *kultur*, which 'refers essentially to intellectual, artistic and religious facts ... to human products which are there like "flowers of the field", to works of art, books, religious or philosophical systems, in which the individuality of a people expresses itself' (Elias, 2000, pp. 6–7). This emphasis on the personal enrichment and artistic and intellectual achievement was considered to be antithetical to the characteristics

associated with 'culture' as expressed in its 'civilized' mode, which was defined in great part by notions of propriety, refinement of manners, urbanity, ceremony and formality. Whereas 'civilization' included political and economic development, *kultur* was focused on personal development in relation to spiritual, artistic and intellectual matters. *Kultur* represented depth of feeling in contrast to the superficiality of 'civilization'. Whereas 'civilization' was expansionist and emphasized what was universal and common to all, *kultur* delimited; it stressed the uniqueness of particular national identities. As Williams (1981, p. 10) points out, the philosopher 'Herder (1784–91) first used the significant plural "cultures", in deliberate distinction from any singular or ... unilinear sense of "civilization"'.

Chapter 1 Culture in a Rationalizing World

1 In a memorable passage in *The Protestant Ethic and the Spirit of Capitalism*, Weber wrote that '[i]n Baxter's view the care for external goods should only lie on the shoulders of the "saint like a light cloak, which can be thrown aside at any moment". But fate decreed that the cloak should become an iron cage' (Weber, 2001, p. 123). There has been much controversy regarding the appropriateness of the 'iron cage' metaphor in Talcott Parsons's translation of *ein stahlhartes Gehause* (Kent, 1983). According to Sayer (1991, p. 144), a more apt analogy would be the shell on a snail's back, which is 'a burden perhaps, but something impossible to live without, in either sense of the word'.

2 In contrast to these two conflicting types of rational action, Weber provides two others which are less rational. The first, *traditional* social action, is on the borderline of meaningfully oriented behaviour in so far as it 'is determined by ingrained habitation' (Weber, 1968, p. 25) and is to some extent a form of automated action. Traditional action is determined by customs handed down from generation to generation in accordance with precedent; sometimes social action which partly fits this ideal type category also crosses over into value-rational action if it is motivated by a conviction or deeply held value. The second less rational type is *affectual* social action which is driven by bodily instinct, emotion and desire, whether for the purposes of immediate sensual gratification, revenge or contemplative bliss (Weber, 1968, p. 105). In its purest form, affectual social action is right on the borderline of meaningful social action. In reality, this type is often commingled with others and, for example, even in the most rationalized social world, the actions of human beings are propelled by emotions and desires. For example, we are told that the 'rational' behaviour of financial traders can sometimes become testosterone-driven aggressivity (Coates, 2012).

3 It is worth reemphasizing Weber's point that these are ideal types of social action which are conceptual abstractions and in social reality they are hardly ever encountered in their pure form; more often than not, social action comprises of a mixture of these types. For example, action that is largely instrumentally rational might include an element of value-rationality when the social actor is choosing between two ends.

Chapter 2 The Fate of Cultural Values

1 Each specific historical example regarding domination and its legitimacy that we encounter might contain elements that fit each of these types.
2 For a critique of Weber's reading of Tolstoy and his argument regarding the antinomy of values, see Oakes (2001).

Chapter 6 Culture in a Globalizing World

1 The European Audiovisual Observatory was set up in 1992 to gather data on the audiovisual industry in Europe. It is 'a European public service body comprised of 37 member states and the European Union, represented by the European Commission. It operates within the legal framework of the Council of Europe' (EAO, 2011, p. 5).
2 The market shares are based on admissions figures for individual films that have been released in member states of the European Union. Due to the international nature of some film production, the attribution of 'country of origin' can be problematic, and so, 'in these cases the Observatory's aim is to attribute a country of origin corresponding to the source of the majority financial input and/or creative control of the project' (EAO, 2011, p. 5).

Chapter 7 The Local on the Global Stage

1 'Alter-globalization' movements tend to oppose economic globalization and seek to encourage global interaction and cooperation so as to promulgate concerns regarding environmental degradation, human rights and economic justice.
2 Viacom also owns a whole range of television brands from Comedy Central to Nickelodeon to VH1 as well as owning Paramount Pictures.

Bibliography

Adams, B. (2007). McDonald's Strange Menu Around the World. Retrieved April 6, 2012, from http://trifter.com/practical-travel/budget-travel/mcdonald%E2%80%99s-strange-menu-around-the-world/

Adorno, T. and Horkheimer, M. (1979[1944]). *Dialectic of Enlightenment.* London: Verso.

Adorno, T. (1991[1960]). Culture and Administration. In *The Culture Industry: Selected Essays on Mass Culture* (pp. 107–131). London: Routledge.

Albrow, M. (1996). *The Global Age.* Cambridge: Polity Press.

Alexander, V. D. (2007). State Support of Artists: The Case of the United Kingdom in a New Labour Environment and Beyond. *The Journal of Arts Management, Law, and Society,* 29(1), 1–16.

Anti-Marketing (2011). Anti-Globalization. Retrieved August 22, 2011, from http://www.anti-marketing.com/anti-globalization.html

Appadurai, A. (1990). Disjuncture and Difference in the Global Cultural Economy. *Theory, Culture & Society,* 7(2), 295–310.

Appadurai, A. (1996). *Modernity at Large: Cultural Dimensions of Globalization.* Minneapolis: University of Minnesota Press.

Archer, L., Hollingworth, S. and Halsall, A. (2007). 'University's not for me – I'm a Nike person'. Urban, Working-Class Young People's Negotiations of 'Style', Identity and Educational Engagement. *Sociology,* 41(2), 219–237.

Arnold, M. (1994). *Culture and Anarchy.* London: Yale University Press.

Arts Council England (2012). Investment in Arts and Culture 2012–15. Retrieved March 4, 2013, from http://www.artscouncil.org.uk/funding/invest-ment-in-the-arts-2012-15/

Barber, B. (2003). *Jihad vs. McWorld.* London: Corgi.

Bauman, Z. (1992). *Intimations of Postmodernity.* London: Routledge.

Bauman, Z. (1998). *Globalization: The Human Consequences.* Cambridge: Polity.

Bauman, Z. (2005a). *Work, Consumerism and the New Poor.* Maidenhead: Open University.

Bauman, Z. (2005b). *Liquid Life.* Cambridge: Polity.

Bauman, Z. (2010). *44 Letters from the Liquid Modern World.* Cambridge: Polity.

Bauman, Z. (2011). *Culture in a Liquid Modern World.* Cambridge: Polity.

Bauman, Z. and Tester, K. (2001). *Conversations with Zygmunt Bauman.* Cambridge: Polity Press.

Beck, U. (2000). *The Brave New World of Work.* Cambridge: Polity.

Becker, H. S. (1982). *Art Worlds.* California: University of California Press.

Bellavance, G. (2008). Where's High? Who's Low? What's New? *Poetics,* 36(1), 189–216.

Benjamin, W. (1968[1936]). The Work of Art in the Age of Mechanical Reproduction. In *Illuminations* (pp. 217–251). New York: Schocken.

Benjamin, W. (1973[1938]). The Paris of the Second Empire in Baudelaire. In *Charles Baudelaire: A Lyric Poet in the Era of High Capitalism* (pp. 9–106). London: Verso.

Bennett, T., Savage, M., Silva, E., Warde, A., Gayo-Cal, M. and Wright, D. (2009). *Culture, Class, Distinction*. London: Routledge.

Bielby, D. D. and Bielby, W. T. (2004). Audience Aesthetics and Popular Culture. In Friedland, R. and Mohr, J. (eds) *Matters of Culture: Cultural Sociology in Practice* (pp. 295–317). Cambridge: Cambridge University Press.

Bielby, D. D. and Harrington, C. L. (2008). *Global TV: Exporting Television and Culture in the World Market*. New York: NYU Press.

Bourdieu, P. (1984[1979]). *Distinction: A Social Critique of the Judgement of Taste*. London: Routledge.

Bourdieu, P. (1986[1983]). The Forms of Capital. In Richardson, J. G. (ed.) *Handbook of Theory and Research for the Sociology of Education* (pp. 241–258). New York: Greenwood Press.

Bourdieu, P. (1987). The Historical Genesis of a Pure Aesthetic. *Journal of Aesthetics and Art Criticism*, 46, 201–210.

Bourdieu, P. (1989). Social Space and Symbolic Power. *Sociological Theory*, 7(1), 14–25.

Bourdieu, P. (1990a[1980]). *The Logic of Practice*. Cambridge: Polity Press.

Bourdieu, P. (1990b[1987]). *In Other Words: Essays Towards a Reflexive Sociology*. Cambridge: Polity Press.

Bourdieu, P. (1993a). *Sociology in Question*. London: Sage.

Bourdieu, P. (1993b[1983]). *The Field of Cultural Production: Essays on Art and Literature*. Cambridge: Polity Press.

Bourdieu, P. (1996[1992]). *The Rules of Art*. Cambridge: Polity Press.

Bourdieu, P. (1998). *Acts of Resistance: Against the New Myths of Our Time*. Cambridge: Polity.

Bourdieu, P. (2000[1997]). *Pascalian Meditations*. Cambridge: Polity Press.

Bourdieu, P. (2003[2001]). *Firing Back: Against the Tyranny of the Market 2*. London: Verso.

Bourdieu, P. and Passeron, J. C. (1990). *Reproduction in Education, Society and Culture*. London: Sage.

Buck, D. (2007). The Ecological Question: Can Capitalism Prevail? In Panitch, L. and Leys, C. (eds) with Harriss-White, B., Altvater, E. and Albo, G., *Socialist Register 2007: Coming to Terms with Nature* (pp. 60–71).

Bull, M. (2005). No Dead Air! The iPod and the Culture of Mobile Listening. *Leisure Studies*, 24(4), 343–355.

Bunuel, L. (1985). *My Last Breath*. Glasgow: Flamingo.

Cato Institute (2011). About Cato. Retrieved March 20, 2011, from http://www.cato.org/about

Cato Policy Report (2003). Globalization and Culture. Cato Institute. Retrieved August 4, 2012, from http://www.cato.org/pubs/policy_report/v25n3/globalization.pdf

Cho, S. H. and Chung, J. Y. (2009). We Want Our MTV: Glocalization of Cable Content in China, Korea and Japan. *Critical Arts*, 23(3), 321–341.

Coates, J. (2012). *The Hour Between Dog and Wolf: Risk Taking, Gut Feelings and the Biology of Boom and Bust*. London: Fourth Estate.

Cohen, S. (2011). Vivendi: A Study of the Media Conglomerate's Mergers and Acquisitions Since 2009. *Global Media*. Retrieved March 4, 2013, from http://globalmediastudies.blogspot.co.uk/2011/05/vivendi-study-of-media-conglomerates.html

Cowen, T. (2002). *Creative Destruction: How Globalization is Changing the World's Cultures*. New Jersey: Princeton University Press.

Credit Suisse Research Institute (2011). *Global Wealth Report 2011*. Zurich: Credit Suisse.

Curtin, M. (2003). Media Capital: Towards the Study of Spatial Flows. *International Journal of Cultural Studies*, 6(2), 202–228.

Davis, M. (2004). Planet of Slums: Urban Involution and the Informal Proletariat. *New Left Review*, 26, 5–34.

de Certeau, M. (1984). *The Practice of Everyday Life*. Berkeley: University of California Press.

De La Fuente, E. (2007). The 'New Sociology of Art': Putting Art Back into Social Science Approaches to the Arts. *Cultural Sociology*, 1(3), 409–425.

De La Fuente, E. (2008). The Art of Social Forms and the Social Forms of Art: The Sociology-Aesthetics Nexus in Georg Simmel's Thought. *Sociological Theory*, 26(4), 344–362.

DeNora, T. (1999). Music as a Technology of the Self. *Poetics*, 27, 31–56.

Dickie, G. (1974). *Art and the Aesthetic*. New York: Cornell University Press.

Dornbusch, R. (1992). The Case for Trade Liberalization in Developing Countries. *Journal of Economic Perspectives*, 6(1), 69–85.

Douglas, M. (1987). *How Institutions Think*. London: Routledge.

Elias, N. (2000[1939]). *The Civilizing Process*. Oxford: Blackwell.

Ellwood, W. (2006). *The No-Nonsense Guide to Globalization*. Toronto: New Internationalist Publications.

European Audiovisual Observatory (2011). Press Release. Strasbourg: Council of Europe.

Fekete, J. (ed.) (1988). *Life after Postmodernism: Essays on Value and Culture*. Basingstoke: Macmillan.

Fiske, J. (1987). *Television Culture*. London: Methuen.

Fiske, J. (1989). *Reading the Popular*. London: Routledge.

Flood, A. (2012, October 25). Self-Publishing Sees Massive Growth. *The Guardian*. Retrieved November 29, 2012, from http://www.guardian.co.uk/books/2012/oct/25/self-publishing-publishing

Frank, A. G. (1998). *ReOrient: Global Economy in the Asian Age*. Berkeley CA: University of California Press.

Freund, J. (1968). *The Sociology of Max Weber*. London: Allen Lane, The Penguin Press.

Friedman, J. (1997). Global Crises, the Struggle for Cultural Identity and Intellectual Porkbarrelling: Cosmopolitans Versus Locals, Ethnics and Nationals in an Era of De-Hegemonisation. In Werbner, P. and Modood, T. (eds) *Debating Cultural Hybridity* (pp. 70–89). London: Zed Books.

Garnham, N. (1993). Bourdieu, the Cultural Arbitrary, and Television. In Calhoun, C., LiPuma, E. and Postone, M. (eds) *Bourdieu: Critical Perspectives* (pp. 178–192). Chicago: Polity Press/University of Chicago Press.

Garnham, N. and Williams, R. (1980). Pierre Bourdieu and the Sociology of Culture: An Introduction. *Media, Culture and Society*, 2, 209–223.

Giddens, A. (2001). Introduction. In Weber, M. *The Protestant Ethic and the Spirit of Capitalism* (pp. vii–xxiv). London: Routledge.

Giulianotti, R. and Robertson, R. (2007). Recovering the Social: Globalization, Football and Transnationalism. *Global Networks*, 7(2), 166–186.

Giulianotti, R. and Robertson, R. (2009). *Globalization and Football*. London: Sage.

Govil, N. (2007). Bollywood and the Frictions of Global Mobility. In Thussu, D. K. (ed.) *Media on the Move: Global Flow and Contra-flow* (pp. 76–88). London: Routledge.

Gray, C. (2000). *The Politics of the Arts in Britain*. Basingstoke: Macmillan.

Gray, C. (2007). Commodification and Instrumentality in Cultural Policy. *International Journal of Cultural Policy*, 13(2), 203–215.

Gray, J. (2009). *False Dawn: The Delusions of Global Capitalism*. London: Granta.

Gronow, J. (1988). The Element of Irrationality: Max Weber's Diagnosis of Modern Culture. *Acta Sociologica*, 31(4), 319–331.

Guilbault, J. (2001). World Music. In Frith, S., Straw, W. and Street, J. (eds) *The Cambridge Companion to Pop and Rock* (pp. 176–192). Cambridge: Cambridge University Press.

Hall, S. (2007[1973]). Encoding/Decoding. In During, S. (ed.) *The Cultural Studies Reader* (pp. 477–487). Abingdon: Routledge.

Hall, S. and Whannel, P. (1964). *The Popular Arts*. London: Hutchinson.

Harrington, A. (2004). *Art and Social Theory*. Cambridge: Polity Press.

Harvey, D. (2005). *A Brief History of Neoliberalism*. Oxford: Oxford University Press.

Hebdige, D. (1979). *Subculture: The Meaning of Style*. London: Methuen.

Heinich, N. (2010). What Does 'Sociology of Culture' Mean? Notes on a Few Trans-Cultural Misunderstandings. *Cultural Sociology*, 4(2), 257–265.

Held, D., McGrew, A., Goldblatt, D. and Perraton, J. (1999). *Global Transformations*. Cambridge: Polity.

Hennion, A. (2001). Music Lovers: Taste as Performance. *Theory, Culture and Society*, 18(5), 1–22.

Hennion, A. (2004). Pragmatics of Taste. In Jacobs, M. and Hanrahan, N. W. (eds) *The Blackwell Companion to the Sociology of Culture* (pp. 131–144). Oxford: Blackwell.

Hennion, A. (2007). Those Things That Hold Us Together: Taste and Sociology. *Cultural Sociology*, 1(1), 97–114.

Hennis, W. (2000). *Max Weber's Science of Man: New Studies for a Biography of the Work*. Newbury: Threshold Press.

Herman, E. S. and McChesney, R. W. (1997). *The Global Media: The New Missionaries of Corporate Capitalism*. London: Cassell.

Hernandez, T. K. (2002). The Buena Vista Social Club: The Racial Politics of Nostalgia. In Habell-Pallan, M. and Romero, M. (eds) *Latino/a Popular Culture* (pp. 61–72). New York: New York University Press.

Herzfeld, M. (1992). *The Social Production of Indifference: The Symbolic Roots of Western Bureaucracy*. New York: Berg.

Hewison, R. (1995). *Culture and Consensus: England, Art and Politics since 1940*. London: Methuen.

Hickey, D. (1993). *The Invisible Dragon: Four Essays on Beauty*. Los Angeles: Art Issues.

Highmore, B. (2010a). Bitter after Taste: Affect, Food, and Social Aesthetics. In Gregg, M. and Seigworth, G. J., *The Affect Theory Reader* (pp. 118–137). London: Duke University.

Highmore, B. (2010b). Social Aesthetics. In Hall, J. R., Grindstaff, L. and Lo, M. C., *Handbook of Cultural Sociology* (pp. 155–163). London: Routledge.

Holcombe, C. J. (2007). Poetry Scene: Current Difficulties. Retrieved November 4, 2012, from http://www.textetc.com/modernist/current-difficulties.html

Hoyler, M. and Watson, A. (2011). Global Media Cities in Transnational Media Networks. *GaWC Research Bulletin*, 358. Retrieved March 4, 2013, from http://www.lboro.ac.uk/gawc/rb/rb358.html

Inglis, D. (2005). The Sociology of Art: Between Cynicism and Reflexivity. In Inglis, D. and Hughson, J. (eds) *The Sociology of Art: Ways of Seeing* (pp. 98–107). Basingstoke: Palgrave Macmillan.

Inglis, D. (2007). The Warring Twins: Sociology, Cultural Studies, Alterity and Sameness. *History of the Human Sciences*, 20(2), 99–122.

Inglis, D. and Hughson, J. (2003). *Confronting Culture: Sociological Vistas*. Cambridge: Polity.

Inkei, P. (2011). *Results of a 2011 Survey with Governments on Culture Budgets and the Financial Crisis and Culture*. Budapest: Council of Europe.

International Forum on Globalization (2011). About the International Forum on Globalization. Retrieved August 4, 2011, from http://www.ifg.org/

Jenkins, H. (2004). The Cultural Logic of Media Convergence. *International Journal of Cultural Studies*, 7(1), 33–43.

Jenkins, R. (2000). Disenchantment, Enchantment and Re-Enchantment: Max Weber at the Millennium. *Max Weber Studies*, 1, 11–32.

Jenkins, R. (2002). *Pierre Bourdieu*. Abingdon: Routledge.

Kafka, F. (2009[1926]). *The Castle*. Oxford: Oxford University Press.

Kant, I. (2005[1790]). *Critique of Judgement*. New York: Dover.

Kavoori, A. (2009). World Music, Authenticity and Africa: Reading Cesaria Evora and Ali Farka Toure. *Global Media Journal*, 3(1), 80–96.

Kellner, D. (1999). Theorizing/Resisting McDonaldization: A Multiperspectivist Approach. In Smart, B. (ed.) (1998). *Resisting McDonaldization* (pp. 186–206). London: Sage.

Kent, S. (1983). Weber, Goethe, and the Nietzschean Allusion: Capturing the Source of the 'Iron Cage' Metaphor. *Sociological Analysis*, 4(4), 297–310.

Kersten, A. and Bielby, D. D. (2012). Film Discourse on the Praised and Acclaimed: Reviewing Criteria in the United States and United Kingdom. *Popular Communication: The International Journal of Media and Culture*, 10(3), 183–200.

Kimmelman, M. (2007, December 19). In Marseille, Rap Helps Keep the Peace. *The New York Times*. Retrieved March 21, 2012, from http://www.nytimes.com/2007/12/19/arts/music/19rap.html?pagewanted=all

Klein, N. (2000). *No Logo*. London: Flamingo.

Kundera, M. (1995). *Slowness*. London: Faber and Faber.

Lane, J. F. (2005). When Does Art Become Art? Assessing Pierre Bourdieu's Theory of Artistic Fields. In Inglis, D. and Hughson, J. (eds) *The Sociology of Art: Ways of Seeing* (pp. 30–42). Basingstoke: Palgrave Macmillan.

Lamont, M. (1992). *Money, Morals, and Manners: The Culture of the French and American Upper Middle-Class*. Chicago: University of Chicago Press.

Lawler, S. (2005). Disgusted Subjects: The Making of Middle-Class Subjectivities. *Sociological Review*, 53(3), 429–446.

Lowith, K. (1993[1960]). *Max Weber and Karl Marx*. London: Allen and Unwin.

Lusk, J. (2008). Saban Bajramovic: 'Gypsy King' of Serbia. *The Independent*. Retrieved March 21, 2013, from http://www.independent.co.uk/news/obituaries/saban-bajramovic-gypsy-king-of-serbia-845067.html

Lyotard, J. F. (1984). *The Postmodern Condition: A Report on Knowledge*. Manchester: Manchester University Press.

Maffesoli, M. (1996). *The Time of the Tribes: The Decline of Individualism in Mass Society*. London: Sage.

Martell, L. (2010). *The Sociology of Globalization*. Cambridge: Polity.

Marx, K. and Engels, F. (1967[1848]). *The Communist Manifesto*. London: Penguin.

McDonald, P. and Wasko, J. (eds) (2008). *The Contemporary Hollywood Industry*. Oxford: Blackwell.

McDonald's (2012a). About McDonald's. Retrieved March 21, 2012, from http://www.aboutmcdonalds.com/mcd.html

McDonald's (2012b). Press Release. Retrieved March 21, 2012, from http://phx.corporate-ir.net/phoenix.zhtml?c=97876&p=irol-news Article&ID=1670633&highlight=

McDonald's (2012c). Financial Highlights. Retrieved March 21, 2012, from http://www.aboutmcdonalds.com/mcd/investors/financial_highlights.html

McDonald's (2013). About McDonald's. Retrieved March 5, 2013, from http://www.aboutmcdonalds.com/mcd.html

McLennan, G. (2002). Sociological Cultural Studies: The Question of Explanation. *Cultural Studies*, 16(5), 631–649.

Medhurst, A. (2007). *A National Joke: Popular Comedy and English Cultural Identities*. London: Routledge.

Miller, T., Govil, N., McMurria, J. and Maxwell, R. (2001). *Global Hollywood*. London: BFI Publishing.

Mills, C. W. (1959). *The Sociological Imagination*. New York: Oxford University Press.

Mulvey, L. (1975). Visual Pleasure and Narrative Cinema. *Screen*, 16(3), 6–18.

Nadeau, B. L. (2011). Italy's Luxury Bailout. *Newsweek*. Retrieved March 4, 2013, from http://www.thedailybeast.com/newsweek/2011/07/17/italy-s-ancient-monuments-and-cultural-heritage-crumbling.html

News Corporation (2013). Retrieved March 4, 2013, from http://www.newscorp.com/index.html

Ngai, S. (2005). The Cuteness of the Avant-Garde. *Critical Inquiry*, 31(4), 811–847.

Ngai, S. (2012). *Our Aesthetic Categories: Zany, Cute, Interesting*. Cambridge, MA: Harvard University Press.

Oakes, G. (2001). The Antinomy of Values: Weber, Tolstoy and the Limits of Scientific Rationality. *Journal of Classical Sociology*, 1(2), 195–208.

O'Neill, J. (1999). Have You Had Your Theory Today? In Smart, B. (ed.) (1998). *Resisting McDonaldization* (pp. 41–56). London: Sage.

Parker, M. (1998) Nostalgia and Mass Culture: McDonaldization and Cultural Elitism. In Alfino, M., Caputo, J. S. and Wynyard, R. (eds) *McDonaldization Revisited: Critical Essays on Consumer Culture* (pp. 1–18). Westport: Praeger Publishers.

Parkin, F. (2002). *Max Weber*. London: Routledge.

Peggs, K. (2009). A Hostile World for Nonhuman Animals: Human Identification and the Oppression of Nonhuman Animals for Human Good. *Sociology*, 43(1), 85–102.

Peterson, R. A. and Kern, R. M. (1996). Changing Highbrow Taste: From Snob to Omnivore. *American Sociological Review*, 61, 900–907.

Peterson, R. A. and Simkus, A. (1992). How Musical Tastes Mark Occupational Status Groups. In Lamont, M. and Fournier, M. (eds) *Cultivating Differences* (pp. 152–186). Chicago: University of Chicago Press.

Petras, J. (2011, March 23). The World's Super-Rich: Billionaires Flourish, Inequalities Deepen as Economies 'Recover'. *Global Research*. Retrieved February 12, 2012, from http://www.globalresearch.ca/index.php?context=va&aid=23907

Pieterse, J. N. (1995). Globalization as Hybridization. In Featherstone, M., Lash, S. and Robertson, R. (eds) *Global Modernities* (pp. 45–68). London: Sage.

Polanyi, K. (2001[1944]). *The Great Transformation: The Political and Economic Origins of Our Time*. Boston: Beacon Press.

Probyn, E. (2000). *Carnal Appetites: FoodSexIdentities*. London: Routledge.

Radway, J. (1991). *Reading the Romance: Women, Patriarchy and Popular Literature*. Chapel Hill: University of California Press.

Rantanen, T. (2004). *Media and Globalization*. London: Sage.

Rapoza, K. (2011, May 26). By 2020, China No. 1, US No. 2. *Forbes*. Retrieved February 12, 2012, from http://www.forbes.com/sites/kenrapoza/2011/05/26/by-2020-china-no-1-us-no-2/print/

Ritzer, G. (2004). *The McDonaldization of Society*. London: Pine Forge.

Ritzer, G. (2005). *Enchanting a Disenchanted World: Revolutionizing the Means of Consumption*. London: Pine Forge.

Robertson, R. (1990). Mapping the Global Condition: Globalization as the Central Concept. *Theory, Culture & Society*, 7(2–3), 15–30.

Robertson, R. (1992). *Globalization: Social Theory and Global Culture*. London: Sage.

Robertson, R. (1995). Glocalization: Time-Space and Homogeneity-Heterogeneity. In Featherstone, M., Lash, S. and Robertson, R. (eds) *Global Modernities* (pp. 25–44). London: Sage.

Robertson, R. (2001). Globalization Theory 2000+: Major Problematics. In Ritzer, G. and Smart, B. (eds) *Handbook of Social Theory* (pp. 458–471). London: Sage.

Robertson, R. (2003). The Conceptual Promise of Glocalization: Communality and Diversity. *Proceedings of the International Forum on Cultural Diversity and Common Values*. Seoul: Gyeongju World Culture EXPO Organizing Committee and the Korean National Commission for UNESCO. Retrieved August 4, 2012, from http://artefact.mi2.hr/_a04/lang_en/theory_robertson_en.htm

Robertson, R. (2007). Open Societies, Closed Minds? Exploring the Ubiquity of Suspicion and Voyeurism. *Globalizations*, 4(3), 399–416.

Rodinson, M. (1974). *Islam and Capitalism*. London: Allen Lane.

Rojek, C. and Turner, B. S. (2000). Decorative Sociology: Towards a Critique of the Cultural Turn. *The Sociological Review*, 48(4), 629–648.

Said, E. (2003[1978]). *Orientalism*. London: Penguin.

Sayer, D. (1991). *Capitalism and Modernity. An Excursus on Marx and Weber*. London: Routledge.

Sica, A. (2000). Rationalization and Culture. In Turner, S. (ed.) *The Cambridge Companion to Weber* (pp. 42–58). Cambridge: Cambridge University Press.

Simmel, G. (1950[1902]). Quantitative Aspects of the Group. In Wolff, K. H. (ed.) *The Sociology of Georg Simmel* (pp. 85–177). New York: The Free Press.

Simmel, G. (1971[1904]). Fashion. In Levine, D. (ed.) *Georg Simmel on Individuality and Social Forms* (pp. 294–323). Chicago: University of Chicago Press.

Sinclair, C. (2012). February 18. Arts for One and Art for All. *Financial Times.*

Singer, M. (1972). *When a Great Tradition Modernizes.* London: Pall Mall.

Skeggs, B. (2004). *Class, Self, Culture.* London: Routledge.

Smart, B. (ed.) (1999). *Resisting McDonaldization* (pp. 207–221). London: Sage.

Smart, B. (2005). *The Sport Start: Modern Sport and the Cultural Economy of Sporting Celebrity.* London: Sage.

Smart, B. (2010). *Consumer Society.* London: Sage.

Sombart, W. (1915). *The Quintessence of Capitalism: A Study of the History and Psychology of the Modern Business Man.* New York: E. P. Dutton and Company.

Stewart, S. (2010). *Culture and the Middle Classes.* Farnham: Ashgate.

Stewart, S. (2012). Reflections on Sociology and Aesthetic Value. *Distinktion: Scandinavian Journal of Social Theory,* 13(2), 153–167.

Stewart, S. (2013). Evaluating Culture: Sociology, Aesthetics and Policy. *Sociological Research Online,* 18(1).

Stiglitz, J. (2002). *Globalization and Its Discontents.* London: Allen Lane.

Strelitz, L. (2004). Against Cultural Essentialism: Media Reception among South African Youth. *Media, Culture & Society,* 26(5), 625–641.

Swartz, D. (1997). *Culture and Power: The Sociology of Pierre Bourdieu.* Chicago: University of Chicago Press.

Tester, K. (1999). The Moral Malaise of McDonaldization: The Values of Vegetarianism. In Smart, B. (ed.) (1998). *Resisting McDonaldization* (pp. 207–221). London: Sage.

Tucker, K. H. (2002). *Classical Social Theory.* Oxford: Blackwell.

Turner, B. S. (1974). *Weber and Islam.* London: Routledge.

Turner, B. S. (2003). McDonaldization: Linearity and Liquidity in Consumer Cultures. *American Behavioral Scientist,* 47(2), 137–153.

Turner, B. S. and Edmunds, J. (2002). The Distaste of Taste: Bourdieu, Cultural Capital and the Australian Postwar Elite. *Journal of Consumer Culture,* 2(2), 219–240.

UNESCO Institute for Statistics (2012). From International Blockbusters to National Hits. Analysis of the 2010 UIS Survey on Feature Film Statistics. *UIS Information Bulletin* 8. Concordia University: UNESCO Institute for Statistics.

United Nations (2009). *State of the World's Cities 2008/9: Harmonious Cities.* London: United Nations.

United Nations (2010). *State of the World's Cities 2010/11: Cities for All: Bridging the Urban Divide.* London: Earthscan/UN-HABITAT.

Urry, J. (2002). *The Tourist Gaze.* London: Sage.

Vivendi (2013). Key Figures. Retrieved March 4, 2013, from http://www.vivendi.com/vivendi-en/key-figures/

Wacquant, L. (1995). Pugs at Work: Bodily Capital and Bodily Labour among Professional Boxers. *Body and Society,* 1(1), 65–93.

Warde, A., Martens, L. and Olsen, W. (1999). Consumption and the Problem of Variety: Cultural Omnivorousness, Social Distinction, and Dining Out. *Sociology,* 33(1), 105–127.

Wasko, J. (2003). *How Hollywood Works.* London: Sage.

Weber, M. (1909). Max Weber on Bureaucratization in 1909. Retrieved August 4, 2012, from http://www.faculty.rsu.edu/users/f/felwell/www/Theorists/Weber/Max1909.html

Weber, M. (1946a[1918]). Science as a Vocation. In Gerth, H. H. and Mills, C. W. (eds) *From Max Weber: Essays in Sociology* (pp. 129–156). London: Routledge.

Weber, M. (1946b[1915]). The Social Psychology of the World Religions. In Gerth, H. H. and Mills, C. W. (eds) *From Max Weber: Essays in Sociology* (pp. 267–301). London: Routledge.

Weber, M. (1946c[1915]). Bureaucracy. In Gerth, H. H. and Mills, C. W. (eds) *From Max Weber: Essays in Sociology* (pp. 196–244). London: Routledge.

Weber, M. (1946d[1915]). Politics as a Vocation. In Gerth, H. H. and Mills, C. W. (eds) *From Max Weber: Essays in Sociology* (pp. 77–128). London: Routledge.

Weber, M. (1958[1921]). *The Rational and Social Foundations of Music*. Illinois: Southern Illinois University Press.

Weber, M. (1968[1913]). *Economy and Society*. Berkeley: University of California Press.

Weber, M. (2001[1904]). *The Protestant Ethic and the Spirit of Capitalism*. London: Routledge.

Weber, M. (2003[1927]). *General Economic History*. New York: Dover.

Weber, M. (2011[1917]). *The Methodology of the Social Sciences*. London: Transaction.

Wenders, W. (Director) (1999). *Buena Vista Social Club*. Germany/France/USA/UK/Cuba: Road Movies Filmproduktion.

Williams, R. (1977). *Marxism and Literature*. Oxford: Oxford University Press.

Williams, R. (1981). *Culture*. London: Fontana.

Wolff, J. (1999). Cultural Studies and the Sociology of Culture. *Invisible Cultures*. Retrieved July 15, 2012, from http://www.rochester.edu/in_visible_culture/issue1/wolff/wolff.html

Wolff, J. (2005). Cultural Studies and the Sociology of Culture. In Inglis, D. and Hughson, J. (eds) *The Sociology of Art: Ways of Seeing* (pp. 87–97). Basingstoke: Palgrave Macmillan.

Wolff, J. (2008). *The Aesthetics of Uncertainty*. New York: Columbia University Press.

Wong, E. (2012, January 3). China's President Lashes Out at Western Culture. *The New York Times*. Retrieved February 20, 2012, from http://www.nytimes.com/2012/01/04/world/asia/chinas-president-pushes-back-against-western-culture.html

Woolf, V. (2012[1941]). Middlebrow. In *The Death of the Moth, and Other Essays*. Retrieved August 12, 2012, from http://ebooks.adelaide.edu.au/w/woolf/virginia/w91d/

Wu, C. (2003). *Privatising Culture: Corporate Art Intervention since the 1980s*. London: Verso.

Xinhua (2012). Two-thirds of Entertainment Shows Cut from China's Satellite Channels: Broadcasting Watchdog. Xinhua English news. Retrieved February 20, 2012, from http://news.xinhuanet.com/english/china/2012-01/03/c_131340680.htm

Yan, F. and Jones, T. (2010, December 15). McDonald's to Double China Restaurants by 2013. *Reuters*. Retrieved March 21, 2012, from http://www.reuters.com/article/2010/12/15/us-mcdonalds-china-idUSTRE6BE0VJ20101215

Index

abstracted empiricism, 108
academic capital, 67–8, 71
administration, 2, 34, 36–7, 38, 48–9,
 139
Adorno, Theodor, 2, 48, 145, 146
aesthetic disposition, 4, 57, 58–9, 61,
 62, 68, 72, 81–2, 85, 92–3, 107,
 128, 179
 legitimate taste and, 76–80
aesthetic properties, of cultural
 objects, 1, 6, 130, 151–3, 157,
 168, 176
aesthetic universalism, 105, 128
 context, 107–9
 sociology and, 106–7
aesthetic values, 4–5, 55, 105, 106, 107,
 108, 109–10, 112, 113, 114, 116,
 119, 120, 127, 128–9, 178, 179
affectual impulses, in tasting, 4, 102
affectual social action, 26, 181n
agency, bureaucratic, 36
agents, 57, 63–4, 65–6, 70, 72, 76, 79,
 97, 118, 145, 153
Albrow, M., 164
Alexander, Victoria, 139
alter-globalization movements, 169,
 182n
amateur, 17, 32, 39, 51, 72, 98–9, 100,
 101, 106
Americanization, 149, 156–7, 169
Ancient Greeks, 46
anti-aesthetic, 115–16
anti-globalization, 134, 164–6
Anti-Marketing campaign, 164
anti-monolithic theories, 109
Appadurai, Arjun, 156–7
Archer, L., 94, 95
architecture, and rationalization, 16,
 123
Arkana, Keny, 169, 171
Arrow (Canadian musician), 171–2
art, 4, 16–17, 40, 51, 52, 56, 68, 69,
 75–6, 77–82, 85, 88, 91, 103,

107–8, 111–13, 115, 116, 123,
 124, 125, 126, 128, 146–7, 162,
 175, 176
asceticism, 12–13, 14, 17
autodidact, 51, 70–1, 88

Bajramovic, Saban, 175, 176
Barber, Benjamin, 141, 143–4, 145,
 148, 162
Baudelaire, Charles, 2, 47
Bauman, Zygmunt, 7, 48, 49, 89,
 90–1, 92, 110, 122, 146–7
Baxter, Richard, 12, 14
beauty, 29, 107, 116, 178
 return to, 106, 115–16, 117
Becker, Howard, 107–8
bedazzlement, 110
being served, 83
Benjamin, Walter, 123, 171
Bielby, Denise D., 117, 118, 153
Bielby, William T., 117
Bollywood, 154
Bourdieu, Pierre, 3–4, 56–89, 92, 93,
 95–8, 100, 101, 103, 105–8, 112,
 118–20, 121, 124, 126, 136, 138,
 139–40, 147–8
Bull, Michael, 127
Bunuel, Luis, 144
bureaucracies, 2, 9, 16, 18, 23, 27, 33,
 34, 35–9, 48, 80, 83
 specialist vs cultivated man, 39–40
 treatment of individuals in, 40–2

calculability principle, 2, 10–11, 23,
 29–30, 33–4, 36, 38, 41, 43, 101,
 129, 148, 153, 157
 of McDonaldization, 19
'calling', 3, 10, 12, 13, 32–3, 36, 40,
 50, 51, 53, 54
Calvin, John, 11, 12
Calvinism, 12–13, 14, 15
capital, forms of, 63–4, 65–72
 academic capital, 67–8, 71

cultural capital *see* cultural capital
economic capital, 4, 60, 62, 63,
 65–7, 70, 71, 72–3, 74, 79, 84,
 91–2, 111, 170
political capital, 91
social capital, 65, 66–7, 84
capitalism, 3, 8, 9–10, 27, 39, 42, 50,
 131, 133, 145, 164
commodity, 51
rational, 10–15, 16, 28–9, 35
spirit of, 13–14
Catholicism, 11–12, 13, 14, 15
charismatic authority, 16, 34, 38, 44,
 107
Chinese film industry, 154–5
Cho, Seungho, 167–8
Chung, Jee Young, 167–8
cinema, 154, 156
and cultural homogenization,
 148–53
cinema-going, 149, 150, 154
civilization, 15, 16, 131, 180–1n
commercialization of economic life,
 11
commodification, 116, 139, 157
community model, of evaluation, 5,
 55, 105, 106, 117–18, 121, 127,
 132, 177–8
comparative model, 27, 111, 114–15
conspicuous consumption, 72–3, 74,
 92
consumerism, 44, 49, 86, 93, 102
contradictory impulses, in tasting,
 102–3
contrary impulses, in tasting, 103
controlling principle, of
 McDonaldization, 20–1
Cowen, Tyler, 141, 142, 143, 144
creative impulses, in tasting, 103, 177
creolization, 160
cultivated man, 80
decline of, and specialist rise,
 39–40, 80
cultural capital, 4, 60, 62, 65, 66,
 67–74, 76, 79–80, 81, 82, 84, 86,
 90, 95, 96, 103, 110, 159, 172, 173
embodied, 58, 68–70, 159, 172, 174
institutional, 70–1
objectified, 57, 71–2

cultural diversity, 5, 6, 141–3, 145,
 160
cultural elitism, 90, 91–2
cultural funding, 121, 137–40
cultural games, 66, 77
cultural homogenization, 143–5, 161
and cinema, 148–53
and film production, 154–6
and logic of profit, 145–8
cultural innovators, 118–19
cultural objects, 1–2, 3, 4–7, 49–50,
 51, 55, 56, 57, 76–7, 78, 80, 81,
 82, 93, 98, 99–100, 101, 102–3,
 105–15, 118–28, 130, 140, 141,
 146, 147, 151–3, 157–8, 162, 168,
 170, 174, 177–9
cultural production, 48, 63, 72, 103,
 105, 107–8, 114–15, 117, 118,
 119, 147, 152, 155, 156, 166,
 169–70, 171, 177
categories of, 114
glocalization, 166
individual objects, 114–15
cultural turn, 110, 111
cultural values, 1, 8, 10, 31, 32–55,
 87, 95, 177
culture
and administration, 2
concept of, 180n
and power, 3–4
rationalized, 15–24
culture creators, 2–3, 6–7, 32, 48–9, 52,
 53, 91, 158, 166, 169, 171, 178
amateur, 17, 32, 39, 51, 72, 98–9,
 100, 101, 106
ignored, 3, 32, 50, 52–3, 178
intransigent, 3, 32, 49, 50, 51, 55,
 176
light-footed, 1, 7, 159, 170, 173,
 175
professional, 3, 32, 49, 50, 55, 168,
 171–2, 175
culture industries, 145–6, 153
Curtin, Michael, 148

Davis, Mike, 44
de Certeau, Michel, 37
de-sociologizing amateurs' responses,
 98–9

dehumanization, 21–2, 35, 40, 41–2, 48
demands of the day, confronting, 42, 46–7
DeNora, Tia, 126–7
deterministic characteristics, of Bourdieu's theory, 96–7
Dickie, George, 107
differing levels of intensity, in tasting, 102
direct observational understanding, 25
disciplinary fears and tensions, 109–11
disenchantment, 2, 42–6, 54, 129
 existential problem, 46–7
dispositions *see* aesthetic disposition
distaste, 4, 53, 96, 102–3, 152
dochakuka, 162
Dodd, Philip, 91
dominant class, 58, 68, 74, 86
 dominated fraction of, 66, 79, 92
domination, Weber on, 33–4
doxic attitude, 78
dynamics of evaluative moment, 5, 55, 105, 120–8, 179
 engagement level with cultural object, 123–5
 impact of location on the moment of evaluation, 125–6
 material qualities of cultural object, 126–7
 methods and practices deployed to engage with cultural object, 125
 presence of others model, 120–1
 pressure to stand out and to fit in, 121–3

economic capital, 4, 63, 65, 66–7, 70, 71, 72–3, 74, 79, 91, 92, 170
economic globalization, 135–7, 165, 166, 182n
Edmunds, June, 95, 96
education, 3, 17, 39, 51, 58, 63, 67–70, 71, 72, 78, 79–80, 85, 88, 94, 95, 96, 107, 113, 121, 137, 165, 179
efficiency principle, of McDonaldization, 18

Elias, Norbert, 58, 180n
elitism, fear of, 109–10
embodied cultural capital, 58, 68–70, 159, 172, 174
Engels, Frederick, 131
enterprise, bureaucratic, 11, 36, 139
European Audiovisual Observatory (EAO), 148–9, 182n
evaluation of culture, 105–29
 disciplinary fears and tensions, 109–11
 evaluative moment dynamics, 120–8
 evaluative possibilities, 112–19
 reflexivity and scholarly positioning, 111–12
 sociology and aesthetic universalism, 106–7
Evora, Cesaria, 175, 176
explanatory understanding, 25
expressions of disgust, 4, 94–5

fashion, 18, 44, 52, 63, 95, 101, 122–3
Fekete, John, 106
field, 63–5
film production, and globalization, 118, 149, 150, 154–6, 182n
Fiske, John, 110, 151
Ford, Henry, 18
formal rationality, 2, 6, 9, 10, 23, 29–31, 32, 41–2, 50, 51, 54, 55, 101, 129, 178
 and bureaucracy, 35–9
 and legal authority, 33–5
 and substantive (value-driven) rationality, 2, 48
Foucault, Michel, 38
free labour, 11
free market, 10, 48, 118, 136–7, 139, 141, 142, 143, 147
free trade, 136, 139, 148, 165–6
free transferability of shares, 11
fundamentalism, 32, 43, 44, 132, 134

game metaphor, 64, 65
Garnham, Nicholas, 96–7
geniuses, 111, 113, 119
germinal phase, temporal-historical path, 132

Giulianotti, Richard, 52, 161
global financial crisis, 26, 135, 138,
 143, 154
global 'finanscapes', 135–7
global inequalities, 165
global markets, 23, 136, 140, 144,
 152, 166
globalization, 5, 44, 52, 130–5, 157,
 161, 163–6, 169, 170, 172
 cultural diversity, 141–3
 cultural funding, 137–40
 cultural homogenization *see*
 cultural homogenization
 nature of cultural exchanges, 144–5
 transnational corporations, 140–1
glocalization, 6, 159
 culture creators and cultural
 habitus, 169–76
 globalizing local production, 168–9
 global–local interaction, 163–6
 hybridization and, 160–3
 localizing global production, 166–8
 strategies, 166–9
Gonzalez, Juan de Marcos, 174
Gothic vault, 16, 44
Govil, N., 154
Gray, C., 136, 139–40
Gronow, Jukka, 10, 31, 53
gross bouffe, 63
Guilbault, Jocelyne, 171

habitus, 58–61, 97–8
 field, 63–5
 forms of capital, 63–4, 65–72
 and homologous positions in social
 spaces, 72–4
 orientation towards reality, 60–1
 as structuring structure, 59–60
 and taste, 61–3
Hall, Stuart, 114, 115
Harrington, Austin, 101, 112–14, 115
Harrington, C. Lee, 152–3, 157
Harvey, D., 140
haute cuisine, 59, 63, 67
Heinich, Nathalie, 111
Held, D., 131, 148
Hennion, Antoine, 51, 97–101, 103,
 106, 107, 125, 127
Hennis, Wilhelm, 28

Hernandez, Tanya Kateri, 174
Hewison, Robert, 91
Hickey, Dave, 116
high culture, 3–4, 59, 76, 109
highbrow, 56, 87, 92, 96
Highmore, Ben, 102, 126
historical quintessence, 105, 118–19
Holcombe, C. J., 51
Hollywood, 147–8, 154–5, 156, 157
homologous positions, in social
 spaces, 72–4
horizontal integration, of
 corporations, 140
Horkheimer, Max, 145, 146
Hu Jintao, 155
hybridization, and glocalization,
 160–3

ideal type of action, 26–9, 31, 33, 34,
 181n
ideal types, 27–8
ideas, emergence of, 40
ignored, 3, 32, 50, 52–3, 178
incipient phase, temporal-historical
 path, 132
individual objects of cultural
 production, 114–15
Inglis, David, 110, 111–12
institutional approaches, 105, 108,
 111
institutional cultural capital, 70–1
instrumentally rational action, 15, 24,
 28–9, 41, 171, 176, 177, 181n
International Forum on Globalization
 (IFG), 166
International Monetary Fund, 164,
 166
intransigents, 3, 32, 49, 50, 51, 55,
 176
inventiveness, 7, 170
inversion, 109–10
involution, 137, 147
irrationality of rationality, 21, 22

Jenkins, Henry, 151
Jenkins, Richard, 37, 43, 44, 58, 103

Kafka, Franz, 38–9
Kant, Immanuel, 56, 106, 111

Kavoori, Anandam, 175
Kern, R. M., 92
Kersten, Annemarie, 118
knowledge and understanding, 45–6
kultur, 180–1n

la grande bouffe, 63
Lane, Jeremy, 119
larrikinism, 96
Lawler, Stephanie, 93, 94, 95, 121
legal authority, 11, 34, 41, 50
 and formal rationality, 33–5
legitimate culture, 3–4, 62, 68, 69, 78,
 81, 82, 83, 85–6, 87, 88, 89, 90,
 107, 109
legitimate taste, 85, 89
 and aesthetic disposition, 76–80
Levitt & Sons, 18
light-footed culture creators, 1, 7,
 159, 170, 173, 175
liquid modern culture, 48, 49, 89, 90,
 100, 110
lowbrow, 87, 92, 96
Lowith, Karl, 9, 24, 54
Luther, Martin, 11, 12
luxury, taste of, 62
Lyotard, Jean-Francois, 109

management, 2, 3, 36, 48–51, 52, 180n
Martell, L., 161–2
Marx, Karl, 8, 9, 10, 32, 131, 170
McDonald's, 18, 19–20, 148, 162–3
McDonaldization, 18–19, 23
 consequences, 22
 principles, 19–22
McLennan, G., 110, 111
measurability, of culture, 2, 5–6, 19,
 49, 128, 177
mechanization, 10
media, 18, 34, 44, 49, 140–1, 150–1,
 165, 166, 167, 168, 170, 174
mestizaje, 160
meta-narratives, 109
middlebrow, 76, 85–8, 92
middle-class identity, 13, 63, 76, 84,
 86, 93–5, 98, 121, 126
migrations, 134, 160–1, 171
millennial phase, temporal-historical
 path, 134

Miller, T., 148, 154–5
Mills, C. Wright, 37, 108
misrecognition, 69, 72, 78
Mitterrand, Frédéric, 138
modern culture, 2, 8, 10, 24, 30–1, 32,
 34, 42, 47, 48, 53–5, 122
modern official functions, 36
mondain, 79–80, 90, 91–2
money making, attitude toward, 8,
 13, 176
motels, unpredictability in, 20
MTV, 166–8
Mulvey, Laura, 115, 116
Murdoch, Rupert, 152
music, 4, 6–7, 16–18, 28, 49–50, 53,
 60, 68, 69, 76, 78, 79, 85–6, 92–3,
 98, 99, 100, 101, 102, 103, 109,
 113, 114, 124, 125, 126–8, 142–3,
 144–5, 147, 159–60, 162, 166–9,
 171–2, 174, 175, 176, 178

necessity, taste of, 62, 82, 84
neo-liberalism, 118, 136, 138, 140
Ngai, Sianne, 102
Nollywood, 150, 154
nonhuman technologies, 20–1, 22
normative aesthetic evaluation, 113,
 114, 116–17, 119
nouvelle cuisine, 62

objectified cultural capital, 57, 71–2
objective and subjective
 considerations, 38, 41, 54, 59, 60
objective classes, 57
omnibus products, 5–6, 147, 148,
 151, 153, 156, 157, 168, 170
omnivorousness, 90, 91–3, 96

Parkin, Frank, 14, 26
Parsons, Talcott, 181n
parvenus, 70, 83
patrimonial societies, 11, 33, 35, 36,
 39, 71
pedant, 79–80
perception, of culture, 4, 7, 34, 41,
 58, 59, 61, 76–7, 94, 105–29, 133
 see also taste
personal limitation, sense of, 44–5
Peterson, Richard, 92, 93

petite-bourgeoisie, 86–7
Petras, James, 165
phenomenal perception, 111
Pieterse, Jan Nederveen, 131, 160–1
poets/poetry, 2, 3, 47, 50, 51, 74, 115, 122
Polybius, 130
popular cultural capital, 110–11
popular culture, 23, 34, 49, 74, 86, 96, 109–10, 117, 156–7, 168
popular taste, 76
and popular 'aesthetic', 80–5
power, 3–4, 34, 38, 65, 66, 70, 76, 78, 79, 82, 84, 95, 97, 101, 103, 113, 120, 133, 136, 140, 144, 155, 159, 161, 170, 173, 177
predestination, 12, 15
predictability principle, of McDonaldization, 19–20
prestige, 15, 50, 66, 67, 69, 71, 76, 85, 87, 98, 109
Probyn, Elspeth, 103
professional culture creators, 3, 17, 32, 49, 50, 55, 168, 171–2, 175
profit, 5, 10, 29, 30, 49, 53, 63, 69, 73, 74, 80, 138, 139, 152, 170
logic of, 1, 2, 49, 55, 106, 128, 130, 145–8, 157, 177, 178
pursuit of, 13, 15, 30–1
pro-free-market position, 142
Protestantism, 11–14, 28
pseudo-individuality, 146
public bourgeoisie, 93–4
Puritan, 12–13

Rantanen, Tehri, 156
rational accounting, 10
rational capitalism, 10–15, 16, 28–9, 35
rational social action, 24–6, 28–9
rationalization, 8, 9–10, 28, 29, 32, 34, 35, 37, 53, 54, 129
and disenchantment, 42–6
effects of cultural phenomena, 15–24
rational capitalism, 10–15
rationalized techniques, 10, 17–18
reality self-mediatization, 134
(re)enchantments, 43–4

reflexivity, 111–12
Reformation (1517–1648), 11, 12
relativism, 110, 111, 114, 119, 128
religion, 28, 30, 34, 46, 47, 58, 67, 131, 134, 144, 180n
and culture, 10
fundamentalism, 32, 43, 44
and rational capitalism, 10–15
and rationalization, 15–16
return to beauty, 106, 116–17
Ritzer, George, 18–19, 20–3
Robertson, Roland, 6, 52, 131–2, 133–5, 157, 159, 161, 163–4, 165, 169–70
Rojek, Chris, 110–11

Saatchi, Charles, 90–1
Sarkozy, Nicolas, 138
Sayer, Derek, 9, 181n
scholarly positioning, 19, 111–12
science/scientific knowledge, 17, 43, 54, 63
and religion, 46–7
secular bureaucracy, 16
Segundo, Compay, 159–60, 173–4, 175, 176
self-assertion, 122
Sica, Alan, 2, 8, 24, 37
Simmel, Georg, 120, 122
Skeggs, Beverley, 93, 95
Smart, Barry, 17, 23
snobbery, 90, 92–3
social action
affectual, 26, 181n
formal rationality, 29–31
ideal types, 26–9, 31, 33, 34, 181n
instrumentally rational action, 28, 29
rationalized, 24–6, 28–9
substantive rationality, 29–31
traditional, 58, 181n
value-rational action, 28–9
social aesthetics, 102
social capital, 65, 66–7, 84
social theory, 112–13, 131
sociological imagination, 37–8
sola fide, 12
specialists, 15, 16, 38, 39–40, 80
Stojanovic, Milos, 175–6

struggle-for-hegemony phase,
 temporal-historical path, 133
subjective motivations, 24–5
substantive rationality, 5, 29–31, 41,
 48, 177
Swartz, David, 97, 101
symbolic capital, 65, 67, 69, 71, 73,
 96
symbolic game, 4, 97–8, 107
symbolic power struggle, 97, 101,
 103
symbolic profit, 73, 74
symbolic system, 76, 92, 99, 119
symbolic violence, 4

take-off phase, temporal-historical
 path, 132–3
taste, 56–8
 affectual impulses, 102
 critical appraisal, of Boudieu's
 thesis, 88–100
 expression of, 58–9, 75–104
 and habitus, 61–3
 hierarchies, 101
 legitimate taste and aesthetic
 disposition, 76–80
 middle-brow taste, 85–8
 negative assertion, effect of, 89
 performances of, 98–9
 popular taste and popular
 'aesthetic', 80–5
 relational aspects of, 4
 taste of luxury, 62
 taste of necessity, 62
tax farming, 11
Taylor, Frederick W., 18
television programmes, 52–3, 76, 110,
 124, 130, 134, 153, 157, 166
temporal-historical model, 131,
 132–5
theatre-goers, 73–4
totalizing logic, 2, 37, 42
traditional authority, 34
traditional social action, 58, 181n

transnational corporations, 1, 5–6,
 130, 135, 137, 140–1, 144, 151,
 152, 156, 157, 162, 166–7, 168,
 170, 178
 media corporations, 149–50
transnational cultural taste, 95–6
Tucker, Kenneth H., 9
Turner, Bryan, 23, 95, 96, 110, 111

uncertainty phase, temporal-
 historical path, 133–4
UNESCO Institute for Statistics (UIS),
 149–50, 154
United Nations, 165, 166

value-affirmation, 112–13
value-distanciation, 112–13
value-laden cultural visions, 3, 135
value-rational action, 3, 24, 28–9, 50,
 181n
values *see* aesthetic values; cultural
 values
verstehen, 25–6, 27
vertical integration, of corporations,
 140
Viacom, 166–8, 182n

Wacquant, Loic, 17
Wasko, J., 156
Weber, Max, 2, 3, 8–16, 18, 22, 24–31,
 32–48, 53–5, 58, 71, 80, 113, 129,
 131, 177, 181n
Whannel, Paddy, 114–15
Williams, Raymond, 1, 96–7, 180n
wine-tasting, 51, 83, 99–100, 124, 125
Wolff, Janet, 106, 108, 115–17, 126,
 127
Woolf, Virginia, 87–8
working-class, 63, 79, 80, 82, 83, 84,
 93–5, 121
World Bank, 166
World Trade Organization, 164, 166
World War I, 133
World War II, 133, 137, 145

Printed in Great Britain
by Amazon